Lighting
Digital Field Guide

Brian McLernon

WILEY

Wiley Publishing, Inc.

Lighting Digital Field Guide

Published by
Wiley Publishing, Inc.
10475 Crosspoint Boulevard
Indianapolis, IN 46256
www.wiley.com

WILEY

About the Author

Brian McLernon is a commercial freelance photographer, educator, and writer based in Portland, Oregon. Originally from New Jersey and educated in Arizona, Philadelphia, and New York City, he shoots primarily for editorial, commercial, corporate, and lifestyle clients. He is the author of three previous Digital Field Guides, the *Canon EOS 5D Mark II Digital Field Guide*, the *Canon Speedlite System Digital Field Guide*, and the *Canon PowerShot G11 Digital Field Guide*.

To share his passion for photography, Brian conducts workshops in photography and lighting for Portland Community College's adult education series. He is often honored to be a guest speaker for several artistic associations, communication groups, and business organizations and enjoys speaking to student groups as well. When he's not photographing in the studio or on location, Brian spends time with his wife and daughter, family, and friends, camping, travelling, white-water rafting, cross-country and downhill skiing, and, of course, photographing nature and all kinds of motorsports.

Credits

Acquisitions Editor
Courtney Allen

Project Editor
Kristin Vorce

Technical Editor
Ben Holland

Senior Copy Editor
Kim Heusel

Editorial Director
Robyn Siesky

Editorial Manager
Rosemarie Graham

Business Manager
Amy Knies

Senior Marketing Manager
Sandy Smith

Vice President and Executive Group Publisher
Richard Swadley

Vice President and Executive Publisher
Barry Pruett

Project Coordinator
Patrick Redmond

Graphics and Production Specialists
Samantha K. Cherolis
Andrea Hornberger

Quality Control Technician
Lauren Mandelbaum

Proofreading and Indexing
Sharon Shock
Penny L. Stuart

For Dean Collins, who started me out on the light path.

Acknowledgments

Although only one name appears on the cover of this book, a project like this brings an entire team of people together in seemingly unrelated ways who all contributed to its creation. My hearty thanks go out to all those friends, clients, and associates who posed for many of the images in sections of this book and to those who contributed conversation, access, equipment, and ideas that helped make this book even better.

First, to my wife Gayle and daughter Brenna, who allowed me to disappear into my studio cave to shoot and write and make my deadlines, all the while providing those smiles, support, and laughter that make my life a joy.

To Bob and Shirley Hunsicker of Pharos Studios, my early mentors in studio photography and business, whose guidance and friendship contribute immeasurably to my photographic career.

To photographer Rick Becker of Becker Studios in New York City, who long ago opened his Pandora's box of lighting tips, techniques, and special effects and shared with me the secrets of studio lighting.

To Michael Durham of the Oregon Zoo for providing access to the zoo and kind encouragement while I was writing this book. An incredible photographer himself, Michael strives to photograph that which can't be seen by the naked eye.

To David Honl, Rachael Hoffman, Phil Bradon, Craig Strong, Kari Friedman, and Michael Paul Wyman for providing me with equipment and technical details about some of the photos and lighting equipment described in this book. You guys truly rock!

To Aaron McNally for assisting in several of the lighting setups and photo shoots, and to Ted Miller, Adrienne Luba and Kathryn Elsesser, Rhonda McNally, and Keegan Mullaney among others who graciously posed for several portraits in this book to describe various lighting angles and styles. I couldn't have done it without you.

To photographers Galen Rowell, Dewitt Jones, George Lepp, and John Shaw, who conducted workshops that keyed me in to the technical considerations of natural light and shared concepts and approaches to nature photography that I still call on today.

To photographers David Hobby, Joe McNally, Syl Arena, Chase Jarvis, and John Harrington, who share their photographic expertise through blogs and Web sites in their selfless desire to see all photographers succeed. I am indebted to them for sharing their experiences that enhance all I attempt to accomplish in photography.

To Courtney Allen, my acquisitions editor, for this edition and first contact at Wiley, for taking me under her wing and providing friendship and encouragement and bringing me into the Wiley fold — may you rock to the metal always.

To Kristin Vorce, my project editor, for her attention to every detail of this book, including her advice on image selection, captions, and sentence structure. Her contributions never failed to make this book better. Also many thanks to Ben Holland, my technical editor, for keeping me on track and helping me explain myself better.

Finally, to Dean Collins, the master of lighting and Photoshop guru who showed me that photography is all about the light, not the gear. His knowledge of how to manipulate light and his entertaining teaching style have made a lasting impression on me. Though Dean is no longer with us, I am forever in his debt.

Contents

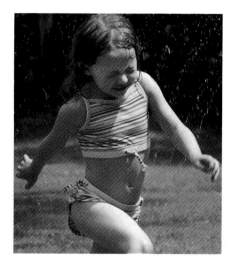

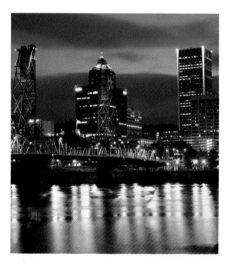

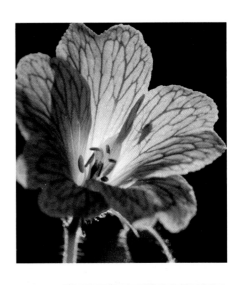

CHAPTER 3
Controlling the Light with Shutter Speed 47

CHAPTER 4
Controlling the Light with Aperture 63

CHAPTER 5
Working with Flash 77

CHAPTER 6
Working with Speedlights 99

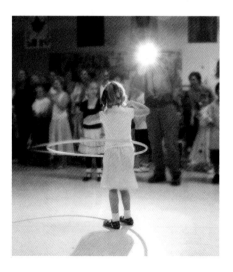

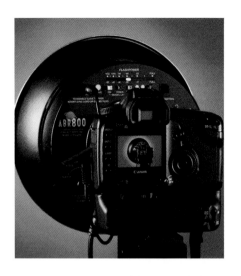

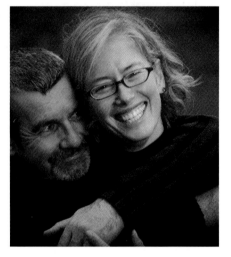

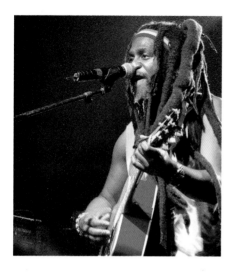

CHAPTER 13
Still Life and Product Photography 211

CHAPTER 14
Wedding Photography 225

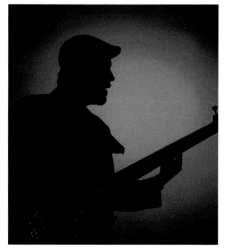

CHAPTER 15
Wildlife and Pet Photography 239

APPENDIX A
Rules of Composition 251

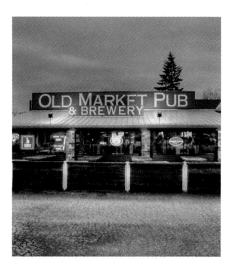

Introduction

Light. You can't make a photograph without it in some form or another. Although light has the ability to give your photographs power and definition, do you consistently consider the quality of light before pressing the shutter button? Sure, you're attracted to your subjects for who they are or to sunset and sunrise photos for the colors of the sky, but what about the quality of the light that defines these situations? Is there some other object or subject you could put into that light that would yield another great photo? That is the road you will be traveling with this book.

Welcome to the new *Lighting Digital Field Guide*. This book will put you on a new path of understanding and appreciation of the power of light in photography. Light comes in thousands of flavors and each one can be used to give your photographs more power when used correctly in the proper situations. By developing an awareness and sensitivity to light, you can begin to come up with picture-taking scenarios that make the best use of the light at hand or to take advantage of that light by quickly making camera exposure adjustments. This book is for those beginning photographers who are comfortable with their cameras but looking to take their photography further by searching out beautiful light.

Seeing Light

Many years ago during an eight-hour photo workshop in New York City, the other attendees and I were challenged by the presenter to "see the light before taking the photo." By the sound of the audience's reaction, it appeared that many of us were confused, not really knowing what we were supposed to be looking for. As the many different qualities of light were explained and the numerous examples shown, it dawned on our group just how powerful a medium light can be and how important developing an understanding of it is. I realized that most of my previous thoughts about photography focused too much on camera and lighting gear (that which I did not own especially) and not really on light and its qualities. Almost overnight, I began to think of photography in a profoundly different way.

What began that evening and continued for many months afterward was a paradigm shift in my approach to photography. I began to really work hard to "see" light and all

the subtle variations in natural light and also how to mimic those subtleties with studio flash equipment. Camera controls and settings were still very important, but now there was reasoning behind those decisions based on the quality of light I either had or wanted to create. All it took was noticing the quality of the light, where it was coming from, which way the shadows fell, and various other nuances. I contemplated lighting before considering what lens, ISO setting, aperture, or shutter speed to use.

What You'll Learn from This Book

Light from sun has the power to oxidize paint, blacken silverware, or burn your skin. Yet this same light can be used for beautiful purposes as well, such as creating dynamic three-dimensional effects in your photos. This book begins by describing the many qualities of natural light, what they are called, and where to find them. You learn how the direction and color of light affects your photos. Then you move on to determining which camera controls best complement the light's qualities. Full chapters are devoted to shutter speed and aperture, explaining how the light on your subject will often tell you which to choose first in order to get the effects you want.

After you learn about natural lighting and ways to get the quality of light you want from the sun outdoors, it's time to move into the studio to get acquainted with many of the types of equipment, tools, and light modifiers found there, and how and when to use them. The popularity of the small external flash units has risen enormously in the past several years, and this book extensively covers the exploding world of small flashes, referred to hereafter as *speedlights*. (Canon calls them Speedlites and Nikon calls them Speedlights, but in all my research I have found the *speedlights* label to be the most generic.)

As you begin to understand just how important and powerful light in your photography can be, look to later chapters that cover the most popular situations photographers find themselves in, namely shooting sports, concerts, landscapes, night scenes, portraits, products, weddings, wildlife, and pets. These chapters discuss specific considerations and practical pro advice for each genre.

It is my sincere hope that this book develops awareness in you that while good quality equipment is necessary, your understanding of light and of the varied methods used to manipulate and shape it, will help make your images much stronger. By "seeing the light" before taking the photo you begin to make conscious decisions when using the camera exposure settings to control and harness that power.

A long time ago, I came to a fork in the road of photography between purchasing more photo equipment or becoming a student of light. Knowing full well that good equipment is still important, I chose the *light* path. It is my honest desire that by studying this new *Lighting Digital Field Guide*, you will, too.

Understanding Light

Capturing light is the essence of photography. In fact, the name used to describe the craft, photography, is a combination of the Greek words *photo* meaning light and *graphi* meaning writing, so photography is fundamentally *light writing*. You use lenses and cameras and storage devices to capture those images that tell your visual stories and for many photographers, that's what photography is all about — the gear. I know I was certainly that way when I started my photography career. I thought photography was more about the gadgets than actually capturing light in all its many forms. Fortunately, at some point I began to see light in a new way and that shift has profoundly affected my photographic work and made it more fun. I want to share that shift in thinking with you, along with various practical ways for you to manage, manipulate, and expose the light.

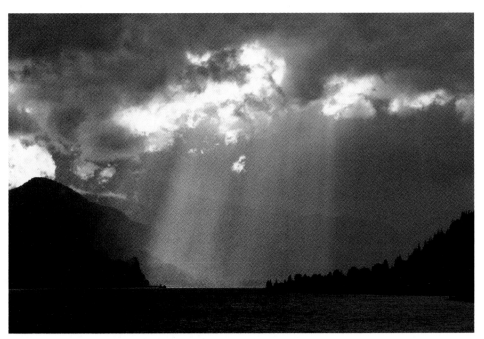

Crepuscular rays of sunlight fall on the Columbia River in late afternoon in the Columbia Gorge. Lighting conditions of this quality can change in a heartbeat, so being ready to quickly change exposure settings ensures you get the shot. Exposure: ISO 200, f/10, 1/640 second.

What Is Light?

Light and its effects in photography can more easily be understood by making an analogy to painting. In this analogy, your digital sensor is the artist's canvas, the camera and lens combinations are the brushes, and the light is your paint. With this light you can create bold colors or pastels, heavy or soft shadows, or no shadows at all. You can also use this light to define or diminish form with highlights and shadows. Light can be used to make the subject stand out from the background or it can be manipulated to provoke an emotional response from the viewer. The power of light is vast and by learning as much as you can about it, you begin to see it in all its many forms.

The problem with light for many photographers is that they are so familiar with it in everyday life, so used to its presence, that they don't really see it and take it for granted. They get excited when they see the subject or scene they want to photograph and see only that, without taking into account what the light is doing, where it's coming from, and where it's going. As a result, they might overlook a slight camera angle adjustment or lens change that could make a world of difference in the final outcome of the photo. I rarely come upon images wholly made, in the field or on location, and often I see something happening with the light that is different from my original intent. Learning to see the light before you trip the shutter takes time, but once you do it raises the quality of your work and makes you a much better visual communicator. In the next section, I discuss some of the types of light you're likely to find and share some of the nomenclature photographers use to discuss the many types of light.

Ambient light

Ambient light simply refers to any light you find when you are attempting to photograph and is also referred to as available light. All ambient light has color characteristics that can be described by the Kelvin scale, which is discussed in full later in this chapter. Ambient light can be any type of light at all and can range from fluorescent to tungsten to daylight and most certainly contributes some form of color to your scene or subject. Realizing what this ambient light consists of and having a good idea of its color temperature and the resulting effect it has on your photograph is critical to creating successful photography.

You also need to pay attention to the sources of ambient light and whether they conflict with one another. Mixed light sources can be a challenge but are much more easily handled once they are identified. It is common in flash photography that the light from the flash can look too blue or cool compared to the warmer light of the interior or setting. Later I discuss adding gels to strobes to match the lighting found on location.

I also explain how the shutter speed controls the brightness value of the ambient lighting of the background when using flash.

Many times, ambient light is reflected back on to your subject. If this reflected light is a problem, it can most easily be corrected by changing the angle of the shot, the background, or both. When you photograph people, the color of the room they are in can have an effect on the outcome and can modify and filter the light to reflect warm, cool, or greenish light back on to the subject.

Hard light

Hard light is undiffused light that strikes a subject directly from its source such as the light from the sun on a cloudless day. Hard light can be identified by the strong highlights it creates on the scene or subject. It also increases the contrast in the image with extremely well-defined shadows and is generally avoided when photographing people. Hard light can accentuate texture and detail in the subject depending on the angle of lighting. It is often used in moderation to provide a hair light for portraits or an edge light for products to make them stand out from a background. Mixed with soft light, a moderate amount of hard light can help define form, create separation, and increase a sense of dimensionality in the image.

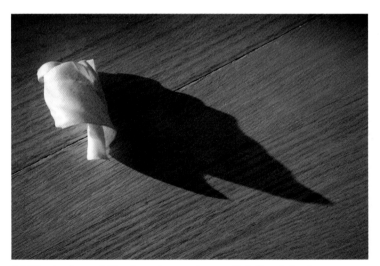

1.1 My dog's rawhide chew toy casts a well-defined shadow on the floor, indicative of the hard light quality of the direct, late-afternoon sun. Do you see a shape in the shadow that reminds you of something? Seeing light is about seeing the absence of light also. Exposure: ISO 3200, f/3.2, 1/1000 second.

Soft light

Soft light is broadly defined as any light that is diffused or reflected by some material to scatter the light rays so that they strike the subject from various angles. This type of light fills in the shadows a bit and reduces the intensity of highlights. Soft lighting is the preferred choice for portrait photography because of its natural depiction of skin, hair, and clothing, moderate contrast, and overall pleasing visual effects. Soft light is most commonly found on a cloudy day where the light from the sun passes through the clouds and scatters, producing less intense shadows, softer transfer edges to shadows, and more diffused highlights. Soft light from overcast days can look slightly cool in your images, so setting your camera to the cloudy white balance setting brings back some necessary warmth to the image. Soft light can also be created in the studio by using lighting modifiers to diffuse the hard light emitted from the direct flash, such as umbrellas, softboxes, and beauty dishes. Much like hard light, too much soft light can reduce shadows and have a detrimental effect on the image by reducing contrast and making the image look flat. In these situations, I try to find some color-contrasting elements to work into the image to give it some edge.

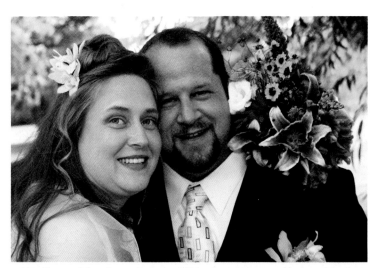

1.2 Dallas and Sarah on their wedding day photographed under some trees that shaded them and created soft light for my photograph. Just a kiss of on-camera flash perked up the colors and provided pleasing catchlights in their eyes. Exposure: ISO 800, f/6.3, 1/200 second.

Diffusion

To produce the desirable soft light for your subjects, you must use diffusion to spread out the light and make it more even. Diffusion involves passing hard light through some type of semi-transparent material to scatter the light rays so that they strike the subject from various angles. In these instances, the diffuser effectively becomes the light source in place of the original source.

While the sun is extremely large in reality, it is very far away and thereby a very small light source that produces hard light on a cloudless day. When clouds come between you and the sun, they diffuse the light and also make the light source larger because of their closer proximity to the earth. A larger light source produces softer light in much the same way that any light source is softer the closer it is to the subject. You can make great macro shots of insects and flowers with a speedlight because of the relative sizes of the light source and subjects.

1.3 Soft, diffused light is produced in the studio by placing the strobe inside a softbox. Placing the light just outside the frame produces the largest highlights in the eyes, face, and hair and creates the softest light. Exposure: ISO 100, f/8, 1/100 second.

Conversely, a light source produces harder light the farther it is from the subject. Understanding this relationship between the size of the light source and the size of the subject helps you produce hard or soft light in any photographic situation.

Diffraction

Photographers striving for the most depth of field for a particular image might assume that all they have to do to attain it is to use their smallest aperture. But using small apertures may introduce the undesirable phenomenon known as diffraction to your

images. Diffraction occurs when light is squeezed through a small opening such as when you're using small apertures. As the light rays bend over the edge of the obstructing object, in this case your aperture blades, the light rays tend to vibrate and disperse the light and this can result in a softly focused image. The problem lies in the fact that when light passes through a large aperture, a very small percentage of light that strikes the sensor is diffracted, but the amount of diffracted light increases as you stop down the lens to the point where more of the diffracted light reaches the sensor.

This is often a problem for photographers who regularly need the maximum depth of field for their images that a smaller aperture affords. Check images shot using your smallest aperture on the computer to see if they are affected by diffraction. You may need to open up a stop or so if you find the amount of diffraction unacceptable.

Lens flare

Lens flare is an optical effect that most photographers experience as unwanted colored objects that cause a degradation of image quality. You can avoid lens flare in your images by using a lens hood or blocking the light that falls on the face of your lens. When hard, direct light enters your camera lens from an angle, it bounces around inside the lens and reflects back and forth between the lens elements. These elements are often coated with special solutions that sometimes mingle with the stray light rays to form multicolored halos, hexagons, or octagons that mimic your aperture's shape. These can be avoided by using a lens hood, your hand, or a piece of cardboard to shade the front of your lens. By doing this, you bring back all the clarity, contrast, and color the shot needs to be successful.

Luminance and efficiency

The luminance value of a subject is the amount of light that is returned from a certain area of your subject. Luminance depends on the angle of light and also the angle of the viewer's eye when looking at the subject. Photographers speak of luminance in reference to the amount of light that returns to the camera from a subject and how bright in the image that subject appears. In an ideal world, the luminance of the subject would equal the luminance of the lighting source, but this is rarely the case. The luminance values of a subject can only be equal to and not greater than the brightness of the source. Taking into account the luminance of a subject, the photographer controls the subject's brightness in the image by managing the aperture and the shutter speed.

The efficiency of a subject refers to how much light is reflected back to the camera from its surface or color. When photographers speak of a subject's efficiency they also take into consideration how much light they need to expose it correctly in a photograph compared to the surrounding tones and elements in the picture. A shiny white car is doubly efficient because of its color and also its surface shine. When exposing an image, you must be aware of the subject's surface finish and color and how large the subject appears in the photo. A black sweater or dog would exhibit low efficiency and would need lots of light or exposure to make up for the dark material's absorption of light.

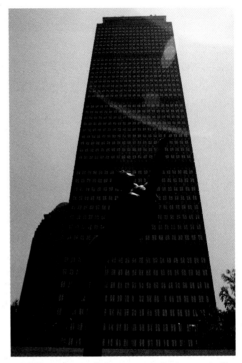

1.4 I shot toward the sun to photograph the Prudential building in Boston, purposely removing my lens hood to dramatize the most common effect of lens flare — multicolored halos. Exposure: ISO 100, f/6.3, 1/250 second.

Specularity

Specularity is the ability of light to travel in a straight line and produce direct mirrored highlights of its source in highly reflective surfaces. This is seen in the reflected highlights of the sun in an automobile's chrome bumper or paint job. Streetlights and the small decorative strands of lights used to adorn holiday displays are examples of *points of light*. In speaking about reflected lighting qualities, a diffused highlight refers to the subject's color that brightly shows through, compared to a specular highlight, which is the reflection or mirror image of the light source itself.

Direction of Light

The direction of the light is important because it determines where the highlights and shadows fall and the amount of three-dimensionality in the photograph. Shadows add

depth to a scene and the photographer has to determine the direction of the lighting on the subject to either show or hide detail. Lighting direction is controlled in the studio by moving the actual lighting around. On location it's done by posing, changing the position of the subject, shooting at a specific time of the day, or adding supplemental lighting to accent what ambient light is already there. This section looks at the four main ways of lighting your subject.

Front lighting

For most photography uses, front lighting is the least desirable because it produces flat results with all the shadows falling away from the camera. This is the lighting effect caused by using on-camera flash and is the main reason many photographers have an aversion to flash photography. Front lighting fills in all the nooks and crannies on the surface of the subject, eliminates textures, and removes the shadows that help define form and complement the highlights. Front lighting can also cause special confusion for the viewer because the lighting is flat, illuminating everything the same.

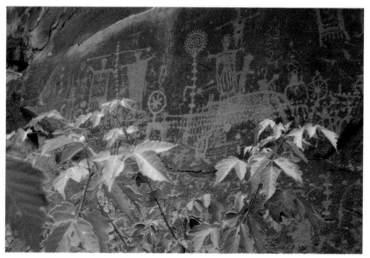

1.5 In this front lit scene of petroglyphs from the Utah desert, there are no shadows to give the viewer a sense of depth and dimension. I tried to work some visual interest into the scene by stepping back and including the green bushes to add color contrast to the red rock wall. Exposure: ISO 100, f/11, 1/250 second.

Side lighting

Side lighting occurs when the light strikes the scene or subject from a low angle off to one side and can be used for dramatic pictorial effects of shadows under hard lighting conditions. The lower the light source is the longer the shadows are and the brighter the highlights are on the side of the subject facing the light source. Side lighting is a great technique when you want to show texture and surface qualities of an object.

Side lighting creates highlights and shadows across the side of the subject that faces the camera and can have a dramatic effect on portraits. This lighting is often employed in food, fashion, and catalog photography to accentuate the product and add separation from the background. By placing the side or rim highlights against a darker-toned background, more dimension is created.

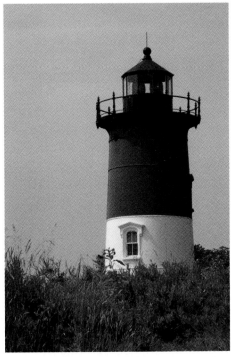

1.6 Soft side lighting can create dimension in the image by illuminating only one side of your subject while the other side falls into slight shadow as in this shot of a lighthouse on the coast of Cape Cod. Exposure: ISO 200, f/5.6, 1/2000 second.

Overhead lighting

Overhead lighting occurs when the light source is directly over the top of the subject, such as the light from the sun at noon on a cloudless day. The top of the subject receives a strong highlight from the light source and the shadows are directly underneath and very noticeable. Overhead lighting is often used in the studio with reflector cards off to either side of the subject to kick fill light back into the side that faces the camera. Depending on the material they are made from, the reflectors only return a percentage of the top light and can be moved closer or angled to increase or decrease this percentage.

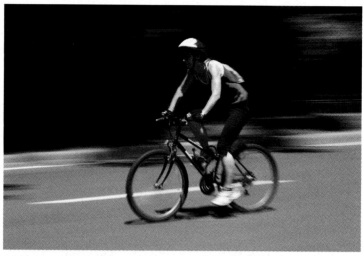

1.7 It was late morning when I photographed this bicyclist with overhead sun. I used my flash on TTL mode to brighten up any shadows. Exposure: ISO 100, f/16, 1/25 second.

Overhead lighting for outdoor photography is not so forgiving. Photographers tend to avoid this kind of lighting for architectural, landscape, portrait, and nature work and others simply call it bad light and go photograph something else. Photographers who don't have this luxury have incorporated flash and flash techniques into their repertoire to fill in the heavy downward shadows on people or objects that may appear in

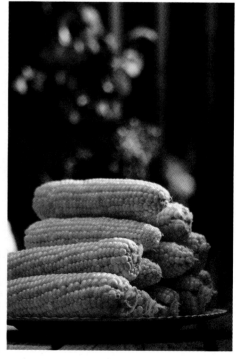

1.8 Top and side lighting can be a creative way to separate your subject from a darker background as in this photograph of some fresh New Jersey corn. Late afternoon sunlight from above right illuminates the top and right side of the corn and background flowers. Exposure: ISO 500, f/2.8, 1/2000 second.

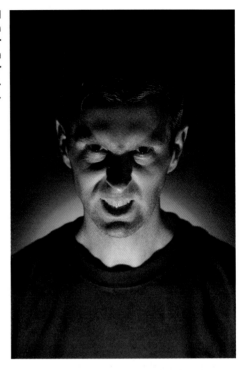

1.9 Bottom lighting is generally avoided for most photography but is often employed for its unsettling effect in horror movies. My mild-mannered friend Keegan holds a speedlight in his lap while I trigger it wirelessly to create the psycho effect. Exposure: ISO 400, f/5.6, 1/200 second.

the images. For portraits, the strong downward shadows of the eyes and chin must be filled in for the people to look natural, and flash is perfect for this type of lighting by adding light where you need it.

The opposite effect of top lighting is bottom lighting and is generally avoided for most photography sub-jects. Because people are conditioned to expect lighting to come from above such as the sun or interior lighting from a ceiling, bottom lighting pro-duces an eerie effect in (and psycho-logical reaction to) photos of people that are lit this way. This type of lighting is successfully exploited for horror and monster movies to create an emotionally discon-certing response in the viewer.

Backlighting

Backlighting your subject can produce dramatic results but can be one of the most challenging lighting techniques to manage properly. If the most light for your image is coming from the rear, that means that the side of the subject that faces the camera is in shadow and must be compensated for with additional light or exposure. The cam-era's internal light meter is hard pressed to get this type of exposure correct because of the bright backlighting, strong shadows in the front, and drastic difference between the lighting levels.

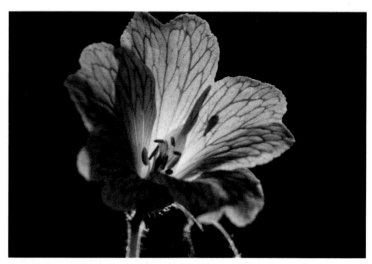

1.10 Strong, late-afternoon backlighting illuminates this wild geranium flower against a darker shadowed background. It was only after I started to compose the image with my macro lens that I noticed the insect silhouette on the opposite side. Exposure: ISO 100, f/8, 1/125 second.

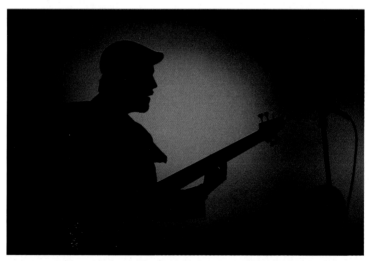

1.11 Reception hall lighting backlights the wedding band in this photo where I noticed the lighting effect and turned off my speedlight to prevent it from firing. I underexposed by 1/2 stop to darken the silhouette against the brighter background. Exposure: ISO 1000, f/2.8, 1/125 second.

At this point, you have several options available to you to manage or manipulate the lighting scenario. If your subject is fairly transparent, such as a flower or foliage, opening the aperture slightly produces enough exposure and the lighting position helps saturate the colors even more.

You could add supplementary light into the photo with a reflector card or speedlight, or you could underexpose slightly to create a dramatic silhouette. Either way, backlighting is a fun and exciting way to add depth and drama to your photos.

Color of Light

Light, whether it is sunlight, moonlight, fluorescent light, or light from a speedlight, has a color that can be measured using the Kelvin scale. This measurement is also known as color temperature. One of the advantages of using a digital camera is the ability to measure the color temperature of light through the lens. If your camera is set to the Auto white balance (AWB) setting, it automatically adjusts the white point for the shot you are taking. However, using Auto white balance all the time can result in inconsistent images from shot to shot as the lighting conditions change even slightly. It's better to use one of your camera's white balance presets or perform a custom white balance setting for each lighting situation you encounter.

> **TIP** If you shoot JPEG images, the white balance is set in the camera by the preset you choose. If you shoot RAW images, the white balance setting is only "noted," and you can set or adjust the white balance in the RAW conversion program after the image is captured.

The whole point of setting the white balance in the camera is to achieve a neutral balance to the colors under all conditions of light, not to make a picture too orange or too blue. The white balance setting in the camera compensates for a shift in the color temperature of the scene by shifting back the opposite direction. For example, setting the camera to the Cloudy white balance preset (6500K) and shooting in bright sun will add some warmth to the photo. If you set the camera to the Incandescent white balance and shoot outdoors in daylight the image will appear bluish. White balance can be used creatively to warm up or cool down an image, but it's best not to overdo it so that the image looks unnatural.

Consider these approaches regarding white balance for shooting scenes in different lighting conditions:

▶ **Higher color temperatures appear cooler.** If your digital camera is set to a white balance setting that represents higher color temperatures (above 5000K), the colors in your images appear more blue, or cooler.

▶ **Lower color temperatures appear warmer.** Setting your digital camera to a white balance setting that represents lower color temperatures (below 5000K) makes the colors in your images appear more reddish orange, giving a much warmer appearance to skin tones.

▶ **Speedlight flashes are set to 5000-5500K.** Most speedlight flash units produce light with a color temperature of around 5000-5500K. When shooting subjects with lots of ambient light and flash, try the different white balance presets on your digital camera to see which ones you like, gel the flashes to match the ambient, or just keep your camera set on the AWB or the Flash preset. Adding colored gels to your flash is a technique used to balance the light from the flash with the available light of the scene.

▶ **Auto white balance (AWB) settings can be very accurate.** Today's digital cameras are accurate in measuring a subject's white balance. Setting your digital camera to Auto white balance often results in a correctly color-temperature-balanced image in a broad range of photographic situations. This setting, however, may exhibit inconsistency. The reason for this is that the color of light reflected in one shot to another can be slightly different because elements change within the scene, so the choice made by AWB from shot to shot will likely change. Even though the white balance may change slightly from shot to shot, AWB is my go-to setting when pressed for time in very difficult lighting situations.

▶ **Shoot in RAW format for ultimate control of white balance.** Most dSLR models can shoot images in the manufacturer's proprietary RAW mode. When shooting your images in RAW format instead of JPEG, you can adjust the white balance of your images during or after transfer of the files to your computer. By using the RAW conversion software that was included with your camera or using Apple's Aperture, Adobe Camera Raw, or Adobe Photoshop Lightroom, you can adjust the white balance of an image after you import it into the computer.

Color temperature (Kelvin scale)

Similar to Fahrenheit and Celsius, Kelvin is a temperature scale normally used in the fields of physics and astronomy, where absolute zero (0K) denotes the absence of all heat energy. The Kelvin scale was devised by heating a metal bar referred to as a black body radiator to specific temperatures and noting the color changes as the temperature increases.

For most people, the color scale of Kelvin and color temperature is opposite of what you generally think of as "warm" and "cool" colors. On the Kelvin scale, red is the lowest temperature, increasing through orange, yellow, and white, to shades of blue at the highest temperatures. Most present-day dSLRs offers three basic approaches to setting white balance. This gives you flexibility to use different approaches in different shooting scenarios.

White balance

White balance options give you a variety of ways to ensure color that accurately reflects the light in the scene. You can set the white balance by choosing one of the preset options included with your camera, by setting a specific Kelvin color temperature, or by setting a custom white balance that is specific to the scene and lighting. The next series of images shows the difference in white balance settings from a photo of the Mayflower II shot outdoors in Plymouth, Massachusetts. Each photo represents a different white balance setting, with color temperatures ranging from 2850K to 6500K. The lower the color temperature, the warmer the image appears. The higher the color temperature, the cooler or more blue the image appears. The goal of white balance is to achieve color neutrality in the image, so the value must be set in such a way as to offset the light in the scene and the white balance setting on the camera. In practical application it is all about compensating and correcting the light and camera settings. Remember it's called white *balance* for a reason.

Don't fall into the habit of always relying on the Auto white balance (AWB) setting, especially in mixed light or other difficult lighting situations. Once you decide on your scene, it takes less than a minute to perform and set a custom white balance.

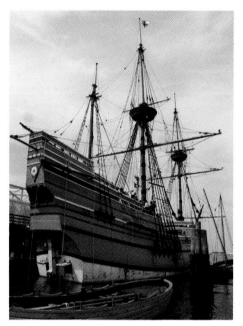

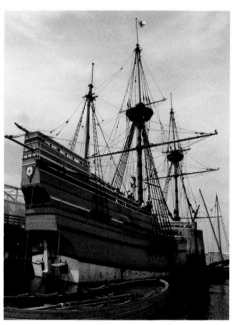

1.12 Daylight white balance, 5500K.
Exposure for all Mayflower II images:
ISO 100, f/8, 1/800 second.

1.13 Shade white balance, 7500K

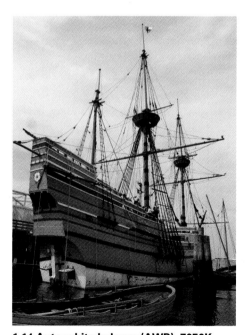

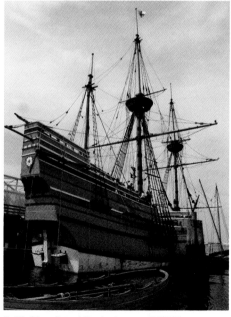

1.14 Auto white balance (AWB), 7050K

1.15 Cloudy white balance, 6500K

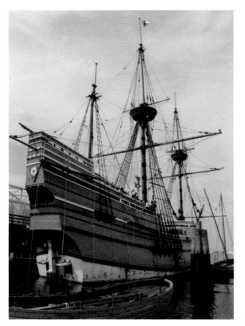

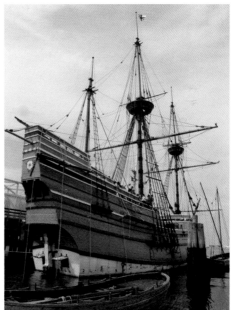

1.16 Fluorescent white balance, 3800K **1.17 Tungsten white balance, 2850K**

Here are some tips that provide a starting point for using each of the three white balance methods:

▶ **Use a preset white balance setting.** For outdoor shooting, especially in clearly defined lighting conditions such as bright daylight, an overcast sky, or in fluorescent light, using one of your camera's preset white balance settings produces accurate color in most cases. The exception is shooting in mixed light and using the Auto white balance (AWB) setting, which I feel produces less than ideal color reproduction. Otherwise, the preset white balance settings have very good color, hue accuracy, and are convenient to use in many types of lighting conditions.

▶ **Set a specific color temperature.** With this option, you set the specific light temperature manually. This is the best approach to use for studio shooting when you know the temperature of your strobes. If you happen to own a color temperature meter, this is a great option to use in non-studio situations as well. I use the color temperature white balance settings in any situation where I'm sure of the specific light temperature.

▶ **Set a custom white balance.** Setting a custom white balance is an option that produces very accurate color because the white balance is set precisely for the light temperature of the scene. To use this option, you shoot a white or gray card such as the one included with this book, select the image of the card, and the camera imports the color data and uses it to set the image color. You can use the custom white balance as long as you shoot in the same light, but if the light changes or you add a speedlight, you have to repeat the process to set a new custom white balance. For JPEG capture, this is an accurate technique that is highly recommended.

Daylight

Daylight is a global term used to describe a wide array of lighting conditions attributed to the sun as it arcs across the sky. The term is attributed to camera films that were said to have a daylight white balance of 5000 degrees Kelvin but were only precisely accurate for a short time of the day. Daylight can include light on sunny and cloudy days as well as the light in shaded areas. Light during the day can range from bright red and yellow in the mornings to clear white light at midday then back to the warmer red and yellow tones of late afternoon. These short times of sunrise and sunset lighting conditions are considered the best times to photograph by landscape and nature photographers because of the beautiful warm light and long shadows. The term alpenglow was actually coined to refer to these golden hours of warm light as it fell upon the Alps. Lighting taking on these warmer qualities has to do with the angle of the sun along with the direction and distance these rays have to travel through the earth's atmosphere.

Because of the sun's position, less clear white and blue light is allowed to pass through the atmosphere and as the light rays travel farther and farther they become redder and redder. When something does finally block their path, such as your subject at these times, the light appears much warmer in red-, orange-, and yellow-toned light. As the sun starts to set, many of these light rays are scattered and reflected away and the light from the sun appears less intense. As the sun sets, it appears to change from white to yellow and finally to red.

As the day progresses the longer, warmer wavelengths of light pass through the earth's atmosphere and are broken up into smaller wavelengths by moisture, dust, or reflected back into the sky. These much shorter wavelengths of light are the reason

why the sky appears blue during the day and the light from the sun appears clear or a neutral white.

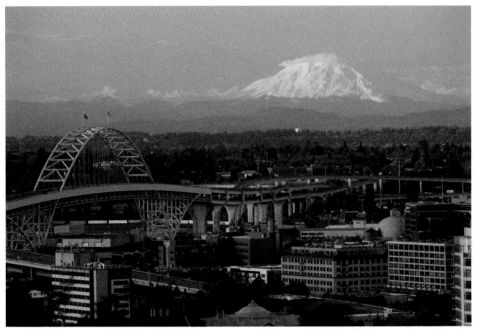

1.18 In this daylight shot, the city of Portland in the foreground is rather cool or bluer than the mountain, which takes on a warm alpenglow cast from the setting sun. Exposure: ISO 2500, f/8, 1/400 second.

Tungsten

Tungsten or incandescent light sources are mostly encountered indoors in the form of ordinary household light bulbs. As the wattage and filament used to produce the bulbs varies, so does the color temperature of the light emitted, which must be accounted for by the photographer. Supplemental light bulbs for photographic applications are often referred to as *hot lights*, not for their constant 3200K rating but for the fact that they produce a lot of heat and can be quite uncomfortable lighting for subjects. Because of this, very few photographers use hot lights anymore, or if they do, they prefer to use the newer, cooler fluorescent versions.

There is also wide variance in the wattage and color output among various manufacturers' bulbs, so it is important perform a custom white balance to really dial in the camera to produce the most accurate color.

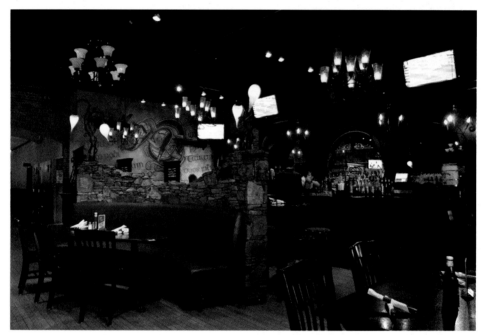

1.19 The interior of this pub in downtown Boston is accurately rendered using the Tungsten white balance setting on the camera. A small bit of daylight from a window on the left just outside the frame graces the dining room table on the right with slightly bluish light. Exposure: ISO 1600, f/3.5, 1/15 second.

Because of the deep blue cast produced by the Tungsten white balance setting when used for outdoor shooting, I prefer to use it for outdoor portraiture when using flash for the intense blue it produces in the sky and shadows of the background. You must add a gel to your flash, specifically one Color Temperature Orange (CTO) gel to compensate for the blue cast of the tungsten setting and get clean white light for your subject. You can warm up the flash lighting even more by adding additional gels in smaller intensities.

Depending upon the time of day, I may also have to use the high-speed sync capabilities of my camera and flash system to keep the ambient light levels manageable. This is a favorite technique to produce intense color with interesting effects.

Fluorescent

Fluorescent lighting, found nearly everywhere, is the preferred type of lighting for large offices, department stores, and just about any other locations that require large light output from cool, quiet fixtures. Fluorescent light is created by sending an electrical current through a sealed glass tube that is filled with a gas. The electrical current causes the chemical phosphors inside the tube to glow and thus produce the light. Because different vendors use various phosphors in the manufacturing of fluorescent bulbs they produce slightly different colors of light that often appear white to the human eye.

1.20 You can create some interesting lighting effects for outdoor portraiture by using the Tungsten white balance setting and CTO-gelled flash. The overall lighting of the scene takes on a bluish cast while anything lit by the flash appears natural. Exposure: ISO 500, f/3.5, 1/800 second.

Camera sensors, however, see this light as quite different and you need to adjust for this. Fluorescent bulbs come in many types with names such as designer white, cool white, daylight white, and neutral white that all vary slightly in the color temperature of light that they produce. Because of this wide variance, some cameras now include two different settings for fluorescent light sources to try to get as close as possible to a neutral white balance.

Unless color corrected, most fluorescent light sources produce an unpleasant green colorcast in your photos. Equally important is the fact that a fluorescent light's color temperature can change on a moment-to-moment basis because of even slight fluctuations in the electrical current. Photographers who are interested in lighting would be wise to become more acclimated with fluorescent lighting because it is quickly becoming more widespread as more of the population becomes more environmentally conscious and switches to fluorescent bulbs for their lower power consumption and quality of light.

1.21 When you photograph a subject under fluorescent lighting with the camera set to Daylight White Balance, the discrepancy in lighting temperatures is evident in the overall greenish cast and must be compensated in the camera or on the computer later on. Exposure: ISO 1000, f/2.8, 1/40 second.

There are a few ways to manage shooting under fluorescent light on locations. You can set your digital camera to one of the Fluorescent white balance settings or shoot in RAW format and color correct later on your computer. To add more punch to photos I create in fluorescent light environments, I have found great success by setting my camera to its Fluorescent white balance setting and adding a speedlight fitted with a green gel to match the ambient fluorescent light.

1.22 Color correcting on the computer or choosing the camera's Fluorescent white balance setting yields much more neutral colors. Exposure: ISO 1000, f/2.8, 1/40 second.

Neon and special light sources

Neon lighting and the vast array of lighting options such as halogen, mercury vapor, and so on, present challenges for the digital photographer to accurately measure and record the light and color. If you are using flash, add color gels to the speedlight to match the flash's output to the ambient lighting

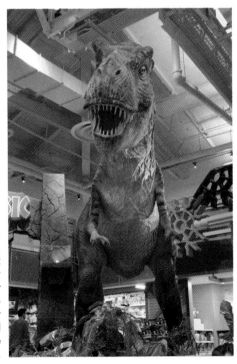

1.23 T-Rex photographed inside a toy store under a mixture of neon, halogen, fluorescent, and incandescent light sources. While it may take a few moments to perform a custom color balance in a location like this, I prefer to shoot in the RAW format and adjust my Auto white balance (AWB) setting and color correct to taste later on the computer.

conditions. The problem is that it is very hard to determine the type of ambient light on a consistent basis. As if this weren't challenging enough, when you add a third light source, such as daylight coming into the scene from a window, all bets are off and you have to decide which light sources are the most important and go from there. My best advice is to try your white balance presets and check the results on your camera's LCD monitor. If that fails to produce the results you seek, perform a custom white balance or delve into your camera's Kelvin temperature capabilities to tweak the light as best you can. While I always recommend getting the exposure and white balance as accurate as possible in-camera, mixed light sources such as neon and others may require a bit of tweaking in post-production.

Setting a custom white balance

If you'd rather be out shooting images instead of behind a computer color correcting them, then getting a handle on white balance is important. Different shooting assign-

ments, the type and consistency of light, and the amount of time you have to set up the camera before and during a shoot are some of the factors that may influence your decision about which white balance approach you choose.

Mixed light scenes, such as those with tungsten and daylight, can be very difficult in getting accurate or visually pleasing image color. Two options work well to get neutral color quickly in mixed lighting scenes. If you're shooting RAW capture, one option is to shoot a gray or white card as described in Appendix C, and use that image as your white balance benchmark. The second option is to create a custom white balance by shooting the same gray or white card image and have the camera use that image as the custom white balance.

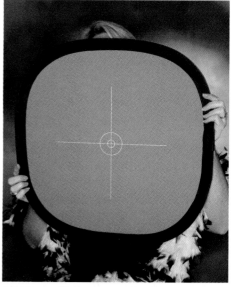

1.24 To perform a custom white balance in the studio, I have the model hold up a gray target in front of her face to accurately measure the light falling on it from the strobes, and then I zoom in to fill the frame with only the gray target to create a custom white balance. Exposure: ISO 200, f/3.5, 1/200 second.

Setting a custom white balance ensures that white is rendered as white in the specific light you're shooting in. It is quick to set, and is a great way to ensure accurate color. Every camera manufacturer has a slightly different way to perform a custom white balance, so check your camera manual for the specific way to do this on your camera, or better yet, pick up the Digital Field Guide that is specific to your camera model. It will include a detailed step by step procedure for you to do this.

When you finish shooting in the light where you set the custom white balance setting and move to a different type of lighting, remember to reset the white balance option to one of the presets or perform another custom white balance setting for the new lighting conditions.

Camera Controls of Light

Your digital camera contains all the lighting controls, shooting modes, and metering modes you need to realize your creative vision and make stunning images. Today's cameras come equipped with an impressive array of microprocessors and sophisticated metering systems that evaluate the light and instantly choose the exposure settings for your images. As a creative photographer, you decide when to use the ISO, aperture, and shutter speed settings that give your images the power you want to convey to your viewers. You also decide which exposure and metering modes to use to get the best results for your intended subjects. This chapter helps you understand how your digital camera manages and interprets light in specific ways, which makes your images stand out from the rest.

I wanted to capture an active, dynamic image of my daughter jumping into a swimming pool to convey the fun of being a child in the summertime. I purposely chose a shutter speed that was slow enough to blur certain elements in the photo but still retain some sharpness in her body. Exposure: ISO 100, f/22, 1/13 second.

ISO

The ISO settings on your digital camera control light by changing the sensitivity of the sensor to the light reaching it, in much the same way that ISO had rated a film's sensitivity to light in the past. By raising the ISO number, you increase the sensor's sensitivity to light and by lowering it you decrease the sensor's sensitivity. ISO affords the photographer another way to control light along with aperture and shutter speed when confronted with very bright or low-lit environments. Understanding ISO and its relationship to light will help you know when to use the high or low ISO settings of your camera.

The term ISO comes from the photographic film days and stands for the International Organization for Standardization. In the past, you would use a film with an ISO rating of 100 for bright and sunny days, and a more light-sensitive ISO 400 or above film for shooting in low-light conditions. Each of these films had limitations. 100 speed films needed a fair amount of light to make a usable image and ISO 400 pictures would show an obvious increase in grain. The same holds true today in digital photography in that a lower ISO setting will yield photos with the least amount of noise and a higher ISO setting will increase the likelihood of producing noise in your images.

ISO and light sensitivity

Once the light passes the shutter, it strikes the image sensor of the camera and creates the picture. That sounds easy, but a lot happens in that split-second of taking the picture. The image sensor inside your digital camera works by converting the incoming light (photons) into an electrical charge that is proportional to the amount of photons that struck each pixel. This electrical charge is then converted to a voltage, which is then sent to a processor for conversion into the 1s and 0s that make up a digital image. In this process, electrical circuit noise is added to the voltage and as that voltage is amplified by increasing the ISO settings, more noise is produced in the image.

Digital noise

Although you have the option of increasing the ISO sensitivity at any point in shooting, the trade-off in increased amplification or the accumulation of an excessive charge on the pixels is an increase in digital noise. And the result of digital noise is an overall loss of resolution and image quality.

This is easy to understand if you equate it to your home stereo and the sound coming out of your speakers. If you only turn on the amplifier part of the stereo and no other components and then slowly turn up the volume knob all the way, you begin to hear a

hum that gets louder and louder. The electrical signal from the stereo to the speakers is amplified more and more. This is the audible equivalent to digital noise.

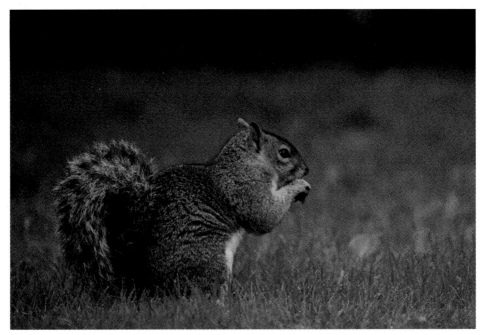

2.1 If any digital noise is present in your image it is readily apparent in the darker or the smooth continuous toned areas of your photo as in image of a squirrel feasting on an acorn. In this image, you will notice noise in the green of the background more so than in the textured surface of the squirrel's fur. Exposure: ISO 4000, f/5.6, 1/2000 second.

High ISO noise reduction

As stated previously, the higher the ISO setting you choose, the greater the chance of producing digital noise in your images. To counteract this, some digital cameras employ in-camera high ISO noise reduction software that works extremely well to reduce unwanted noise artifacts from degrading your image's quality. This sounds like a good feature to use all the time but in reality using this setting significantly adds to the time it takes to write the image data from your camera's buffer to your memory card when shooting a sequence of images. Your burst rate or frames per second will not be affected unless the buffer is full. Then the camera will not allow you to shoot until enough space has been freed up in the camera's buffer after writing the images to your memory card.

Many times, you find that you have to use higher ISO settings because there is no other way to make the image. This is all too evident in shooting concert photography and low-light images. To avoid blurred elements in your photos you need to pick a fast enough shutter speed while still allowing the proper exposure to make the image. If you are already using your widest aperture, your only other alternative is to increase the ISO setting.

As you shoot more of these types of images you find that digital noise is most evident in the dark areas of your images. Colored pixels called *artifacts* are more visible as the ISO increases. Using the camera's onboard noise reduction software is a good idea when you may want to quickly upload photos to a gallery or social media Web site and don't want to spend any time reducing noise in post-processing. You should know though that this can use up more battery power, take a longer time to write the images to your memory card, and cause noticeable degradation to the sharpness of an image. Image processing software such as Apple's Aperture and Adobe's Photoshop and Lightroom include noise reduction modes if you would rather perform it to individual images when you process them. Specialized software packages such as PictureCode's Noise Ninja, which I use, are available for trial downloads to gauge their effectiveness on your images before you buy.

Shutter Speeds

By changing the shutter speed you change the amount of time the sensor in your camera is allowed to gather light and thus how much action is frozen or blurred in the photo. There are certain shooting situations that demand the proper shutter speed for a successful picture and these are outlined in the following sections.

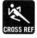 Chapter 3 is devoted entirely to shutter speeds as an extremely powerful tool to manage light and motion in your photographs.

Fast shutter speeds

Fast shutter speeds are used when you want to freeze action and only photograph a tiny sliver of time. Shutter speeds are considered fast at any setting over 1/125 second and extremely fast from 1/1000 to 1/4000 second. Some higher end cameras are even capable of shooting at 1/8000 second, the fastest shutter speed a digital camera is capable of at this time.

Fast shutter speeds are a necessity when shooting fast action and sports photos but require a large amount of light because you are only opening the shutter for a very short

2.2. Shooting photos of basketball action demands the use of fast shutter speeds for consistently sharp images such as this image I shot for AND1 Sportswear. Exposure: ISO 3200, f/2.8, 1/1000 second.

time. The subject distance from the camera also helps you determine how fast of a shutter speed you need to freeze the action. Being very close to the action or using a longer focal-length lens necessitates the use of faster shutter speeds than something farther away or shot so as to appear smaller in the frame.

Medium shutter speeds

Medium shutter speeds are considered the norm for subjects that are stationary, such as portraits of still life images, and generally fall in the 1/30 to 1/125 second range. These shutter speeds are not slow enough to blur action or fast enough to freeze action of moving subjects, which makes them ideal for landscapes or product photography. These are the default shutter speeds for many cameras when using the onboard pop-up flash or in any of the Auto modes and can be used for a broad range of subjects as long as the subject is not moving.

2.3 Medium shutter speeds are ideal for shooting static subjects and are often the camera's choice when using Auto modes or the camera's onboard pop-up flash such as this shot of a floral display in a hotel lobby. Exposure: ISO 400, f/2.8, 1/60 second.

Slow shutter speeds

Slow shutter speeds are considered anything from 1/30 second down to 1 second. Using shutter speeds in this range leads to many creative possibilities to depict motion but can also have a detrimental effect of too much unintentional blur. Shooting in this range takes a bit of practice to pull off sharp handheld shots without too much subject blur or when panning with your subject. A tripod will keep your camera steady and is usually recommended when shooting anything stationary at speeds below 1/30 second such as a landscape. When panning with slow shutter speeds, I prefer to shoot without a tripod to free me up to move and more easily track my moving subject. When shooting in this range of shutter speeds, it's also a good idea to turn on your camera's Image Stabilization (Canon), Vibration Reduction (Nikon), or SteadyShot (Sony) systems if your camera or lens includes it, to correct any camera or subject movement.

You can also mimic the effect of a tripod with your body position. Start by keeping your feet slightly apart to match the width of your shoulders with your left hand supporting the camera and lens and right hand holding the camera grip with your elbows tucked in. Regulate your breathing. Very gently press the Shutter Release button to avoid moving the camera as much as possible. A tabletop, bike seat, fence post, doorway, or any solid surface can also be used to steady the camera when shooting with these speeds.

2.4 Slow shutter speeds are perfect for capturing movement and adding motion effects to images. As this man waited for a light rail train, I photographed his reflection in the window glass of another passing train. Exposure: ISO 50, f/29, 1/2.5 second.

Aperture

Aperture affords the photographer as many creative possibilities as shutter speed does for capturing light but differs in the fact that it determines *depth of field* as well. (Depth of field is the area in front of and behind what you are focusing on that will be in acceptable focus.) By changing the aperture you control the intensity of light entering the camera and thereby the amount.

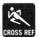 See Chapter 4 for more detail on controlling light with aperture selection to make your images extraordinary.

The aperture (also known as the iris or diaphragm) in a camera lens is a device that opens and closes to allow more or less light to pass through the lens during the exposure. As you peer through the viewfinder to compose a photograph, the aperture remains fully open in order to allow you a nice bright view of the scene, and also to allow a sufficient amount of light into the camera so that it can calculate exposure and focus. At the precise moment of the exposure, the lens *stops down* to the specified f-stop and returns to its wide open position once the exposure has been made. Some camera models are equipped with a Depth-of-Field Preview button that allows you to view your subject or scene with the selected f-stop applied to check focus range. This tends to darken the display in the viewfinder and make your subject difficult to see. Learning to master aperture control is a huge step to fully realizing photography's extraordinary potential.

Large apertures

Large apertures let lots of light into the camera to form the image on your sensor. They also provide the shallowest depth of field, which when used creatively blurs the background or foreground and places all the emphasis on your subject. Lenses that have maximum apertures of f/2.8 and larger are often called *fast glass* for their ability to allow you to shoot at faster shutter speeds because they let so much light into the camera.

2.5 A large aperture selection blurs both the background and foreground poppies placing all the attention on photographer Ted Miller as he lines up a shot. Exposure: ISO 50, f/5.6, 1/250 second.

Medium apertures

Medium apertures range from f/6.3 to f/11 and are believed to provide the sharpest images the lens is capable of. Medium apertures are the preferred choice for a host of subjects ranging from portraits to product shots. They afford a fair amount of depth of field while still managing to isolate the subject at the focus point and give modest separation of the background and foreground elements.

Small apertures

Apertures from f/13 and above are considered small, yielding the deepest depth of field and also allowing the least amount of light to enter the camera and strike the image sensor. When you want everything in the frame to be in sharp focus, such as when shooting landscape photos or panoramic, use a small aperture to provide a deep depth of field. The trade-off when using these smaller lens openings is that you need a brightly lit scene, a slower shutter speed, a tripod, or some combination of all three.

An added benefit to using smaller apertures is that any spectral highlights such as streetlights, stars, or holiday lights in the photo have star points that can be very attractive. You can even create this effect with the sun by placing a solid object in front of it and only letting a tiny portion of the sun peek through.

2.6 To get the deepest depth of field for this shot of a freight train and still maintain maximum sharpness, I dialed in a small aperture and shot the image. Exposure: ISO 200, f/14, 1/200 second.

2.7 You can create a very attractive star point in the photo with the sun by placing most of it behind a solid object such as a tree branch or building and only letting a small amount show through. Letting too much light show through can cause lens flare, which introduces unwanted halos, hexagons, or octagons in your image. Exposure: ISO 100, f/22, 1/160 second.

Camera Exposure Modes

Many digital cameras come equipped with exposure and scene modes to make your shooting faster and more enjoyable under special circumstances or when shooting certain subjects. Several manufacturers offer Portrait, Landscape, Close-up, Sports, and Night Portrait Scene modes for those exact situations. These modes set the shutter speed/aperture combinations to predetermined parameters that help you get the most desirable depth of field and exposure for each subject. While these modes are tailored to specific shooting situations, the broader shooting modes of Programmed Auto, Aperture Priority, Shutter Priority, and Manual modes provide a greater amount of lighting control for a much wider range of usage.

Programmed Auto mode

Digital cameras set to Programmed Auto mode decide both the aperture and shutter speed values and in some cases even the ISO. This is the default setting for many photographers because unlike full Auto mode, it allows you to have some say in the exposure values by giving you the choice of shifting the combination one way or the other for greater or lesser depth of field or faster or slower shutter speeds. Some cameras retain the new settings once the program has been shifted and some revert back to the original setting once the picture has been made, requiring you to do it again for the next picture.

Shutter Priority mode

Shutter Priority mode allows the photographer to pick the shutter speed first and the camera then chooses the aperture to go along with it to provide the best possible exposure. You want to use this mode when shooting in situations when you know for sure what shutter speed you want to use to freeze or blur the action or for those times when shutter speed is more important to you than aperture selection. Shutter Priority is an ideal mode to use when shooting sports or in low-light situations where you must use a particular shutter speed to maintain image sharpness.

Aperture Priority mode

In Aperture Priority mode, you pick an aperture and the camera selects the proper shutter speed to go along with it. Controlling the aperture also controls the depth of field in the image. By controlling the amount of light that enters the camera and is allowed to strike the image sensor with Aperture Priority mode, you determine how much visual separation your subject has from the background and/or foreground elements. Aperture Priority can also be used effectively when you want to shoot wide open and require the fastest possible shutter speed under the present lighting conditions.

2.8 I wanted a shallow depth of field to blur the background and place all the attention on these swan boats, so I shot this image in Aperture Priority mode. Exposure: ISO 100, f/2.8, 1/2500 second.

Manual mode

Manual mode lets you control all the exposure settings and gives you the greatest creative control but can also leave you alone to create under- or overexposed images. The camera's built-in light meter still is on the job to give you feedback about your settings compared to what it thinks is the correct exposure. Being able to set both the shutter speed and aperture values gives you a broader range of creative freedom but can lead to disaster if you do not pay attention to what the camera's exposure scale tells you. Manual mode is useful in a variety of shooting

2.9 I use Manual mode when I shoot in the studio and want to control all aspects of the exposure values. Exposure: ISO 100, f/4.5, 1/125 second.

scenarios, including shooting fireworks or interiors when you want to intentionally underexpose or overexpose a part of the scene, or when you want a consistent exposure across a series of photos such as for a panoramic series.

Camera Metering Modes

Your digital camera includes a built-in light meter for measuring the amount of light coming into the lens to help you adjust the camera's aperture and shutter speed controls to make a properly exposed image. Most cameras today have three ways of doing this and these methods are called metering modes. Understanding each method and applying the most appropriate one to each shooting situation you encounter makes your images stronger and improves your knowledge of light and its effect on your pictures.

Scene metering mode

Different manufacturers refer to Scene metering mode by different names, but they all do basically the same thing. Canon calls it Evaluative metering mode, Nikon calls it Matrix metering, and Sony refers to it as Multi-segmented metering. No matter what they call it, Scene metering mode seeks to intelligently decipher the light coming into the camera from the various areas of the scene and select an exposure setting to best render the scene. This is my overall default metering mode for a host of subjects.

With the advancement to digital processing and memory speeds, the light meters in today's digital cameras have become smarter and work faster than ever before. In Scene metering mode, the camera's light meter analyzes the scene before it, and by analyzing separate light readings from all over the frame, attempts to make an intelligent determination of the appropriate exposure for whatever you are photographing.

This happens so quickly you never even know it's happening. The newer face detection software and blink detection capabilities are prime examples of this new technology at work. By attempting to work out the exposure values in milliseconds and predict what you are photographing, today's digital cameras deliver more keepers and less poorly executed images.

Center-weighted metering mode

Center-weighted metering mode places most of the exposure emphasis on the center part of the frame (assuming that's where your subject is) and pays less attention to the lighting values on the edges of the scene. Several camera models allow changing the size of this center spot to varying degrees so you can tweak this mode to suit your

tastes and subject matter. This mode is ideal when you are composing scenes with your subject as the center of attention in the middle of the scene such as those of flowers or centered faces.

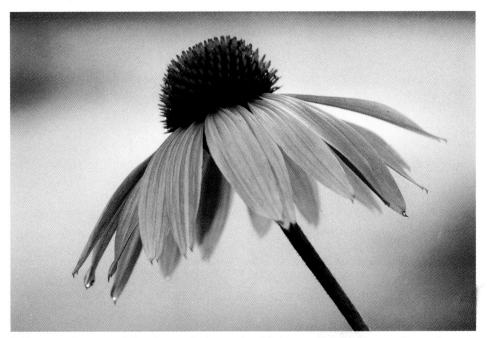

2.10 I used Center-weighted metering to make this image of an Echinacea flower in my brother's garden. I wanted to place all the emphasis on getting the exposure correct in the center of the frame. Exposure: ISO 400, f/5.6, 1/200 second.

Spot metering mode

Spot metering mode bases the exposure of the entire image on only a small fraction of the overall scene and thus reads only a small amount of light entering the camera. When Spot metering is chosen, it measures less light and therefore is unaffected by other areas of the scene, which may contain overly bright or dark colors. Some cameras use the area of the scene around a preselected focus point, allowing you to move the Spot metering circle around by changing the focus point to make sure the exposure is based on the most important element in your frame.

This mode is ideal when shooting subjects against very dark or light backgrounds such as a spot-lit performer on a dark stage. It bases all the exposure calculations on the performer in the center of the spot and disregards any exposure information coming from the darker surrounding areas of the scene.

2.11 Spot metering mode was used to maintain detail in the bright white sail and not blow out the highlights in this shot of a sailboat. Exposure: ISO 100, f/4.5, 1/1600 second.

Exposure Compensation

Exposure compensation involves consciously changing the exposure values either positively or negatively away from the camera's recommended exposure by dialing more or less of it in the camera. This is used when you know that certain areas of your photo are going to get more or less exposure than they require. Most digital cameras include controls to set exposure compensation between -3 to +3 stops of light in 1/3-stop increments, and top-end cameras allow the exposure to be changed by up to 5 stops in either direction. Check your camera manual to see the range available for your camera. Exposure compensation works in Programmed Auto, Aperture Priority, and Shutter Priority modes. It has no effect in Manual mode because the camera's internal light meter has no control over aperture or shutter speed in Manual mode and turns all that control over to you. Take a brief look at what exposure compensation does in each of the modes it works in:

▶ **Programmed Auto mode.** In Programmed Auto mode, the camera's light meter seeks to give you the best possible settings depending on the brightness of the scene. When exposure compensation is applied, the camera attempts to apply this compensation equally across both the shutter speed and the aperture values unless you reach the end of your range for that control, such as your largest aperture or fastest shutter speed. Then the camera changes only the control that can still be adjusted.

▶ **Aperture Priority mode.** With this mode, you pick the aperture and the camera selects the proper shutter speed based on the reflected light readings of the

camera's meter. When you dial in exposure compensation in Aperture Priority mode the camera only adjusts the shutter speed in greater or lesser amounts to match the amount of compensation you have specified to maintain the amount of depth of field relative to the chosen f-stop. Changing the shutter speed via exposure compensation may have more of an effect on freezing the action or creating motion blur.

▶ **Shutter Priority mode.** In this mode, you select the shutter speed and the camera picks the aperture. When you apply exposure compensation, the camera opens or closes down the aperture to the amount you have dialed in, up to the limits of the aperture range. These settings also change the depth of field you have in the image.

Bracketing Exposures

Bracketing your exposures is an approach to take when you are confronted with a very difficult lighting situation and is the first step to creating High Dynamic Range (HDR) images. Bracketing means taking several pictures at, above, and below the camera's recommended exposure values by changing the aperture or shutter speed in three, five, or seven sets. Several models of digital cameras may have a bracketing feature in the camera. Check your camera manual for instructions of how to set this.

Bracketing is not the ideal method to use in all problem photo situations, however, and I always stress taking the time to get the exposure correct in the camera. Moving subjects involving fashion, sports, or action do not benefit from this approach because very often the best exposure could be the least pleasing composition and vice versa. Bracketing is best used for static subjects, such as nature or landscapes, where the only thing changing is the exposure.

I use bracketing in the studio for static product shots when I want to see varying degrees of depth of field on the set. When using flash, as I am in the studio, changing the shutter speed has no effect on the scene, so I am locked in to bracketing by changing the aperture, reducing the power output of the flashes, or moving them closer or farther away from the subject. Outdoors, I am free to change either of the values when bracketing exposures to produce a range of exposures.

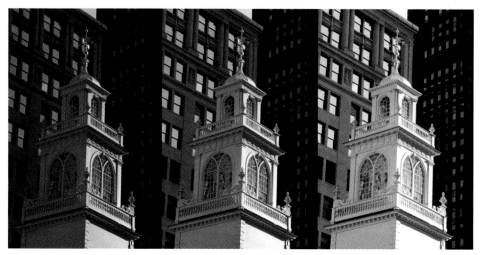

2.12 This example shows three bracketed images in full-stop increments. The camera's recommended exposure is in the middle, along with a 1-stop underexposed image on the left and a 1-stop overexposed image on the right. Exposures: ISO 100, f.5, 1/400, 1/200, and 1/100 second.

Another time you would employ bracketing an image is when creating images to combine into a High Dynamic Range (HDR) photograph. HDR photography involves combining several differently exposed images in specialized software such as Photomatix or Photoshop to produce one image with a much wider exposure range. The software takes the best values of the lighter, darker, and middle-toned areas and merges them into one photo using a process called *tone mapping*.

 For more on HDR imagery, see Chapter 11.

Using the Histogram

Histograms are helpful for analyzing the exposure of a captured image by showing you where pixels fall between pure black and pure white. Horizontally, the histogram shows you the distribution of pixels across a range of tones, while the vertical axis shows you the amount of pixels that occupy each tone. Some digital cameras offer two types of histograms: a brightness or luminance histogram and an RGB histogram that shows the tonal values for the Red, Green, and Blue color channels. The histogram is a great tool built in to your camera for evaluating the exposure of your images.

Brightness histogram

The brightness or luminance histogram is a simple bar graph that shows you the distribution of pixels across the tonal range. Reading a histogram is important while shooting because it gives you a graphical representation of what the camera's sensor recorded. Making exposure adjustments based on the histogram, rather than how the image looks on your camera's LCD monitor, is a much better technique for gauging exposure. Several cameras display the histogram differently, but the information they present to you is basically the same.

The left edge of the histogram shows you the amount of pixels in the darkest values of the tonal scale (level 0), and the brightest values (level 255) on the right edge with the midtones in the middle. You can notice some important things about your exposure by studying the histogram to see where the pixels fall. If the pixels are crowded against the left edge of the histogram and do not extend all the way over to the right edge, the image will be underexposed with a loss of detail in the shadows. Conversely, if you notice more pixels touching the right edge of the histogram, your image will be overexposed and a loss of detail in the highlights will be evident. This is indicated on some cameras as a highlight alert and the areas that have lost detail and are beyond the range that the sensor can capture will blink in the LCD monitor's image display. Some photographers have referred to these areas as the *blinkies* and avoid them at all costs.

For this reason, you want a fairly even distribution of pixels across the range of the histogram with the highlight or shadow pixels just barely touching the left and right edges of the histogram respectively. When a high concentration of pixels starts at either of the top corners of the histogram and slopes down toward the center, it means that some of the highlight or shadow tones have been exposed beyond the range of the image sensor's capabilities, resulting in an image that does not make full use of your camera's exposure range. This is what photographers mean when they say that the image's highlights are blown out or the shadows have blocked up.

RGB histogram

Some cameras allow the display of separate histograms of the Red, Green, and Blue color channels of an image, along with a combined histogram showing all three in relation to each other. The three color histograms may all have the proper exposure but will all look slightly different due to the different amounts of each color in the image. You read these histograms in a similar fashion as you do the brightness histogram. More pixels on the left means that the color is darker and more obvious in the photo and more pixels on the right means that the color is lighter and less dominant in the image.

Different types of shooting will determine which type of histogram display is more beneficial to you. For most of my outdoor landscape, nature, and wedding photography, a brightness histogram is more useful to determine highlight detail. When shooting fashion, art creations, or catalog work where the color rendition must be highly accurate, the RGB histogram provides better feedback of the image exposure.

The basic idea for evaluating exposure when using either type of histogram is to avoid clipping, which is indicated by a spiking of pixels on either of the far edges of the histogram scale. This spiking on the histogram will represent a loss of detail in either the highlights, shadows, or both. If you take a picture in a very bright situation and the histogram displays spiking on the far right of the scale, you will have lost subtle detail in the highlights of the image. Conversely, when an image is made in a low-light situation or is underexposed and a spike appears on the left edge of the histogram, you may have lost a considerable amount of shadow detail.

Keep in mind that the histogram is dependent on the tonality of the image and some scenes where the lighting contrast is so high that it may be beyond the range of tones on both sides of the histogram scale. Unless you add supplemental light such as from a speedlight or reflector, you may have to accept some loss of highlight or shadow detail in the image. In many cases, the best exposure will show an even distribution across the tonal scale, but this does not always occur. Take for example a photograph of a polar bear in a snowstorm. In this photo there may be no dark tones in the image, so none will show on the far left edge of the histogram. Minor overexposure of small details such as the edges of clouds or the sun are usually not too bad but avoid creating images that only have pixel information on the left half of the histogram because in addition to being underexposed you run the risk of adding more digital noise to the image.

File Formats

The file format you choose determines whether the images are stored on your memory card in JPEG or in RAW format and the quality level you choose determines the number of images you can store on the card, as well as the overall image quality and the sizes at which you can enlarge and print images.

Your choice of file format and quality usually is assignment- and/or output-specific. For example, I always shoot RAW images during portrait sessions, industrial location shoots with mixed lighting, and so on. Then I might switch to Large/Fine JPEG format for a wedding or luncheon reception because I know that these images likely are printed no larger than 5 × 7 inches. For most other assignments, where I know I have the time to post-process them, I shoot only RAW images to get the highest image

quality and to have the widest latitude for converting and editing images later on. Other times when I need to upload images right away, I will shoot RAW + JPEG or just JPEG if I need to produce the images quickly and speed is of the essence.

It took me a while to work out storage and workflow issues and to see the differences in image quality and file management between the two. The following sections look at the differences between JPEG, RAW, and TIFF file formats.

RAW

RAW files are stored in a proprietary format that produces image files that are significantly larger than JPEG image files. Because the images are stored in this format, they can be viewed only in programs that support your camera's RAW image file format. RAW files save the data that comes off the image sensor with little internal camera processing. Because many of the camera settings have been noted but not applied to the data in the camera, you have the opportunity to make changes to key settings, such as exposure, white balance, contrast, hue and saturation when you convert the RAW files on the computer. The only camera settings that the camera applies to RAW files are ISO, shutter speed, aperture, and Shooting mode.

This means that during RAW image conversion, you control the image rendering, including the colorimetric rendering, tonal response, sharpening, and noise reduction. Plus, you can take advantage of saving images in 16 bits per channel when you convert the RAW images in your camera's software program, Simply put, the higher the bit depth, the finer the detail, the smoother the transition between tones, and the higher the *dynamic range* (the ability of the camera to hold detail in both highlight and shadow areas) in the image.

JPEG

JPEG, which stands for Joint Photographic Experts Group, is called a *lossy* form of compression but a highly portable file format that enables you to view the images on any computer platform. Your camera probably includes several levels of compression and file sizes to choose from in the JPEG format. The lossy file format means that some image data is discarded when saving the files and while compressing image data to reduce file size for storing images on your memory card. Because JPEG images are compressed to a smaller file size, more images can be stored on the memory card. However, as the compression ratio increases, more image data is discarded and the image quality degrades accordingly. Additional image data is discarded each time you save the file when you edit JPEG images on the computer.

In addition to losing image data during compression, JPEG files are automatically converted from 12- to 8-bit and are preprocessed by the camera's internal hardware/software before they are stored on the memory card. As a result of the low bit depth and preprocessing, color in general, and skin tones in particular, as well as subtle tonal gradations suffer. By the time you get the JPEG image on the computer, you have less latitude for editing with moves in tones and color becoming exaggerated by the lower bit depth.

Which format you decide to shoot depends on a variety of factors and what you intend to do with the images once they are captured. The JPEG format enjoys universal acceptance, which means that the images can be displayed on any computer, opened in any image-editing program, uploaded faster to the Web and social media sites or printed directly from the camera or the computer. RAW capture affords you the largest image file size in a format that can be processed in a variety of different ways, retains wide exposure and color adjustment latitude, but takes longer to write to your camera's memory card and also takes up more room so you will be able to fit fewer images on the card than with JPEG capture. You can also set your camera to shoot RAW and JPEG images of the same image for the best of both worlds. Both formats have their pros and cons that need to be considered for your type of shooting and workflow.

TIFF

Another type of file format is the TIFF format. TIFF stands for Tagged Image File Format and is the standard file format for desktop publishing and the publishing industry in general. This file format is included in some digital cameras for its ability to save an uncompressed image file with all the camera's settings applied to the file although these cameras are rare. The largest of the three file formats, TIFF files are considered lossless in that they retain all the image file data no matter how many times they are opened up and then saved, thereby maintaining superb image quality and a heftier file size.

For the highest quality and long-term storage, my workflow includes shooting the images in RAW format, using computer software to process the RAW files and then saving them to disk or hard drive as a TIFF file. Because of their lossless quality and large file size, TIFF images are widely used in the publishing industry and can then be used in many computer software applications without any further processing. For example, all the images you see in this book were supplied to the publisher in the TIFF file format.

Controlling the Light with Shutter Speed

In just a moment in time, with a click, a lasting memory is captured forever. But just how long that moment is recorded is controlled by the photographer and his or her choice of shutter speed. The shutter is a device in front of your camera's image sensor that controls the duration of time that light is allowed to strike the sensor. The amount of time the shutter is open determines the amount of light that reaches the sensor as the scene is captured. Shutter speed also controls other characteristics such as the depiction of movement, speed, and time. This chapter explains controlling light with shutter speed, including special techniques such as time exposures, freezing action, and panning the camera.

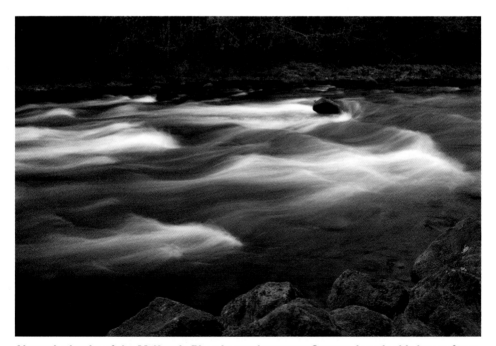

Along the banks of the McKenzie River in southwestern Oregon, I made this image from my favorite campsite. I purposely chose a long shutter speed to produce the silky effect to the moving river. If you look very closely, you can even see a small bird on the large rock poking out of the water. Exposure: ISO 100, f/4, 1.3 seconds.

Choosing a Shutter Speed

Several times in my manual digital photography classes and workshops I remind my students that their subjects can often clue them in to what the camera settings should be. As they look through their viewfinders I gently ask them if anything important in the frame is moving, and if so, shutter speed becomes an initial priority.

It could be something as simple as a flower softly swaying in a slight breeze or a Little Leaguer chasing a hot grounder that makes the selection of shutter speed an important consideration. Photographs in which the subject is blurry are caused by subject movement or camera shake and the easiest way to avoid this is by choosing the best shutter speed for the situation.

Any time you have a moving subject or movement in the image, shutter speed has to be considered primarily in the ultimate exposure mix, but which way you go with it is entirely up to you. Sure, many times you want to freeze an action or an event, but what if you want to slow down time as in the image that opened this chapter, where the rushing water of the McKenzie River traveled several feet between the time the shutter open and closed, resulting in the lush, silky rendition of the water? This is how photographers convey the *feeling* of motion in a static image. By stretching out the amount of time the shutter is open, objects can move within the frame that, ideally, support the photographer's intent.

Your dSLR camera is equipped with an array of shutter speed choices, and knowing how to choose the most appropriate one for the feeling you want to give your image is key to understanding what happens once you press the Shutter Release button.

3.1 My daughter Brenna enjoying being thrown into the air by our good friend Bob "BBQ" Kuhn. Direct top lighting separates them from the darker background. Even with a fast shutter speed to freeze Brenna and the water droplets in midair, Bob's legs are slightly blurred. Exposure: ISO 400, f/5.6, 1/800 second.

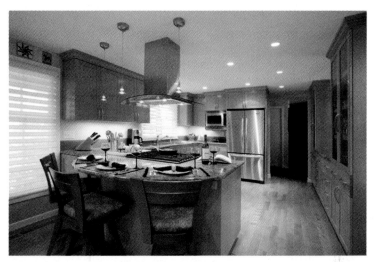

3.2 Even though it was midday, I still needed a long shutter speed with a tripod and remote switch to properly expose this remodeled kitchen for an interior design client. Exposure: ISO 100, f/22, 10 seconds.

Most dSLR cameras, and even several point-and-shoot cameras, have shooting modes that greatly influence the selection of shutter speed, such as Programmed Auto mode, Shutter Priority mode, Aperture Priority mode, and Manual mode. You can access and control these modes through your camera's menu system or with buttons or dials on the outside of the camera. Refer to the original operating manual that came with your camera, or better yet, check out the *Digital Field Guide* that is specific to your camera model.

Many of the aspects of these different shooting modes are discussed in Chapter 2, but a few additional points are addressed here. The green-box Full Auto mode on several manufacturers' cameras should be avoided in all shooting situations by serious photographers because it gives you absolutely no creative control of ISO, shutter speed, or aperture combinations and picks what it thinks are the best settings for the light it perceives coming into your lens.

In Programmed Auto mode, usually signified by a "P" on your camera, you can adjust the shutter speed/aperture combination that the camera has selected by turning a dial or pressing a button and turning a dial. This provides some creative input from the eye behind the viewfinder to help you get the shot you want. You can select a faster or slower shutter speed and the camera then adjusts the aperture to an appropriate opening for the new shutter speed. This is performed on an image-to-image basis and

is not a good mode to use if you are going to be shooting a lot of images of the same subject, tediously adjusting the exposure between every shot.

A better approach is to use Shutter Priority mode to lock your camera into a predetermined shutter speed whereby the camera selects the appropriate aperture to go along with it. This is the best shooting mode to use when you are only concerned with shutter speed and its effect on your subject. As you make the shutter speed faster, the camera selects a wider and wider aperture. At a certain point, you reach the largest setting for your particular lens, and if you continue increasing the shutter speed your pictures become darker and darker because an inadequate amount of light is reaching the image sensor. In this situation you'd be wise to increase your ISO setting to change the sensitivity of your sensor, but look out for additional digital noise the higher in ISO range you go.

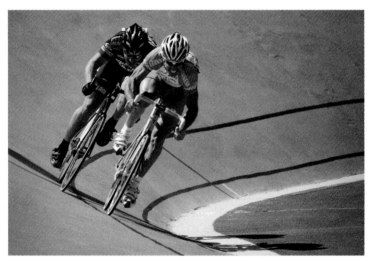

3.3 Bicycle racers come out of the fourth turn at the Alpenrose Velodrome and pour it on for the finish. A fast shutter speed freezes the closing moments of the race. Exposure: ISO 500, f/5.6, 1/4000 second.

Shutter Priority is also my go-to mode for shooting sports and action because I want to freeze the action to create a tack-sharp image. I like Shutter Priority mode because it frees me to concentrate on the image in the viewfinder and not on a lot of camera settings. I also like that my camera shows me the aperture/shutter speed combination inside my camera's viewfinder so I can quickly change it if I need to. I never have to

take my eye away from the action to change camera settings and run the risk of missing a shot.

Being able to see the aperture/shutter speed combination in the viewfinder is also important when shooting in Manual mode because all the settings are left up to you. Similar to the old match-needle metering system in film cameras, today's dSLR models show a small cursor that moves from plus exposure to minus exposure as you change settings. This is the camera's way of telling you exactly where it thinks you are exposure wise from a normal proper exposure. Manual mode gives you total control over the exposure settings but still provides a reference point or benchmark for what the camera considers the right exposure.

When shooting in Manual mode, pay close attention to the camera's exposure settings and histograms of the images. It is very easy to overexpose or underexpose images in this mode because the camera does not prevent you from doing so. Purposely adding or subtracting exposure in Manual mode is the same as dialing it in by exposure compensation when shooting in your camera's Auto modes. Exposure compensation has no effect on exposure however when shooting in Manual mode.

I usually go through a quick mental Q&A when determining shutter speed. Take a second or two to run through this list to see if it can be helpful to you for your type of shooting:

▶ **Is the subject moving?** This sounds like a no-brainer, but I'm not kidding when I tell you that I've had workshop participants so intent on photographing grasshoppers and butterflies that they never considered the fact that the subjects were slightly bouncing on a branch or leaf. Poor shutter speed choice was responsible for their blurry photos, not a focus or lens problem. I always err on the side of caution if I think there is a chance of the slightest movement by choosing a faster shutter speed than the subject requires.

▶ **How fast is the subject moving?** If it's moving very fast I'm going to need a very fast shutter speed to keep up with the action and yield crisp, sharp images. I might even go all the way up to 1/4000 or even 1/8000 second if my camera is capable of it. If the subject is moving moderately slowly, as the aforementioned grasshopper bobbing merrily on a leaf, I choose a moderate shutter speed somewhere in the 1/125-1/500 second range.

▶ **How far away is the subject?** Subjects that are very far away are going to appear smaller in your viewfinder and in the final image. The speed of a moving

subject is dramatically increased the closer it is to the camera, so you need a fast shutter speed for closer subjects. Subjects farther away yet still moving quickly may not cover as much ground visually in your frame and afford a slower shutter speed.

▶ **What's the lowest ISO setting I can use and still maintain my preferred shutter speed?** You want to always use the lowest ISO setting you can to avoid digital noise in your images while still allowing you enough flexibility to shoot using a wide range of shutter speeds. I would rather accept some noise in the image as long as it is optically sharp. When shooting handheld, I want to stay at 1/60 second or faster for wide-angle lenses to medium telephotos, so I make sure to choose an ISO setting that allows me to do this.

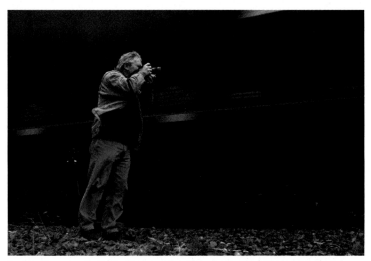

3.4 Soft overcast light illuminates photographer Dave Lutz as he photographs a passing freight train. Handholding the camera at the slowest shutter speed I could use while retaining my preferred aperture, I had to boost the ISO to get a usable image. Exposure: ISO 1600, f/6.3, 1/60 second.

Keep in mind how important shutter speed is to obtaining sharp photos — don't get so locked into looking at the subject and how cool it is that you fail to notice that it is moving ever so slightly. Even people standing still are actually moving very slightly by breathing and blinking their eyes. It is not enough to just keep the camera steady; you need to select the proper shutter speed relative to the subject or scene you want to photograph. Even a tripod and remote switch setup is of little help if the shutter speed is set incorrectly.

Freezing the Action

Freezing the action means selecting the proper shutter speed for the subject at hand, whether it's a pro football player catching a pass or a small child riding a bike, to produce a sharp image. When contemplating the action before you, consider the subject's speed, direction of movement, and size.

Developing a feel for the movement of the scene gives you a good idea of the right shutter speed to start out with. I have found that it is almost always a tick or two faster than what I originally thought. Many photographers share the heartbreak of coming home and pulling up some hot images they just shot only to find they are soft and not entirely tack sharp. Learning to pick the best shutter speed to capture a split second at the peak of the action takes practice. If it were that easy to shoot *Sports Illustrated* covers, wouldn't everyone be doing it?

First, you need to determine how fast the camera or subject is moving. Shooting racing cars requires a faster shutter speed than photographing a dog running on the beach. Children at play and sporting events require faster shutter speeds. Photographing water skiers from a towboat means both of you are moving, so an even faster speed must be chosen to freeze the motion. The more you shoot objects in motion, the better you can judge the proper shutter speed.

Second, you need to figure out which way the subject is moving. Front-to-back movement, where the subject is heading toward or away from you, needs less of a shutter speed boost than objects moving from side to side. Early autofocus cameras had a problem with accurately focusing on front-to-back moving subjects, so Servo or Predictive focus modes were developed to solve the problem of the subject moving after the camera had autofocused. The speed of the subject and the direction it's moving plays a major part in shutter speed selection.

The last consideration before pressing the Shutter Release button is subject size. Most of the time, you want to fill the frame with your subject, visually cropping out the elements in the scene that don't support the subject or main idea for your photo. The larger the subject is in the frame, the more distance it covers visually in a certain amount of time. Shoot that subject at a greater distance or with a wide-angle lens and it takes longer to cross the frame and can tolerate a much slower shutter speed.

I have discussed several considerations for using shutter speed to freeze the motion of the subject, but there is another motion to be aware of when shooting and that's the movement of the photographer and thus, the camera. Camera movement during the time the shutter is open results in blurred photos from camera shake. Camera

shake used to be a very common problem when shooting in Programmed Auto mode in low-light situations. Some digital cameras can pick a shutter speed you cannot safely handhold in low-light scenes and the resulting images can be blurry. However, most cameras today have a warning light or sound when this is the case. At those times, I increase my ISO setting, open my aperture, or do both to reach an acceptable shutter speed I can safely handhold.

Camera shake is especially a problem when shooting with telephoto lenses. The longer the focal length of the lens, the faster the shutter speed needs to be because the telephoto lens captures less of the scene by narrowing the field of view. The general rule to follow has always been to select a shutter speed that equals 1 over the focal length of the lens you're using when shooting handheld. To apply this to a standard 100mm lens, your shutter speed should be at least 1/100 second; a 200mm lens needs a shutter speed of at least 1/200 second. However, there is popular lens technology that helps you get around this longtime rule and allows you to shoot between 1 to 4 stops slower than you normally would.

Image Stabilization (IS) mode by Canon and Vibration Reduction (VR) by Nikon are two of the most popular lens technologies for shooting sharp images at slower shutter speeds. If the handholding limit is pushed, then camera shake bends the light rays coming from the subject into the lens relative to the optical axis, and the result is a blurry image.

Image stabilization technology is employed in optical systems such as binoculars, telescopes, and video cameras. It is commonly used in cameras to reduce blurred images due to camera shake, and is particularly useful at slower shutter speeds and with telephoto lenses. Different manufacturers use various methods to produce this advantage but the overall effect is the same. The stabilization systems attempt to compensate for the pan, tilt, or angular movement (pitch and yaw) of the camera.

Stabilization is particularly important with longer lenses where the effect of shake is more pronounced as the focal length increases. And, as a result, the correction needed to cancel camera shake increases proportionately. Some manufacturers place the stabilizing system in the camera body while others opt to place it in the lens, making it available for that lens only. Lenses that include image stabilization built-in are generally more expensive than ones that do not. The in-camera models use a system that involves moving the image sensor to counteract for the camera's movement.

But how do image-stabilized lenses respond when you want to pan or move the camera with the motion of a subject? The lens detects the movement and responds accordingly to produce a sharp image. Some cameras automatically sense this movement while others include switches to tailor the stabilization to adjust for whichever

way the camera is moving such as panning, which is discussed in greater detail later on in this chapter. Image stabilization needs to be turned off when using a tripod-mounted camera because the stabilizing system looks for camera movement which the tripod has effectively neutralized.

Regardless of the method of image stabilization utilized, the end goal is producing sharp images at slower shutter speeds or when shooting longer telephoto lenses handheld, and this technology is very beneficial in that regard and worth exploring.

The question is whether this technology is worth the premium prices for these lenses and, of course, how much you hate schlepping around a tripod. Comparing the cost of similar lenses, the price is usually a few hundred (U.S.) dollars more for an image-sta-bilized lens than for a similar non-image-stabilized lens. Only you can decide, but for my photography, this technology *is* worth the price, particularly in low-light situations such as weddings and music concerts where tripods or monopods are impractical.

Another method of freezing the action involves firing your built-in flash or add-ing an external flash unit to the expo-sure mix or shooting in High-speed Sync mode. High-speed Sync mode allows you to use virtually all your shut-ter speeds while working with flash and only works in dedicated TTL systems. With many of today's dSLR cameras including high-speed flash sync to their list of features, you can use virtually any shutter speed you want.

Time Exposures

The wonderful thing about shutter speed control is that there are so many creative possibilities involved and it's not just a utilitarian device to get tack-sharp pictures of moving subjects. Time exposures, where the shutter is fully open for longer periods of time, are one of the more enjoyable activi-ties to discover the power of the shut-ter speed.

3.5 External light meters usually include several modes for measuring light and come with a dome diffuser for incident light measuring. To take reflected light readings, simply remove the dome. Light meters can be a big help when taking long time exposures.

Time exposures can usually be broken down into three distinct types: short, medium, and long. There are certain qualities to each type and understanding the effect each shutter speed provides and how it renders the subjects in your images will give you the confidence to handle any subject. This section takes a look at each type and the benefits it provides.

Shorter time exposures in the 1/15 to just under 1 second range are considered shutter speeds you have chosen to depict some form of motion of an object or action in the shot. You may be shooting *from* a moving position such as a speedboat, bicycle, or car or you may be *in* a stationary position shooting a moving subject or action. Assuming you are capturing these images during the day, you probably have loads of light in which to shoot, which may present exposure problems when you try to choose a slower shutter speed.

3.6 With my camera mounted securely to my mountain bike, I chose a slower shutter speed of 1/30 second to add motion blur to the background yet still keep me sharp. Exposure: ISO 100, f/5.6, 1/30 second.

The easiest technique to slow down your shutter speed to achieve motion blur and still yield accurate exposures is to drop your ISO as low as it can go. On most cameras this is ISO 100-200, but some digital cameras can go as low as ISO 50. By de-amplifying the sensor, you make it less sensitive to light thereby requiring more light to make a usable image. You can also shoot with smaller apertures that require more light as well.

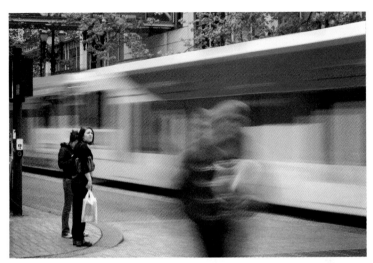

3.7 A short time exposure blurred the light rail train and a pedestrian walking toward me but kept the woman waiting to cross the street sharp. To create this effect, I used the lowest ISO and smallest aperture my camera was capable of to facilitate the use of a slower shutter speed. Exposure: ISO 50, f/32, 1/2 second.

In really bright situations where you have already stopped down the aperture and selected the lowest ISO, you could add a polarizing or neutral density (ND) filter to further reduce the amount of light coming into the camera by a few stops.

Medium time exposures are those that fall into the 1- to 60-second range and are great for showing action and motion such as water, fireworks, and clouds. These are arguably the most widely used times for time exposures. They require a sturdy tripod, a cable release, and a stable place from which to shoot. Nightscapes and cityscapes are especially fun subjects to shoot in this range along with streams of traffic with headlights and taillights becoming long strings of color on the roads. Water especially takes on a beautiful soft glow if there is any man-made illumination falling on it, and by extending the time, most surface detail disappears.

Another great use of medium time exposures happens when shooting interiors. I am fortunate to work with a number of interior designers, architects, and building contractors photographing completed projects for their Web sites and marketing materials. When setting up the shoot, I always suggest we can plan the shoot for late afternoon/early evening when the outside light is fading and less intense to better blend the interior and exterior illumination values, as the golden time makes the shot look more natural and inviting.

3.8 The perfect time of the day for shooting interiors is when the outside intensity of light matches the inside, in this case 6 p.m. in February. A medium time exposure of 15 seconds yields warm tones of the interior tungsten lighting that contrast nicely with the cool blues of the outside sky. Exposure: ISO 100, f/22, 15 seconds.

Medium time exposures of several seconds allow me to keep the window shades open when shooting interiors, letting the light in for a more natural look. Clients do not want me to bring in extra lighting gear to shoot the images because they want the rooms to appear natural and lit they way they were designed. To gain depth of field I use smaller apertures that let in less light, so I need to use medium time exposures that keep the shutter open to compensate for the lower light level. I have hidden some small flashes to open up some darker problem areas, but overall the scene is photographed as it appears. Because I want good detail throughout the scene, I use a cable release or remote switch, a tripod, and a 16-35mm lens set to its widest setting and positioned to minimize distortion.

Longer time exposures of a minute and beyond are used for many creative purposes, such as star trails and light painting. For this you again need a tripod and cable release or remote switch, but the trigger needs to be able to lock in the open position because any camera handling during this long of a time degrades image sharpness.

Many photographers who shoot star trails find the North Star by locating the leading edge of the Big Dipper's cup and following an imaginary line up from the two stars. By placing the North Star somewhere in the frame, all the other stars appear to rotate

around it. Use the Bulb exposure on your camera to keep the shutter open longer than the 30-second default time most cameras include as their longest and lock the shutter open with the switch. Keeping the camera in an active state for this long really takes its toll on batteries, so always be sure to have spares available for this type of work.

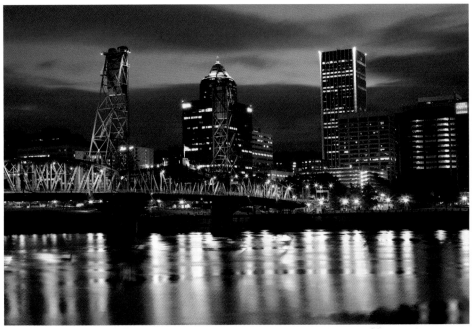

3.9 The Morrison Bridge, Willamette River, and Portland skyline are captured with a medium time exposure. Notice the sheen of the reflections on the river surface caused by the lengthy amount of time the shutter was open. As a bonus, using a small aperture creates star points on the spectral highlights. Exposure: ISO 100, f/13, 30 seconds.

Zoom Blur

Another technique of creating motion blur is the zoom blur. This works with both stationary and moving subjects with equal success. The secret is to place your subject in the center of the frame and zoom the lens while you make the exposure. A tripod is helpful but not always necessary because much in the scene ends up blurry from the motion, which is the effect you are going for. Shutter speeds longer than 1/4 second work well for this technique and allow enough time for you to zoom through the range of your lens.

continued

continued

The following image is a small pink flower I found in subdued light. I set up my tripod without a remote switch, composed the shot so that the flower was centered, and set my zoom lens to its longest focal length. Zooming from long to short focal lengths allows you to pick up depth of field and sharpness as you zoom. Starting the zooming before opening the shutter provides a more fluid look to the zoom.

Panning the Camera

Panning the camera is another way to convey speed, motion, and color to create compelling images. Most panning involves moving the camera from side to side while tracking a moving object through the viewfinder. There are a number of techniques to use for successful panning that yields sharp subjects.

I try to plan the pan by standing with my feet slightly apart in an A-frame position and keep my weight evenly distributed on both feet. I search out a pleasing background to

use for the pan, not worrying about the details because they will be blurred but also trying to avoid large discrepancies in tonality or color. This is a great technique to use for parades or sporting events where there are people everywhere and no good backgrounds.

I focus on a spot where I want to take the picture and shut the autofocus system off or set my camera to Continuous focus mode. Then I pick up the moving subject through the viewfinder by twisting my waist slightly and track it as it moves into position. When I feel my body center itself, I press the Shutter Release button knowing I'm in the right spot because that's how I set it up, and follow through in a smooth fluid motion as the object passes.

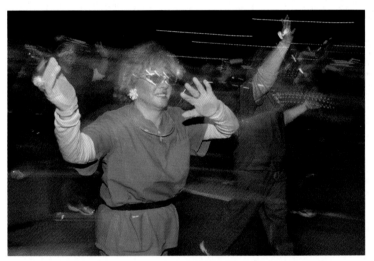

3.10 Panning the camera and using an external flash set to Rear-Curtain sync creates unique one-of-a-kind light trails and other interesting lighting effects. Exposure: ISO 800, f/5.6, 1/3 second.

As you can see from this chapter's examples, there is a world of creativity waiting for you in the land of shutter speeds. If you spend a week concentrating on controlling light with only shutter speed and let the camera pick the other settings, you can develop the confidence to know that with shutter speed and enough light you can handle any subject.

Controlling the Light with Aperture

Aperture is another camera control that changes the quantity of light that reaches the camera's image sensor. While the shutter speed controls the *amount of time* that light is allowed to reach the sensor, the aperture controls the *intensity of light* that strikes it. Sometimes referred to as the diaphragm or iris, the aperture is an electronically controlled mechanical opening the light has to pass through in order to make an image. The size of this hole is variable and can be adjusted by the photographer. Aperture is designated by f numbers, with a lower f number signifying a larger opening allowing more light, and a higher f number representing a smaller opening that lets in less light. Understanding aperture and its effect on your photography makes your images stronger and more dynamic.

My daughter Brenna leaps over a hay bale maze at a pumpkin farm in Yakima, Washington. I used a large aperture to blur the background and to keep the focus on her, along with a fast shutter speed to freeze the action. Exposure: ISO 400, f/4, 1/2000 second.

Choosing an Aperture

The relationship between shutter speed and aperture is much easier to understand if you consider a bucket that you are trying to fill with water. In this analogy, the bucket is your sensor and the water represents the amount of light allowed to fall on the image sensor. You can add water to the bucket with a straw, drop by drop, in which case the bucket eventually gets filled over a long time. Alternatively, you can use a fire hose for a short burst and the bucket will fill rather quickly. The aperture is the size of the water stream into the bucket and the shutter speed is the time it takes to fill it.

You gain creative control over the elements in your photograph by making conscious decisions about which aperture to pick. Today's digital cameras include controls for changing the aperture on either the front or back of the camera, usually in the form of a dial, and also are configurable to allow exposure adjustment in increments of 1/2 or 1/3 stops to facilitate fine-tuning of the exposure. While the controls for the aperture are located on the camera, the actual aperture resides inside the lens and is only stopped down to the preselected aperture at the moment of exposure.

This relationship between the aperture and what you normally see in the viewfinder needs to be understood before you can get predictable results with your photography. The camera must maintain the largest aperture for whatever lens is attached to it to give you a bright view through the viewfinder and speedy autofocus and metering. Reducing the light values entering the camera slows these systems down and makes the image in the viewfinder too dark for you to see. By shooting images of the same subject at varying apertures you begin to learn the language of the f-stop and with time develop an understanding of how those choices affect the near and far elements in your photographs.

A lot happens when you take a picture. On dSLR cameras, you press the Shutter Release button, the aperture closes, the reflex mirror flips up, and the shutter opens to make the exposure. Of all these operations, the aperture and what it controls may be the hardest to grasp. The most important thing to think about regarding the aperture is that the larger the f-number, the smaller the aperture opening, and the smaller the f-number, the larger the opening. I know that sounds confusing, but there is a solid reason for it. The f-number is derived by dividing the size of the aperture opening by the focal length of the lens.

Imagine you are shooting wedding photos with a 100mm lens set to a medium aperture of f/8. This reveals that the size of the aperture opening is 12.5mm, or 1/8 of the total 100mm of the lens. Photographers replace the 1 in the fraction with an f/ and thereby refer to aperture settings as f/8, f/16, f/22, and so on. For example, 1/4 or 1/8 of the focal length is referred to as f/4 or f/8. Thinking this way makes it easy to see that if you need

more light to make an image with a 100mm lens, you switch to f/4, which creates an aperture opening of 25mm. A bigger opening means more light. If you remember that f-stops are fractions of the total focal length of the lens, it becomes much easier to understand the relationship of the numbers as to how much light they let in.

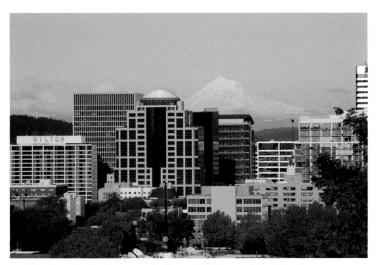

4.1 The Portland, Oregon, skyline with Mount Hood in the background required a small f-stop to achieve the desired depth of field. Exposure: ISO 500, f/11, 1/400 second.

You can control the aperture with today's digital cameras in a number of ways. Several models include special scene modes such as Close-up, Portrait, and Landscape for specific shooting situations. My advice would be to try them in a pinch to see what kind of results they produce, but don't spend a lot of time shooting in them. You can do a much better and more accurate job in Programmed Auto, Aperture Priority, or Manual mode.

Programmed Auto and Aperture Priority modes are quick modes to switch to when the action picks up. Many photographers choose these modes because you can adjust the aperture to let more or less light in and the camera automatically changes the shutter speed to compensate for the change. This makes shooting on the fly fun and easy.

In Programmed Auto mode, the camera picks safe aperture and shutter speed combinations that avoid the extremes depending on the information received from the camera's onboard light meter. You turn a dial to your preferred exposure setting and the camera does the rest. This mode is a great way to learn the relationship between aperture and shutter speed as you see how the camera compensates for each exposure change.

Manual mode is the choice of many photographers who want to control all aspects of the exposure. Shooting in Manual mode means it can be very easy to under- or over-expose your images if you are not paying close attention to the changes in lighting, but it affords the most creative control of all. Even though you are picking both the aperture and shutter speed values, the camera still gives you feedback via the built-in light meter as to how your settings stack up in terms of your ISO settings and a proper exposure.

Depth of Field

All lenses used for photography produce only one true plane or area of focus but include areas of adequate focus in front of this plane and also behind it. When you focus your lens on an object exactly 10 feet away, it may appear that some things a bit closer or farther away are also in focus. In reality, the only true point or plane of focus is at precisely 10 feet. The appearance of sharpness in front of or behind the area of true focus is referred to as depth of field (DOF). The aperture is the main factor that determines the DOF in your images. A large aperture creates a shallow depth of field while a small aperture yields a deep depth of field. Understanding and manipulating DOF with aperture and magnification via lens selection makes your images so much stronger by placing the viewer's attention exactly where you want it.

4.2 I captured photographer Ted Miller creating senior portraits of a young lady at a nearby poppy field. A large aperture was used for a 350mm lens to keep the focus only on him and blur the entire background. Exposure: ISO 50, f/5.6, 1/250 second.

Depth of field is where the magic of apertures becomes evident, but it is one of the hardest concepts of photography to understand. The problem is in the approach many people take to photography by usually shooting in the safe auto modes and never really seeing the benefits of choosing the aperture because their photos look okay for the most part. Furthermore, the lenses that come with camera kits don't show all that much difference between f/8 and f/16 without seeing it on the computer, making it difficult to grasp the creative power and advantages of controlling the depth of field. DOF comes in various strengths for the many picture-taking situations you encounter.

Selective focus

Selective focus means limiting the depth of field and is the ideal approach for many picture-taking situations where you want to blur out a background or foreground to keep your subject in the viewer's eye.

By controlling the aperture, you control how great or small the range of acceptable focus is in your photograph and where the viewer's eye lingers.

You can apply selective focus anywhere in the frame, but the closer you are to your subject and the farther it is from the background, the more dramatic your results are. Selective focus can be employed anytime you want to manage the elements in your photograph for maximum impact.

4.3 Selective focus keeps Tap Water percussionist Rudy Slizewski sharp and bassist Wes Elliott softly out of focus in the background. Exposure: ISO 400, f/5.6, 1/800 second.

Controlling depth of field

You control the depth of field in your photograph by aperture and lens selection. You achieve a greater depth of field by using small apertures and a shallow depth of field by using large ones. Lens selection also plays a part in DOF because when the magnification is small, such as when using wide-angle lenses, the DOF is great. As the magnification of the subject increases, the depth of field decreases. Choosing the

right lens for the shot you see in your mind's eye comes with visualizing how you want the subject to look.

Many digital cameras include a dedicated button for checking the depth of field of the scene called a Depth-of-Field Preview button. When this button is pushed, the lens is temporarily stopped down to the preselected aperture setting so you can see the range of the depth of field for that f-stop in the viewfinder. When you stop down to f/11 or f/16 the scene becomes extremely dark, almost too dark to see, and certainly too dark to focus with unless you are in a very bright environment. Give your eyes a few seconds to adjust and look for elements in the scene achieving greater sharpness. Adjust the aperture to a higher f-stop number for greater depth of field and a lower number for less. When you're pleased with what you see in the viewfinder, release the Depth-of-Field Preview button and shoot the picture.

4.4 To make this lupine really stand out against the foliage in the background, I chose an aperture of f/5.6 that provided sufficient depth of field around the buds for the leaves. Exposure: ISO 4000, f/5.6, 1/2500 second.

Shallow depth of field

A shallow depth of field can be employed by selecting an aperture of f/5.6 and under when you only want a small part of the scene or plane of focus to be sharp in the final image. A shallow depth of field is very useful for separating your subject from a busy or distracting background. The widest aperture on your lens provides the shallowest depth of field and is often referred to as *shooting wide open*. You can further reduce the DOF by moving in closer to your subject, moving your subject farther away from the background, or switching to a longer focal length lens.

You often see shallow depth of field in sports action, wedding, and product photos, and these images are all indicative of a very large aperture. You must pay particular attention to focusing when using large apertures because the margin of error is high if the lens is not focused properly on the subject. With such a small window of acceptable focus when shooting wide open, special care must be taken when focusing; otherwise a set of blurry photos could be the result.

4.5 A shallow depth of field was achieved when I shot this racing dragon boat by using my largest aperture. The busy urban background was kept in check by shooting wide open. Exposure: ISO 200, f/2.8, 1/4000 second.

Midrange depth of field

The middle aperture settings between f/6.3 and f/11 are considered safe to use because of the ample depth of field they provide, which is neither deep nor shallow. There used to be a saying among photojournalists that the secret to a great shot was "f/8 and be there." The middle f-stops are usually where your lens is the sharpest and the range of focus is very forgiving if your focus is slightly off.

4.6 Buses pull away from the curb as the school day ends. I focused on the front bus and selected f/8 to give me adequate sharpness throughout the range of the scene. Exposure: ISO 400, f/8, 1/640 second.

Maximum depth of field

Maximum depth of field is often sought for landscape, interior design, and architectural photography where a large expanse of area must be rendered tack sharp throughout the image. This is achieved by setting a very small aperture for your lens and then selecting a corresponding shutter speed. This often necessitates using a tripod unless you are in a very brightly lit scene or location.

Diffraction

In still photography, diffraction can have a negative effect on your images when using the smallest aperture on certain lenses. Diffraction occurs when light traveling in a straight line is squeezed through a very small opening, such as the smallest aperture of your lens, and the light rays tend to bend slightly as they pass over the edge of the aperture blades. The optical effects are subtle and without getting into the physics of diffraction, suffice it to say that images shot at the smallest lens aperture may appear a little smooth compared to photos taken with larger apertures. I try to avoid the absolute smallest aperture and use a stop larger to prevent diffraction and soft images.

4.7 Interior design, architectural, and landscape images all benefit from a small aperture, which provides deep depth of field. Exposure: ISO 100, f/16, 1.3 seconds.

Variable and Constant Aperture Lenses

Lenses with a single focal length are often referred to as prime lenses and have a constant maximum aperture. For example, a 50mm f/1.4 lens has a focal length of 50mm and a maximum aperture of f/1.4. Zoom lenses, with a range of focal lengths in one lens, come in two types: variable and constant aperture.

Variable aperture lenses

Variable aperture zoom lenses use different maximum apertures as the lens is zoomed and the focal length increases or decreases. They're still capable of all the other f-stops up to the smallest aperture, but as the focal length changes so does the maximum aperture. This maximum aperture variance is clearly designated on the lens barrel or on the face of the lens around the front lens element as in Figure 4.8.

Suppose you are shooting with a 70-300mm f/4-f/5.6 variable aperture lens at a sporting event. When the lens is set to the 70mm zoom setting you can achieve a maximum aperture of f/4, and when the lens is fully zoomed out to 300mm the maximum aperture changes to f/5.6. The maximum aperture changes automatically as you zoom in or out through the range and this is communicated to you via the viewfinder or LCD readout on the outside of the camera.

4.8 This 18-55mm zoom lens is a variable aperture lens with a maximum aperture range of f/3.5 at the 18mm focal length and f/5.6 at the 55mm focal length.

The camera makes this adjustment for you in any of the shooting modes but can be especially vexing in Aperture Priority mode where you have specifically chosen the largest aperture setting of f/4. You compose your shot of the action as 70mm and purposely choose f/4 to blur the background and allow you to shoot with a faster shutter speed. However, when you zoom in to get a tighter shot of the scene, the aperture changes to f/5.6 and automatically drops the shutter speed 1 stop to compensate for the loss of light from the smaller aperture. This is a problem because now you may be in a shutter speed range that is too slow for the lighting conditions to nail the action, which could cause the scene to blur from camera shake.

Why are variable aperture lenses so popular? There are two parts to the answer. They are less expensive to manufacture because they are smaller than constant aperture lenses and use less sturdy materials in their construction thereby making them more compact and lightweight. Variable aperture zoom lenses are often included in kits when you purchase a new dSLR body and their cost is a fraction of their bigger, heavier cousins in the same focal-length range. Couple the size and weight factor along with the significant cost savings and you can see why many photographers don't mind losing that extra stop.

If this is the type of zoom lens on your camera, do not fret over that lost f-stop. Here are a few tips to consider to still get the images you desire when using variable aperture zooms:

▶ **Recompose the shot by moving in.** If the largest aperture is important to you for its ability to blur the background or other qualities, try zooming out to attain that maximum f-stop while physically moving in closer to the subject for the same look to the composition.

▶ **Raise the ISO to keep the same shutter speed.** When the shutter speed drops to a lower speed to compensate for the loss of 1 stop of light when you zoom in, raise the ISO to get back to the speed you were using with the larger aperture.

▶ **Move the subject farther away from the background.** Create more distance physically between the subject and the background by looking around for a different shooting angle. This works great with portraits and you can achieve the same look as the image shot with a larger aperture.

4.9 A point-and-shoot camera in Aperture Priority mode with a variable aperture lens was used to make this image of a cocktail and a bonfire on the beach along the Oregon coast. Even with an aperture of f/9, there is still adequate depth of field throughout the scene to render the fire, people, and mountains acceptably sharp. Exposure: ISO 100, f/9, 1/100 second.

Constant aperture lenses

Any lens that has only one focal length uses a constant aperture and is considered a prime lens. These lenses offer the full range of apertures no matter where you focus or how you compose the shot.

Some photographers swear by prime lenses for this factor and the quality of images they deliver. Prime lenses are slightly more difficult to compose with because you have to physically move your body to frame the shot instead of just zooming the lens. For this reason, along with image quality, many photographers choose more expensive zoom lenses that include a constant aperture. The maximum aperture of these lenses remains constant at all the focal lengths the lens can provide. That means a 70-200mm f/2.8 zoom lens keeps its maximum aperture of f/2.8 throughout the zoom

range. It also means that lens is heavier than its variable aperture counterpart and physically larger. Photographers often refer to these lenses as *fast glass* because their maximum apertures are in the f/2.8 to f/4 neighborhood.

4.10 This 24-70mm constant aperture zoom lens shows its designation as such on the side of the lens barrel. It maintains an available aperture of f/2.8 throughout its zoom range.

Constant aperture lenses are the first pick by professional photographers who can't afford to compromise on image quality and are willing to pay considerably more for that constant f-stop throughout the zoom range. These lenses are usually classified in your manufacturer's professional line and are more durable, weather sealed, and made with better quality materials that add weight and bulk to the lens. Some are made with higher-quality, special low-dispersion glass that transmits light better than a standard lens.

If you accept the considerable increase in price, the major advantages of constant aperture zoom lenses are:

▶ **They are excellent in low light.** Because they usually have a 1- to 2-stop larger maximum aperture than variable aperture lenses, they work better in many low-light situations such as weddings, concerts, and nighttime photography.

▶ **The aperture remains the same throughout the zoom range.** The maximum aperture is available from the shortest to the longest focal length, meaning you have the full range of apertures to choose from over the zooming range of your lens.

▶ **Autofocus works faster.** A larger aperture means the camera has more light to work with and the auto focusing system works faster. More light also means a brighter image in the viewfinder, which can speed up manual focusing and composing the image as well.

Only you can decide if these lenses are worth the extra expense by considering the type of photography you do. Most manufacturers release new camera bodies with some new features every 12-18 months but lens debuts are much less frequent than that. You may want to consider purchasing a better lens rather than upgrading camera bodies next time a new one comes out. For photographers who shoot a variety of events like I do, having a lens with a constant aperture that delivers a brighter image in the viewfinder is a necessity and a true joy to work with.

The most popular size of constant aperture lenses across many manufacturers is the 70-200mm f/2.8 zoom lens. Canon, Nikon, Sigma, Sony, and Tamron all make them with various cosmetic differences, but they offer varying performance and flexibility that lens affords across a wide range of price points. Adding Image Stabilization or Vibration Reduction to the lens further increases the cost, but this technology allows you to shoot at slower shutter speeds than you normally would be able to with a comparable zoom lens without it.

Macro Lenses, Aperture, and Depth of Field

Macro and close-up photography involves filling the frame with your subject, and to do that you almost always have to get closer to it. This type of photography can be very rewarding, and special attention must be paid to camera placement and aperture in order to get adequate depth of field. As you move closer to your subject, the magnification rate increases and the depth of field begins to diminish. Even very small apertures may not be able to give you the depth of field your subject requires. With insects and flowers, your depth of field may be less than an inch using your smallest aperture.

The biggest hurdle photographers face when creating successful macro photography is getting the proper lighting and depth of field for their subject. They understand the need for very small apertures, but this often puts them into the predicament of having to use slow shutter speeds to get enough light into the camera. This can be solved by using a tripod if you're in the studio or taking static shots indoors, but in the field a tripod is not always a practical solution because of the time and room it takes to set up.

4.11 This columbine flower was lit by holding a speedlight with a small softbox diffuser directly over the top of it. Because the light source is bigger than the subject, the lighting looks soft. Exposure: ISO 100, f/32, 1/160 second, f/32, ISO 100.

Working very close to the subject in order to fill the frame with it also means that any movement in the frame is greatly exaggerated, so a higher shutter speed is necessary to produce a sharp image. You must also watch the relationship between the subject and the background and make sure they do not interfere. Remember the camera's aperture only stops down to the f-stop you selected at the moment of exposure, so when you compose the image you are looking at the scene through your lens's widest aperture. Check your camera's Depth-of-Field Preview if it has one and recompose the shot if the background takes attention away from your subject.

I often use an external speedlight and a small softbox diffuser, either handheld or on a bracket attached to the camera, when taking close-up and macro photos. This allows me to use the aperture of my choice at a shutter speed I can safely handhold, leave the tripod in the van, and work faster. When the light source is larger than the subject, you get soft light even if it comes from a hard source like a speedlight flash. By shooting small objects with a softbox-equipped speedlight, I actually can get softer light that looks natural. If the background goes too dark as to look unnatural, I add a second speedlight to light the background and trigger it wirelessly.

Working with Flash

For various reasons, many photographers have a phobia about using flash lighting for their images and prefer instead to work in natural light, mistakenly thinking it is more a pure and less contrived approach to photography. The technology and tools of flash lighting have evolved so that it has become easy to match the power, flexibility, and nuanced lighting quality of natural light for all types of photographic applications. Flash systems come in many sizes and capabilities and are rich in features for all types of lighting control. No longer only associated with producing garishly lit photos, using flash in your photography can now produce better results than ever before. From the mighty, powerful pack-and-head systems to monolights or hot-shoe-mounted speed-lights, working with flash truly expands your knowledge of light and increases the impact of that light on all your photographic subjects.

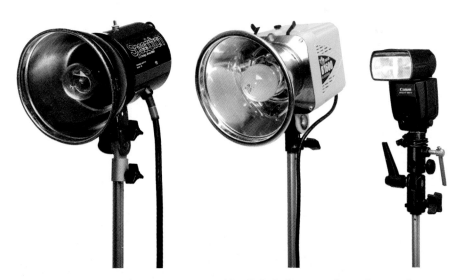

The three main types of flash systems used in digital photography today are the pack-and-head system shown on the left; the monolight, sometimes referred to as a monobloc, in the middle; and the small hot-shoe-mounted flash called a speedlight, on the right. You can easily see the size difference among the three styles.

Flash Systems

Most photography studios employ some type of flash system in their daily work because they just cannot afford any down days where the light is not quite up to snuff. They require flash to make outstanding photographs on a day-to-day basis. Shouldn't you strive to accomplish the same thing in your work, no matter what that might be? Taking a cue from these studios and incorporating flash into your photographic repertoire for those times when the light just needs a little boost can go a long way to consistently producing dazzling results.

There are three main types of flash lighting systems you should consider as you start to plan your lighting setup and purchase equipment. The most power is realized with a pack-and-head system, which includes individual flash heads connected by cables to a power pack. These systems are usually supported by a large number of light modifiers such as softboxes, grids, and snoots and are well suited to everyday studio use. However, they tend to be rather large, and require AC power or an external power source, such as a generator for location work, to operate. Some systems use dedicated battery packs, making them easy to take on locations where there is no power supply.

5.1 Commercial photography studios rely on a stable flash lighting system that produces consistent results to maintain a solid reputation. To create lighting for a broad range of subjects, such as this mother/daughter portrait, studios choose systems that provide flexibility and accept a large amount of lighting accessories. Exposure: ISO 50, f/4, 1/100 second.

The second type is the monolight, which is designed to marry the power supply and flash head into one convenient unit. It is fairly easy to transport, has a good range of output adjustments, and also requires AC power, a portable battery, or generator to operate.

The last type is the small dedicated flash, now called a speedlight. While lower in power output than the previous two systems, its portability, TTL capabilities, and ease

of use, make it a great candidate for travel and location work. Small flash popularity has exploded in the last few years.

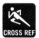

See Chapter 6 for more in-depth information on working with speedlights.

In order to make an informed decision concerning what type of flash lighting system to purchase, you have a few other considerations that should be addressed as well. Only you can decide which system best meets your shooting needs. The following sections provide more information on all three of these systems and their advantages for particular types of shooting.

Pack-and-head system

The most powerful commercially available flash system today is the pack-and-head system. The term *pack and head* refers to a power pack or transformer, which runs on household current and is usually stored in a series of capacitors, and the flash head, which is connected to the power pack by a long cable. These systems rate the power output of the flash in terms of lumens or watt-seconds, which simply means the power pack delivers a certain amount of light wattage for 1 second. The capacitors store the power from the AC line and unleash it once the shutter is tripped.

Some photographers confuse the relationship between watt-seconds and the light that is produced by pack-and-head systems. A watt-second refers to the amount of power consumed by the light and is not about the light that

5.2 The pack-and-head system includes a power pack that stores the power and a flash head.

is put out from the flash tubes. Several manufacturers' systems have the same watt-seconds ratings but produce different guide numbers (GN) for the light emitted from the flash, which has more to do with the efficiency of the unit rather than sheer power.

Modern electrical technology has made pack-and-head systems smaller and lighter than they used to be, although they still take up a fair amount of room and are bulky to transport. Top brands of the pack-and-head system for today's digital photographer include Profoto, Elinchrom, and Speedotron.

The power packs have a set amount of power, which can be symmetrically distributed between multiple heads, but the more you hook up, the less power each is capable of utilizing. Or they can be used asymmetrically, where if the power of one goes up, the others have to go down. The power output and controls of these packs are a little complicated and do take a while to learn, but they are well worth it for the power and light quality they provide. With many newer, high-end power packs, all the settings can be controlled through your computer. This allows for extreme precision and your power settings can be recorded for future shoots.

Here are some of the reasons photographers choose this type of flash equipment:

▶ **Power.** For shear, raw power, pack-and-head systems can't be beat. They offer stable light sources as long as there is a receptacle to plug in to or a consistent power supply. They allow you to shoot in controlled environments at higher f-stops resulting in greater depth of field or the ability to adequately light larger sets or locations. There is, however, a price to pay for all that flash power, usually in the form of portability and cost.

▶ **UV-coated flash tubes.** The flash tubes of these systems include a special coating to prevent unwanted ultraviolet light from causing discoloration in the images. These bulbs appear to have a slight yellowish cast that has no effect on the subject but absorbs any extra UV light emitted from the bulb at the moment of exposure. This coating is very beneficial when shooting glassware, silver, and other reflective surfaces.

▶ **Short flash duration time.** These flash systems offer the shortest flash duration time of any system available to freeze moving objects such as water. A shorter flash duration effectively becomes the shutter speed to capture extremely small slices of time in the images.

▶ **Recycle time.** *Recycle time* refers to the time it takes the flash to power up fully to make another exposure. Many of these systems take from 1 to 4 seconds between shots depending on the power output selected, and can be more than 4 seconds at full power. This is a plus in fashion and other studio photography situations where the subject can be moving around a lot.

▶ **Ready lamp/audible beep.** Power packs include a ready light and an audible signal to let the photographer know the pack is fully recharged and ready for the

next exposure. This is beneficial in fashion and portrait work when the photographer wants to maintain a connection with the subject.

▶ **Modeling lights.** Studio flashes usually have the capability to illuminate a subject using a modeling light. A *modeling light* is a secondary light element in the flash head that when turned on, simulates the light output of the flash, allowing the photographer to model highlights and shadows and adjust the lighting output and placement.

▶ **Power adjustment.** The power pack is the command center for these systems and includes precise power adjustment sliders, dials, and switches for symmetrical and asymmetrical power output through the various ports or channels. If power output is symmetrical, the same amount of power is distributed through the channels; if it is asymmetrical each head has its own amount of flash power output. You can adjust the power output on some newer units down to 1/10 f-stop.

▶ **Softboxes.** Softboxes are lighting modifiers that create a beautiful soft quality of directional light. They come in a variety of sizes and shapes and connect to the flash head with speed rings. Speed rings are aluminum or plastic brackets that connect a flash lighting modifier to the flash heads and accept a broad range of lighting accessories. Once attached, they allow the photographer to rotate the modifier to get just the lighting angle or quality desired.

▶ **Accessories.** Pack-and-head systems offer a wide array of light modifiers and accessories. Diffusion panels, grids, snoots, barn doors, gobos, gel holders, cookie cutters, umbrellas, octabanks, beauty dishes, and softboxes are common accessories for all commercial studio systems.

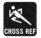

See Chapter 7 for more details on light modifiers.

Pack-and-head systems offer the greatest power output of any flash system and are the most expensive. Photographers choose this kind of equipment when they want rock-solid performance and reliability from their flash systems and are mainly involved with studio work such as portraiture, tabletop/still life, and special effects.

Monolights

Monolights or monoblocs refer to flash lighting systems where the power supply and flash head are housed in the same unit. Fairly lightweight and portable, monolights allow the photographer to take some hefty flash lighting power outside the studio for location work. They offer many of the same features as larger studio flash systems and are more powerful than speedlights on location or in the studio.

Less expensive monolights include individual power settings of 1/4, 1/2, 3/4, and full, but sometimes you need the more precise control of continuously variable output.

Continuously variable output monolights are more expensive and allow you to fine-tune the lighting and the exposure with sliders or dials to get precisely the aperture and depth of field working distance that you want. Having the power supply and flash head in one unit makes them highly portable. Monolights offer the best of both worlds by including the following features.

5.3 Monolights (or monoblocs) contain many of the same features as pack-and-head systems in a small, convenient unit. Although not as powerful as their larger cousins, they offer more portability and accept a similar range of lighting modifiers and accessories.

▶ **Power.** Monolights offer a good range of power options with the ability to be adjusted from very large watt-second output down to very small output, making them ideal for digital photography. With separate monolights, it's also easy to set the power level for each individual unit rather than try to figure out the power distribution for the flash heads on a power pack.

▶ **Modeling lights.** Similar to the larger pack-and-head systems, monolights also include modeling lights so you can approximate the lighting effect on your subject and move the lights around or increase the output to get just the lighting effect you want. Lower-priced monolights provide a simple On-Off modeling light to give you some idea of that final lighting effect. Monolights with proportional settings allow the modeling light to vary as you adjust the flash output.

▶ **Built-in optical slave.** Most monolights also have an *optical slave* that can be set to trip the flash when it sees another flash go off. This is advantageous for location work because it means you only have to trigger one unit from the camera with a PC cord or wireless remote and the others fire at the same time.

▶ **Convenience.** Monolights offer power and convenience in a handy lightweight package. Another reason they are great for studio and location work is that if one head goes down you still have the other lights to work with. If your power pack goes down, none of your lights works.

▶ **Portability.** Several monolights can easily fit inside a medium-size case along with all the cords, reflectors, and accessories you need. Monolights are easier to transport and are way less bulky than studio pack-and-head systems, making them ideal for taking on the road for location work.

▶ **Accessories.** Monolights offer the same wide range of lighting modifiers and accessories that the larger pack-and-head systems do with many of the same features such as speedrings and umbrella systems. Most manufacturers of monolights offer a full line of snoots, grids, and reflectors to fashion the lighting the way you want it.

A set of monolights for studio or location work can be purchased for a fraction of the cost of a larger pack-and-head system. Many digital photographers go this route when stepping up their lighting equipment and use monolights for location wedding portraiture, fashion, and documentary and photojournalism work. Monolights offer outstanding power in a small compact unit that can provide professional lighting results and are very easy to work with. I use the Paul C. Buff line of monolights called White Lightning and Alien Bees. Other manufacturers include Balcar, Broncolor, Hensel, and Photogenic. Monolights are the next logical step for photographers looking to move up from speedlights to more powerful flash lighting units.

5.4 This Alien Bees ABR 800 Ring flash is another type of monolight. It is a self-contained unit, which includes the power supply, modeling light, and flash tubes.

Speedlights

Lower in power than the larger studio units, speedlights offer portability and ease of use unmatched in any type of lighting system. Speedlights are also the least expensive way of creating a photographic lighting kit. Chapter 6 deals specifically with details on working with speedlights because they are the most popular and accessible system for most photographers. This section briefly looks at some of the features available to you when working with this type of flash unit.

▶ **Through-the-Lens (TTL) metering.** Today's most advanced small flash metering system uses preflashes and flash-metering algorithms to determine the proper flash exposure. The TTL system reads information from all metering zones before and after the preflash. After the preflash, areas with little change in brightness are then weighted for flash metering. This is done to avoid highly reflective surfaces such as glass or chrome or other overly bright areas from creating a false reading, thereby causing underexposure. When you use certain lenses, distance information is also reported back to the flash and entered into the algorithm.

▶ **Wireless control.** Many of the latest speedlights allow you to fire flashes wirelessly. When using this feature you need to have either a flash set as a master/commander unit or an optical wireless transmitter fitted on your camera's hot shoe. A master unit fires a preflash, which then transmits information back and forth between the camera and the flash. The master unit can control multiple speedlights wirelessly, allowing for more creative lighting setups. This enables you to control up to three groups of speedlights in TTL or Manual mode. RadioPoppers and PocketWizards, discussed in greater detail in Chapter 6, also fire your flashes manually or in TTL mode using radio communication instead of optical signals.

▶ **High-speed sync.** Standard sync speed is usually 1/200 or 1/250 second to allow enough time for the flash to fire while the shutter is open. Dependent on your flash/camera combination, this feature allows you to use your flash at a higher shutter speed than normal sync speed by pulsing your flash imperceptibly as the shutter curtain moves across the sensor enabling you to use any shutter speed. This setting is often used when you want to freeze action or shoot outdoor images that require a wide aperture and higher shutter speed in bright ambient light conditions.

▶ **AF-assist beam.** Many speedlights have a built-in light that projects onto the subject to aid the camera's autofocus (AF) system in very dark or low-contrast situations.

▶ **Flash exposure lock.** Flash exposure lock enables you to meter the subject, get a reading for the proper flash exposure, and lock in that information. Pressing a button on some cameras allows you to meter the subject and then recompose the shot while maintaining the proper flash exposure for that subject.

▶ **Red-eye reduction.** Available on some speedlights, red-eye reduction fires a preflash to contract the pupils to diminish or remove red-eye from the subjects in your photos. Your camera may instead have a built-in red-eye reduction lamp to achieve the same effect.

▶ **Modeling lights.** This feature fires a short burst of flashes allowing you to see what the light falling on your subject looks like.

▶ **Stroboscopic Flash mode.** Some speedlights include a Stroboscopic Flash mode that can be set to fire a user-specified number of flashes per second, similar to a strobe light, and also the total number of flashes for creative effect.

▶ **Tilting/rotating flash head for bouncing flash.** This speedlight feature allows you to tilt the flash head up to bounce light from the ceiling or to the side to bounce light off of a wall. This is a very effective way of softening the light but not very efficient for shooting longer events and can diminish battery power quickly.

▶ **Automatic zoom head/wide diffuser panel.** Speedlights automatically zoom internally to project light into the scene at a similar angle to the angle of view that the lens covers. Several

5.5 Even when attached to the camera's hot shoe, the speedlight's flash head can be rotated and adjusted for bouncing the light from modifiers, walls, or ceilings. The flash head is marked with a degree scale for precise positioning.

speedlights incorporate a built-in diffuser panel that can be employed manually and allows you to use the flash with a lens as wide as 14mm and still retain full flash coverage without having light fall off at the edges of the image.

▶ **Bounce/catchlight panel.** High-end speedlights have a pull-out white plastic card that can act as a fill card and reflect light back, providing a pleasing catchlight when the flash is used in the bounced position.

▶ **Accessories.** Speedlights have a wide range of lighting modifiers and accessories available similar to the larger systems. Third-party manufacturers such as Honl Photo and FJ Westcott offer a full line of accessories, such as softboxes, snoots, grids, and reflectors to create the lighting from your small flash just the way you want it.

> When getting ready for a photo shoot, I make sure to put a fresh set of rechargeable batteries in the speedlights I intend to use. One set of batteries can last for hundreds of photos, and often last for the entire assignment or event. You should, however, always have at least one set of extra batteries along for each flash you plan on using.

Flash Techniques

When most people think of flash photography, they tend to think of product advertisements and studio portraits, but flash can be used for a much broader range of subjects. Using studio lighting out of the studio allows the photographer to take quality images anywhere, including weddings and special events. Flash lighting techniques described in this section can help raise the quality of your lighting, adding power, subtlety, or drama to your photographs.

When planning your flash photographs, keep these ideas in mind:

▶ **Visual impact.** The first thing to consider is how to create a photograph of your subject that has strong visual impact. You have several tools at your disposal to achieve this such as composition, color, background, aperture and shutter speed selection, and lighting placement. Breaking down the shot in terms of the individual problems that need to be solved exposes creative solutions.

▶ **Lighting direction.** Especially when you shoot with a mix of ambient and flash lighting, the direction of the lighting is very important. You must take into account where the sun is and where the shadows fall and try to mimic that in your lighting placement. You can use reflectors and fill flash to perk up shadow areas, but you want to avoid crossed overlapping shadows. Because you live in a world with only one sun, your lighting pattern should look that way, and overlapping shadows is a dead giveaway of poor flash use. The indoor studio relieves that burden and gives you complete control over the lighting, so this consideration becomes less significant.

▶ **Lighting amount.** The terms *high-key* and *low-key* are used to describe bright and dark lighting setups. High-key lighting is bright and evenly lit, usually used

with a bright background to create an upbeat tone. Conversely, low-key lighting is moody and dramatic, often featuring large dark and shadowy areas in the picture.

In many flash photography situations, you use flash with natural light, and must also consider the natural, or ambient, light, whether it's sunlight, incandescent, or fluorescent. Studio lighting can be tricky outdoors; you must take special care when blending flash and ambient light. Use flash lighting as the main light on the subject, or use it to create fill or illuminate the background to avoid a bad lighting combination.

Direct flash

Using direct flash or front lighting, refers to illuminating your subject directly from the front, usually by using your built-in pop-up flash or adding an external speedlight to your camera's hot shoe. This is probably the least flattering lighting position for most subjects.

5.6 Direct flash, or front lighting, produces the least flattering light for portraiture and most photographic subjects. The hard, direct light from the flash creates shadows behind the subject and surface shine on the face. Exposure: ISO 100, f/5.6, 1/80 second.

5.7 Bounce flash softens the light on the face, reduces overall contrast, and softens the transfer lines of shadows to midtones to highlights. Exposure: ISO 100, f/5.6, 1/60 second.

You rely on this type of lighting for snapshots of your families and friends when you just want to take a quick picture and aren't really concerned about the lighting quality (or lack thereof) in your images. In portraiture, front lighting can produce red-eye, deep shadows on the background depending on its proximity to the subject, and exaggerated surface shine on foreheads, cheeks, and lips. It also tends to flatten everything it strikes by sending the shadows away from the camera angle.

Bounce flash

Using bounce flash refers to directing the flash light, usually from a dedicated speedlight, into a surface or light modifier in order to scatter the light rays, making them softer by the time they hit the subject. Bounce flash is very effective for eliminating problems created by direct flash and gives a very pleasing look to portraits by making skin look softer and shadows less harsh. Although it's not as efficient as direct flash, bounce flash does produce a soft light effect by bouncing the light up to the ceiling or scattering around the room so that it strikes the subject from many angles. Photographers often use a bounce card or diffuser attached to the flash to further soften the light.

Fill flash

A fill flash or fill-in flash refers to using a flash unit to fill in the shadowed areas of the face or image with light. In bright sunlight, you are at the mercy of the sun's angle, direction, and intensity, and using a flash to add fill light can help balance out the exposure while still retaining a three-dimensional look to the light. I use fill flash either on or off my camera when shooting wedding couples or portraits outside during the day in all lighting conditions when I want to balance out the ambient light and create less contrast in my images. Exactly matching the ambient level with the flash looks flat and fake in my opinion, and often my goal is to try to mask the fact I used flash at all. It's not that I don't have enough light in these situations; it's just that it's not available in the spots I need it.

Fill flash is very easy to apply when using a camera-mounted flash set to TTL mode. Some camera models have a fill flash feature that attempts to adjust the amount of flash used dependent on the ambient light levels. A very good technique to achieve proper fill flash is to use a diffuser dome along with the bounce feature of your speedlight and angle the flash head up slightly so that it's not pointing directly at your subject. This way the power of the flash does not have to be lessened as much because only a small portion of the light emitted from the flash reaches the subject. Start at 45 degrees and try adjusting the flash head to slightly different angles to see what looks best.

Camera and flash settings

When shooting with pack-and-head or monolight systems, always set your camera to Manual exposure mode and dial the exposure settings in yourself. The other modes on your camera are of no use at all when using these larger systems because your camera's light meter needs continuous light to operate properly and flash happens in a fraction of a second.

Decide what the subject and background are and how much depth of field you need, and position the lights or adjust the power settings to get just the look you want. The shutter speed won't be nearly as important when shooting in the studio as it is when shooting outdoor location work, but you still want to keep it high enough to avoid any camera shake. Take time to review the images on the camera's LCD monitor and study the depth of field and critical focus. Remember that aperture choice controls both depth of field and the exposure of the flash when using strobes.

Your speedlight can be used in all the camera exposure modes such as Programmed Auto, Aperture Priority, Shutter Priority, and Manual for convenience or faster shooting.

Regardless of what type of flash system you are using, you should always remember this when shooting outdoors: Shutter speed controls the ambient light level, and aperture determines the flash exposure. Understanding these relationships rapidly increases your knowledge of light and the beneficial role that flash can play. I do a lot of outdoor location work with flash, and once I fully understood this basic principle, it was much easier to determine what my camera and flash exposure setting should be. Experiment and review the images on your camera's LCD monitor to gauge your results.

Setting lighting ratios

Oftentimes, studio photographers rely on lighting ratios to determine the look and feel of their images. Lighting ratios refer to the difference in light intensity between the shadowed and highlighted areas of your subject. Lighting ratios are expressed numerically: For example, 2:1 means one side of the subject is twice as bright as the other; 3:1 means that the shadowed side is only getting a third of the light that the highlight side is getting. You use ratios when you want to plan how much contrast you want in a consistent portrait or studio lighting setup. Lighting ratios also determine the amount of highlight and shadow detail in your images. You can get very accurate measurements for lighting ratios using an external light meter that can measure flash. Set ratios by making adjustments on the power pack, monolight, or each flash unit.

Using Flash for Outdoor Locations

Using flash to help perk up the light in your outdoor scenes is fairly straightforward. You position the lights and add whatever lighting modifiers you want to use, just like in the studio. Unlike in the studio, ambient light is a major player in your outdoor lighting mix.

With speedlights, the first approach to shooting in ambient light is to use TTL mode on your flash with full Programmed Auto on the camera settings and Auto white balance (AWB) and hope for the best. In some fast-breaking shooting situations this is all you can do. The next method involves sticking with TTL but changing the white balance settings to accurately match the natural lighting conditions and adding a colored gel to the flash to match the ambient light. Gels are colored pieces of transparent material that change the color of the light emitted from your flash to match the color of light in a specific environment, such as when shooting in an office lit with fluorescent lights or the living room of a home lit by incandescent light. A third approach that is a little more creative is to shoot manual power, forget accurate color balance for a moment, pick a totally inappropriate color temperature for the ambient light, and gel the flash back to neutral or even warmer.

Whatever you decide, taking a flash system along on location will give you the confidence you need to know you will get the shot, even under the worst lighting conditions. Because of their portability you can quickly make many of the light-shaping tools you may need on the fly from some paper and cardboard if you don't already own them or bring them along. More professional third-party accessories are rapidly becoming available for a large variety of flash equipment.

Advantages of using flash when taking shots outdoors include:

- ▶ **Creating a fill light.** Using a speedlight as a fill light complements the ambient light and opens shadowed areas, providing more information and less contrast to the viewer. It also adds nice catchlights to the eyes.

- ▶ **Reducing contrast.** Speedlights can also improve the tonal range of an outdoor portrait in high-contrast situations. Mostly, I try to avoid direct sun for shooting portraits but when I can't, such as during a wedding ceremony, using a small flash can help reduce the difference between the brightest and darkest values of the image by raising the values of the darker areas closer to the darker middle tones.

- ▶ **Creating light in the dark.** You can create some of the most dramatic portrait images ever by using the changing colors of an evening sky as a background and your flash as the main light source. As night falls, city lights come on and a

5.8 Using flash for outdoor portraits can add fill light to facial shadows and attractive catchlights to the eyes as in this portrait of Sheila, my favorite florist. Exposure: ISO 100, f/3.5, 1/250 second.

whole new background palette emerges as shadows grow long, colors intensify, and daylight fades. As long as there's enough light to focus, using a speedlight can extend your shooting time and add a distinctive look to your images.

Remembering light theory

Without getting into a dissertation on photons and Sir Isaac Newton, the light theory I suggest you remember is simply that light only goes in one direction unless diffused or broken up. Oh sure, you can bend light and shape it with modifiers, but the original direction of the light should look consistent with the scene. Opposing lights can be used as rim lights or fill but should remain low enough in value so as to not confuse the viewer and create crossed shadows. You can get away with a little more rule breaking in advertising and product photography than you can in documentary or photojournalist work. Keep the light as simple or dramatic as you want, but remember to pay attention to the shadows to see where they fall.

Setting power output

With location photography, the ambient light must be carefully evaluated to determine whether it is adequate to use as the main light source. The ambient light can provide a sense of the subject's environment that helps set the prevailing scene, particularly in outdoor locations. I try to make the most of ambient light and use it as the main or fill light source when possible. As a result, I use flash to boost ambient light and to help define areas in the scene that are poorly lit or to create edgier light.

To this end, I use a wireless transmitter with the speedlights' TTL ratio settings or manual power output controls to dial in and fine-tune my light for the look I want. Adding light modifiers may absorb some of the power output, but this is no problem

for TTL and is figured into the exposure calculation. Manual Flash mode may require you to boost the flash power, which is diminished slightly by the accessory. Colored gels do this also, so be sure not to attach a gel so large that it covers up the flashes' sensors when you shoot in TTL mode.

If the speedlights cannot light the scene with enough power to get the look I want, then I pull out the monolights or pack-and-head system. Speedlights produce a set amount of light at full power and when you need more than that, your only option is to use more powerful units to light up your scene.

Balancing for the ambient light

Because of a speedlight's small size and high flash output, it is ideal for professional location lighting when your scene is a manageable size. It can be placed almost anywhere, triggered with remotes, and dialed in to produce just the right amount of light you need to create a dramatic portrait or interior shot. The exposure controls of the camera in tandem with the settings of the compatible speedlight make balancing ambient and flash simple.

But what do you do when the full output from your speedlight is not enough light for your shot? A number of highly portable systems just slightly larger than your speedlights are available to give your lighting a big boost in power. Models such as Elinchrom, Lumedyne, Norman, and Quantum offer mobile units that provide a lot of light on location and are the flash systems of choice for wedding, sports, and photojournalist photographers when they need an extra powerful flash. Speedlights can only go so far when your scene is large or involves many people. Larger flash options such as monolights and pack-and-head systems will give you all the power and light you need to make your images under any lighting conditions.

Sometimes you find yourself shooting in locations or situations where you need all the ambient light you can get but still need flash to add some snap to the colors. In these situations, I set my camera to the ambient white balance preset that corresponds with the ambient light and gel my flash to match that light. Personally, I like the Honl Color Correction gels that quickly Velcro to a Speed Strap for their easy application, but you can buy larger sheets of the same gels from many camera stores and theatrical supply houses and cut them down to the size you need.

The three main color-correcting gels I use on my speedlights are:

▶ **CTO.** Color Temperature Orange gels are used to color-match the flash to tungsten light, which results in a more realistic look if the ambient light is also tungsten light and white balance is set properly.

These are the gels I use most, as I often shoot in indoor locations and need to match the flashes' outdoor color temp to the ambient light of the interior. CTOs come in 1/8, 1/4, 1/2, and full strength. One full CTO usually gets you back to neutral, but not all tungsten light sources are the same temperature. I sometimes add another quarter or half gel to warm up the light from my flash.

▶ **CTB.** Color Temperature Blue gels are used less frequently but are beneficial in situations where I need to balance tungsten to daylight, such as when there is a window in the scene. CTBs come in the same strengths and denominations as CTOs. I add these inside lamp shades or light fixtures to balance the lamp and the tungsten light indoors to match the sunlight coming in from a window if they are both in the shot.

5.9 A full Color Temperature Orange (CTO) gel from the Honl Speed System applied to my speedlight. I use warming gels like these to balance the color of the light from my flash when shooting in tungsten lighting situations and lower intensity gels for slight warmth to skin in daylight.

▶ **Green.** For fluorescent conversion, green gels color-match the flash to fluorescent light. These are a lifesaver in office situations.

Flash Exposure Settings

For those of you who want to go old school style and figure out the flash exposure yourself, it's really not that difficult once you know how.

After you know what the exposure numbers mean and where to plug them, it becomes quite easy. This can be a huge timesaver if you've been keeping a lighting diagram booklet and need to create repeatable lighting setups in the field.

If you use your speedlight in TTL mode, all these calculations are done for you, but it's always good to know how to achieve the same results when shooting in the studio or on location with the larger flash systems in Manual mode. When you know this information, you can use any flash and get solid, repeatable results. By learning flash exposure and what it's all about, you begin to understand the reason your speedlight's TTL mode may not always give you what you want and the broader limitations of flash itself.

5.10 Shooting portraits in the studio requires accurate color and exposures and repeatable results. Keeping a lighting diagram notebook with exposure settings and lighting placement along with any information about lighting modifiers you used for the shot can come in handy for future sessions. Exposure: ISO 100, f/4, 1/160 second.

The following sections cover how to use the guide number, the distance from the speedlight to the subject, and the aperture to determine the proper flash exposure.

Guide number

The guide number (GN) is a numeric value that represents the amount of light emitted by the flash. You find the GN for your specific flash in the owner's manual that came with it. The GN changes with the ISO sensitivity, so that the GN at ISO 400 is greater than the GN of the same speedlight when set to ISO 100. The GN also differs depending on the zoom setting of the flash.

If you have access to a flash meter, you can determine the GN of your particular flash at any setting by placing the light meter 10 feet away and firing the flash. Usually GN is published and talked about in terms of ISO 100, so make sure the meter is set at ISO 100. Now, take the aperture reading from the flash meter and multiply by 10. This is the correct GN for your flash.

Aperture

Another factor that determines the proper flash exposure is the aperture setting. The wider the aperture (smaller f-number), the more light hits the sensor. The aperture or f-number is a ratio showing the fractional equivalent of the opening of the lens compared to the focal length. For example, a lens opening at f/8 is the same as 1/8 the distance of the focal length of the lens. So, if you have a 50mm lens, the lens opening at f/8 is 6.25mm. 50 divided by 8 equals 6.25.

All mathematics aside, all you really need to know is this: When shooting in Manual Flash mode your speedlight power output is going to remain the same, so in order to lessen the exposure, you need to stop down the lens to a smaller aperture, move the off-camera flash farther away from the subject, or use flash compensation to knock the flash power down slightly. Often the GN at various power level settings is published in user manuals.

Distance

The third part in the equation is the distance from the light source to the subject. The closer the light is to your subject, the more flash exposure you have. Conversely, the farther away the light source is, the less illumination your subject receives. This is due to the Inverse Square Law, which states that the quantity or strength of the light landing on your subject is inversely proportional to the square of the distance from the subject to the speedlight.

This means you divide 1 by the increase in distance and square the result. So if you double the distance, you get 1/2 squared, or 1/4 of the total light; if you quadruple the distance, you get 1/4 squared or 1/16 of the total light. This factor is important because if you set your speedlight to a certain output, you can still accurately determine the exposure by moving the speedlight closer or farther away as needed.

Another consideration of flash to subject distance is the softening to hardening effect discussed in Chapter 1. No matter what size the light source is, the closer it is to the subject the softer it appears in the photo; conversely, the farther away it is, the harder the light looks. Keep this in mind when setting up your shots by setting the distance first, then set flash levels and modifiers.

Guide number ÷ distance = aperture

Here's where it all makes sense. Take the GN of your flash, divide by the distance the flash is from the subject, and you get the aperture at which you need to shoot. Because you can complete an equation a few different ways, you can change this equation based on the information you already have to find out what you want to know specifically.

▶ **Aperture × Distance = GN**

▶ **GN ÷ Aperture = Distance**

▶ **GN ÷ Distance = Aperture**

Flash Sync Modes

The sync speed of your camera is the fastest shutter speed you can shoot with and still get the full exposure of the flash. The sync speed is based on the limitations of the shutter mechanism, usually up to 1/250 second. The sync speed on different camera bodies differs with the type of shutter mechanism used, usually either a leaf or focal-plane shutter. You are not locked into this sync speed if you employ high-speed sync on the flash.

Sync speed

When you use dedicated speedlights, the digital camera body prevents you from selecting a shutter speed faster than the rated sync speed, but you can select any of the slower ones. When you use larger equipment such as monolights and pack-and-head systems, it's better to switch to Manual exposure mode and have complete control of the shutter speed. This is a great technique to use when you need to bring up the value of the ambient light levels and is often referred to as *dragging the shutter*. This technique provides some context for subjects in low-light images.

Sync speed is also important when a non-dedicated flash on your camera or an external flash is triggered via the camera's PC terminal, because there is no mechanism to make the camera aware that the flash is connected, so it is easy to set a shutter speed higher than the rated sync speed. The disappointing result of this is usually a partially exposed image because the shutter is already closed when the flash is still reaching its peak output.

First-curtain sync

All digital dSLR cameras have two moving *curtains* in the shutter mechanism. The first curtain opens the shutter and the second curtain closes it. The normal operation of the shutter and flash causes the flash to fire immediately when the first curtain is fully open. This is called first-curtain sync and it is fine for most general speedlight flash applications. You press the Shutter Release button, the shutter opens, the flash fires, and then the shutter remains open to complete its exposure. The only problem with this arrangement occurs when you try to use flash to photograph a moving subject. The subject is moving and you are tracking it using a slow shutter speed to pick up some ambient light. When the flash fires at the beginning of the exposure it looks unnatural. When you review the image on the camera's LCD monitor, you see motion trails out in front of the object you tracked and it looks like it's moving backward.

Second-curtain sync

When photographing moving objects with flash, the technique to use is called second-curtain sync. It enables the flash to fire right before the shutter closes, which thereby shows the motion trails behind the object and makes the scene look much more natural and realistic. Depending on camera/flash combinations, this feature is either set in-camera or on the flash directly.

When you shoot in TTL mode and the flash is set to operate in second-curtain sync, the preflash fires to determine the proper exposure the moment the Shutter Release button is pressed, the shutter opens for the specified time, and then the flash fires right before the shutter closes. This preflash can sometimes be confusing and cause you to believe the flash has fired and that the camera or flash is set incorrectly. Rest assured this is only the preflash and the only way the camera can accurately set the TTL exposure.

External Light Meters

There are two methods you can use to measure light and find the best exposure — incident metering and reflective metering. An external light meter has the capability to take both kinds of readings and it is often beneficial in different types of shooting situations. This section briefly looks at the characteristics of each:

▶ **Incident metering.** This method measures the light falling on the subject from the subject's position. Place a white translucent dome over the eye of the light meter and position the meter with the dome facing the main light source near the most important part of the image and pointed back toward the camera. Once the meter is activated it takes a reading of the light falling on that part of the scene and displays the proper settings. This procedure is repeated for each light in the setup. The camera is set according to the reading of the main light, and the additional lights (fill, hair, background) are set at whatever ratios you choose for the look you want. An incident meter is also beneficial for available light photography as well.

▶ **Reflective metering.** A reflective light meter measures the light in the scene that is reflected from your subject back to the camera. The light meter then attempts to measure the overall brightness of the scene and return an exposure setting that provides accurate middle, highlight, and shadow tones based on the 18 percent gray theory. You can use an external light meter to take readings of the highlight, shadow, and midtone areas of the shot separately and then use your brain to dial in the perfect exposure. A handheld meter makes you stop and think about what you're doing instead of just trusting the camera. In the process

of setting the exposure you will begin to understand about the intensity of light as it affects the photograph.

The light meter in your camera does a very good job in most photographic situations of metering the light and then letting you know what the proper aperture and shutter speed settings should be at any given ISO. This is the exact meaning of the Through-the-Lens (TTL) system. It measures just the light that passes from the scene, through the lens, and into the camera.

An external light meter can come in handy in several shooting situations such as when taking time exposures or working in the studio with flash units other than your TTL system. Having a light meter positioned at the subject that can trigger the strobes gives you an accurate reading that you can input into your camera using Manual mode. Having the ability to measure the light in all kinds of shooting situations is why many photographers rely on an external light meter.

Gray Cards and Exposure Targets

Included at the end of this book is a handy 18 percent neutral gray card and color checker, and Appendix C fully explains how to use them. Professional film photographers have used gray card and color checkers for decades to get proper exposures and accurate color reproduction. The advent of digital photography has made the use of these tools even more widespread because not only are they helpful in attaining the proper exposure values but also because they can help ensure you get the most accurate color.

The exposure calibration target that I use includes three panels of color: one white, one middle gray, and one black. At the beginning of a shooting session, I place the target into my intended scene and fire a shot.

Then in post-processing, I match the highlights with the white value of the target, the midtones with the gray value, and the darkest areas with the black value. Although I always try to use proper photo technique and strive to make sure I get the best possible exposure, having an exposure target is the best insurance for making accurate exposures and color adjustments later on if need be.

5.11 Photovision's 14" Exposure Calibration Target.

Working with Speedlights

Digital technology has increased the public's interest in photography and consider-ably shortened the time it takes to learn about light and how it is captured in photographs. Speedlights afford fantastic results within the reach of a broader number of photographers with exceedingly various photographic pursuits. Small flash use has exploded in the last several years and this chapter brings you up to speed on these amazing creative tools. I also discuss some accessories for your small flash and a few third-party wireless systems that help expand your creative options.

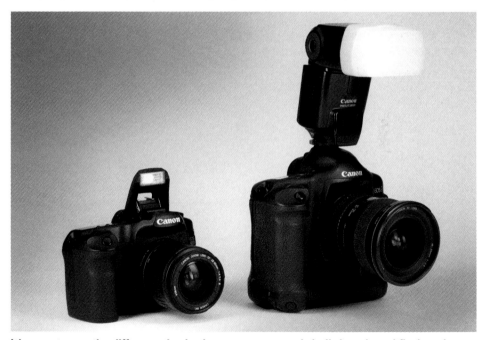

It's easy to see the difference in size between a camera's built-in onboard flash and an external speedlight when they're compared side by side. The larger speedlight expands the power, range, and versatility of using flash to light your subjects by including TTL, High-speed Sync, Second-curtain Sync, Flash Head Zoom, and Stroboscopic Flash shooting modes.

Overview of Speedlight Flash Units

Canon calls them Speedlites, Nikon calls them Speedlights, and most other manufacturers simply call them flashes. They're also called strobes, small flashes, and flashguns. For purposes in this chapter and for the rest of the ensuing chapters, I refer to small hot-shoe-mounted flash units as *speedlights*. Although this chapter is not a comprehensive look at all the ways you can use speedlights, it provides an overview of the technology, as well as some techniques that you can use with one or more strobes and your dSLR camera.

Most people think of only using flash indoors or in low-light situations, but that's just scratching the surface of what speedlights combined with intelligent TTL and high-speed sync can accomplish. Working outdoors with flash may seem very difficult at first as you try to balance the ambient light with the flash output through various times of the day.

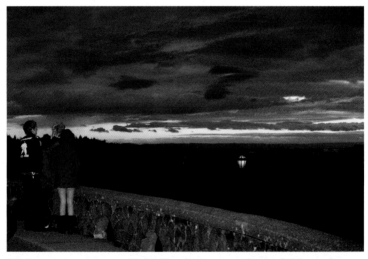

6.1 An on-camera speedlight illuminates members of this punk band enjoying the sunset from Crown Point, Oregon, and TTL flash does a great job matching them to the ambient light of the scene. Without flash, they would have been nothing more than silhouettes devoid of color. Exposure: ISO 800, f/9, 1/60 second.

Just remember this in any picture-taking situation when you are using any kind of flash: The shutter speed controls the ambient light and the aperture controls the flash output. Say it over and over again like a mantra. The TTL system uses the aperture settings and reflected light readings of the subject to make its calculations on flash exposure and duration. You control the relationship between the flashed subjects and

the brightness or value of the ambient light, and thus control the overall feel of the scene. Once you begin to see this aperture/shutter speed relationship in action you easily get it, like learning to ride a bicycle. One day you couldn't ride and the next day you could. Learning to see light is a lot like that. One day you can't see it, and the next day, there it is.

Using on-camera flash

Moving up from your onboard pop-up flash to an external speedlight is effortless and the results may far surpass any flash pictures you have taken previously. You simply slide the foot of the speedlight onto the camera's hot shoe, turn everything on, and shoot. In TTL mode, you don't even have to think about flash exposure or balancing the ambient light because the TTL system does all that for you in a split second.

6.2 The Nikon SB-900 shown here mounted on the camera. Speedlights provide a powerful light unit in a small package, TTL capabilities, and are a big step up from the camera's pop-up flash.

6.3 My friend Dallas enjoys a stogie and a cocktail on the back patio of the reception hall at the end of his long wedding day. On-camera flash was used for this quick snapshot, and works well with his "tough guy" expression. Exposure: ISO 1600, f/11, 1/25 second.

Using on-camera flash is a great way to learn about flash in general and explore your speedlight's other shooting modes such as Manual and Stroboscopic. Getting comfortable with your speedlight and how to set it up properly is what makes flash photography so much fun. The more you learn about using your flash on-camera, the easier it will be to advance to learning about off-camera flash techniques and how to trigger them wirelessly.

On-camera flash tends to make everything in the photo appear flat and evenly lit because all the shadows fall away from the camera. Shadows equal depth and dimension in a photograph and if you don't have them, the photo suffers. When you want to get creative (which is why I hope you've purchased this book) you can use your speedlight off-camera to create dimension, mood, drama, and a wide variety of interesting lighting effects.

On-camera strobe can easily cause red-eye and hot spots on the skin from surface shine. It can also remove textures from the image and increase contrast. The main benefits of using on-camera flash are that it is easy and quick to use, and when the flash is set to TTL mode, it produces safe, adequate results. I rarely shoot for safe and adequate results. I want pop and pizzazz in my images, so I much prefer moving the speedlight off-camera for more directional lighting and more interesting effects in my pictures. When you want to get creative with your lighting, taking the flash off-camera is a real game-changer.

Using off-camera flash

Both Canon and Nikon offer wireless transmitters that work seamlessly with their latest model flashes. The Canon version is the ST-E2 Wireless Transmitter and Nikon's is the SU-800 Wireless Speedlight Commander. These transmitters take the place of an on-camera flash by mounting to the hot shoe of the camera using the electrical contacts of the shoe to gather the information from the camera's TTL system, and relaying the exposure instructions to the speedlight optically via a line-of-sight infrared beam. Except for a few entry-level cameras,

6.4 Both Canon and Nikon offer transmitters to fire off-camera speedlights. The Canon version, pictured here, is the ST-E2 Wireless Transmitter. Nikon's is the SU-800 Wireless Speedlight Commander. Each uses infrared optical signals to convey TTL information and fire the strobes.

the pop-up flashes in Nikon's dSLRs can also act in commander mode for wireless flash triggering. Sony Digital cameras also have wireless capabilities built-in as well.

Taking the flash off-camera frees you up to really explore creative lighting with your speedlights. Whether you are using off-camera cords or wireless remotes to fire them, using off-camera flash and light-shaping accessories allows you to begin to express yourself with light. You're no longer confined to the lighting conditions of the scene as you find them.

6.5 Computer IT specialist Mathew Wilson, photographed on the job with three speedlights triggered by a wireless transmitter connected to the camera's hot shoe. Exposure: ISO 400, f/5.6, 1/50 second.

TTL exposure mode

Speedlights employ advanced Through-the-Lens (TTL) flash exposure control, but each manufacturer calls it something a little bit different. Nikon calls its system intelligent TTL (i-TTL), and Canon refers to its latest system as Evaluative TTL (E-TTL II). In simple terms, this TTL technology receives information from the camera, including the focal length of the lens, distance from the subject, exposure settings, and the camera's built-in evaluative metering system to balance subject exposure with the ambient light.

In TTL flash photography, the camera's meter reads the light specifically through the lens (TTL) and processes the information in a millisecond to give superlative results with the least amount of worry. The basic procedure is this: Having connected your

speedlight to the hot shoe of your camera, pressing the Shutter Release button starts the sequence of the TTL system. With the shutter still closed, the flash fires a pre-flash, which is received through the lens by a sensor in the camera. The information from the preflash is then processed by the camera and combined with data from the camera's TTL metering system to determine the proper amount of exposure to add to balance the light from the flash with the ambient light levels of the scene. The analyzed information is briefly stored to fire the flash as the shutter opens and is then discarded. Then the entire TTL system resets for the next exposure. All this happens when you simply press the Shutter Release button. The beauty of the TTL system is that a lot of technology happens in a very short amount of time and makes using flash for your photography that much easier.

Here is the basic sequence, all of which happens in mere milliseconds each time you make a TTL flash photograph:

1. Press the Shutter button halfway to set focus on the subject and determine the exposure needed given the amount of ambient light.

2. Press the Shutter button completely to fire a preflash so that the amount of light reflected off the subject can be measured.

3. The camera quickly compares and evaluates both the ambient and preflash readings and determines the proper subject and background exposure.

4. The reflex mirror flips up, the first shutter curtain opens, and the flash fires, exposing the image on the sensor. The second shutter curtain closes, and then the reflex mirror goes back down.

Regardless of the focal length of the lens you are using, the speedlight automatically adjusts the flash zoom mechanism to produce the best flash coverage and illuminate key areas of the scene, which conserves power. The speedlight knows not to illuminate a scene for a 24mm wide-angle lens when you are taking the picture with a 70mm zoom lens.

This latest TTL technology also enables high-speed sync with speedlights that allows the flash to sync with the camera at a shutter speed faster than the camera's x-sync speed of 1/200 or 1/250 second. As a result, you can now use flash creatively outdoors and turn day into evening or when you want to use a really large aperture to control depth of field and a fast shutter speed to control the ambient light. Remember, shutter speed controls the ambient lighting values and aperture determines the flash output. Put another way, you could use a fast shutter speed outdoors and flash for your subject and have total control over the lighting relationship of the two via high-speed sync. Most top-of-the-line flashes offer this capability.

Manual exposure mode

Canon's E-TTL II and Nikon's i-TTL are great for those times when you want to get the best results possible when shooting on the fly. You just set the camera to Program, Aperture Priority, or Shutter Priority modes, and shoot away. The sophisticated camera/flash communications take care of the exposure and produce well-lit images. In the old days, photographers had to figure out a guide number and do a few calculations that took their eyes away from the viewfinder. Now, it's as easy as shooting a test shot, judging the results on your camera's LCD monitor, making adjustments, and shooting again.

If you have begun using a few speedlights in multiflash setups, the TTL system still produces great results but may begin to feel a little limiting and rigid, considering you are locked into only a 3-6 stop range among all the speedlights in the setup. This is not an extremely large range. Most flashes that offer Manual mode allow you set the flash from 1/1 (full power) all the way down to 1/128 power in 1/3-stop increments for precise lighting control.

6.6 I photographed Three Finger Jack in front of one of their favorite venues for a CD cover. I shot this with one stand-mounted speedlight firing through a 32-inch small white umbrella. A friend held another speedlight behind them fitted with a blue gel. I made sure to select a shutter speed to properly expose the neon sign and triggered the speedlights in TTL mode with RadioPoppers. Exposure: ISO 100, f/8, 1/60 second.

6.7 Using speedlights off-camera provides more directional lighting with shadows that fall where you decide. This shot of Mimi the Clown uses one speedlight in Manual mode mounted on a stand just outside of the frame on camera-right and a small white reflector clamped to a stand camera-left. Exposure: ISO 4000, f/5.6, 1/160 second.

You have to set each flash's power output individually when working with your speedlights in full Manual mode. It may take some getting used to, but it does offer the photographer the greatest amount of creative control especially in multiflash setups.

Using wireless Manual flash

Going off of TTL mode into manual land is not as scary as it sounds. Sure, photographers in the old days had to figure out some guide numbers and set their flashes accordingly. They also had to wait a few days to get their results back from the lab. In that amount of time, camera settings and flash-to-subject distances could be forgotten, replaced by other details in life unless they were written down. Those days are so over. Today, with digital cameras and the ability to review your results on the camera's LCD monitor immediately, more time can be spent shooting than figuring out Manual flash output settings.

Manual flash output works in a different fashion than TTL, because you get to do all the calculations and check the results on your camera's LCD monitor. For most wireless flash shooting situations, I usually start in the middle of the power output range such as 1/16, 1/8, and so on. I always check the camera's LCD monitor to gauge my results and fine-tune the speedlight's output until I get just the right amount of light. I may move the flash closer or farther away from my subject, or add a colored gel or some other lighting modifier such as a grid or a snoot. It's all about molding and shaping the light to perform the way you want it to.

To fire your flashes wirelessly you need to use RadioPoppers, PocketWizards, or some other brand of radio control triggers. Whether you're shooting in TTL or Manual flash mode, I encourage you to explore the many lighting options that multiple speedlight flashes triggered wirelessly can offer. For more detailed information on using your brand of speedlights, be sure to check out my *Canon Speedlite System Digital Field Guide, Second Edition* (Wiley, 2010) or the *Nikon Creative Lighting System Digital Field Guide, Second Edition* (Wiley, 2009) by J. Dennis Thomas. For a more comprehensive look at the creative aspects of what speedlights can do, go to Nikon shooter David Hobby's blog at http://strobist.blogspot.com and Canonista Syl Arena's blog at http://pixsylated.com.

6.8 I used two speedlights for this humorous shot of video producer Vernon Vinciguerra having a close encounter of the second kind. I set the shutter speed to expose for the background and placed a speedlight on a stand with a blue gel camera-left while my assistant Dave held a boom connected to another speedlight directly over his head for the flying saucer effect. Both speedlights were set in Manual mode and fired by PocketWizards. Exposure: ISO 400, f/4, 1/100 second.

Using stroboscopic flash

If you own one of today's high-end speedlights such as the Canon 550/580EX/EX II or the Nikon SB-800/900, your flash is capable of shooting stroboscopic flash pictures. In Stroboscopic Flash mode, a series of flashes are fired continuously within a single

exposure. Canon calls this feature Multi mode while Nikon calls it Repeating Flash (RPT) mode. Stroboscopic flash is easy to set up and fun to use for dancing or action shots and it surprises me that more photographers, myself included, don't explore this speedlight mode more often.

Before you use Stroboscopic Flash mode, set the flash power output, the frequency of the flashes (expressed in Hz), and the number of flashes. After you set these three variables, you need to set the exposure for the aperture by using the guide number table in your flash's manual, checking an external light meter, or just experimenting. All that's left is to set the shutter speed by using the following formula.

To find the proper shutter speed for your photograph, you simply take the number of flashes and divide it by the frequency number you have selected. If you selected 10 flashes at a frequency of 5 Hz, you need a shutter speed of at least 2 seconds or slower. Start with these settings and adjust the number of flashes and the frequency to suit your tastes. A higher frequency means the flash fires faster. It helps if you shoot into a darker background, and you can always use your camera's Bulb setting and a remote switch to give you some more leeway in getting the time of the exposure just right.

Setting flash exposure compensation

Flash exposure compensation is much like auto exposure compensation in that you can set compensation for the flash exposure up to 3 stops +/-, in 1/3-stop increments. A positive compensation setting increases the flash output and a negative compensation reduces it. Flash exposure compensation can help reduce

6.9 Using a speedlight set to Stroboscopic Flash mode off to the side and a camera on a tripod, I dropped a baseball to make multiple exposures in one frame. Because the actual exposure was only determined by the flash, I turned all the lights off in the studio and used a 10-second exposure to give me enough time to drop the ball and fire the flash. Exposure: Flash at 50 Hz, ISO 100, f/8, 10 seconds.

shadows in the background, balance unevenly lit scenes, and produce natural-looking images. Generally, you can set compensation on either the camera or the flash, or both.

Flash exposure compensation can be very helpful when shooting subjects against very bright or very dark backgrounds. For the most part, smart TTL mode on the flash gives you great results, but it can sometimes get confused if you are changing the scenes quickly or shooting continuously and moving the camera around a lot. I often use flash exposure compensation to drop the power output of the flash by -1 or -2 to more evenly match the ambient light levels when shooting with flash outdoors. I really don't want the flash to match the ambient light levels but rather have it assist in opening up the shadows and adding some fill.

Using Speedlights with Remotes

There is perhaps no more fun in flash photography than when you use multiple wireless speedlights to create stunning photographs with uber-cool lighting effects. Whether using several speedlights with wireless TTL transmitters, or using full Manual flash mode, you can create lighting setups in minutes and add light modifiers and gels depending on the subject and the mood you're trying to create.

6.10 Two speedlights in TTL mode triggered wirelessly by RadioPoppers were used to make this shot of Rhonda and Aaron. Even with a green gel on the secondary speedlight, TTL technology figured out the exposure, and all I had to do was shoot. Exposure: ISO 100, f/4, 1/160 second.

Speedlights employ a line-of-sight infrared blink of light to operate the remote flashes, so getting a good connection between the transmitters and the flashes is critical. In a closed environment indoors such as a studio where the signal can bounce off of walls, ceilings, and floors, the performance is usually pretty good. But take them outside on a bright and sunny day and they barely operate reliably. That's because they use light to operate and when the ambient light levels are too high, the transmitters and remotes can't "see" each other. Because of these limitations, several third-party manufacturers have provided radio signal transmitters and receivers that use your camera system's signal or interpret it to fire your speedlights. Two of the most popular styles of these types of radio remotes are PocketWizards and RadioPoppers.

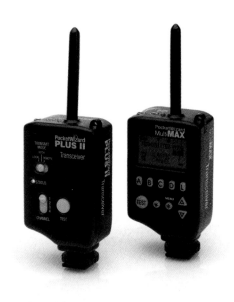

6.11 The PocketWizards Plus II and MultiMAX units are compact and feature rock-solid electronics to fire speedlights and cameras.

PocketWizards

Although there are any number of remote triggers you could find inexpensively on eBay to use with your speedlights or fire your cameras, the PocketWizard brand has earned a reputation for reliability and outstanding range. PocketWizards have a very generous 1600-foot range of use, fast sync speeds, locking shoe mounts, and a fast FPS rating, up to 12 frames per second on capable cameras. They also include red status ready and connect LEDs that let you know they are communicating successfully.

Because of their widespread popularity, PocketWizards come with several channel settings to dedicate your remote camera and flash triggering to different channels and to prevent triggering the flashes or cameras of other photographers who might be using the same system close by. These channel settings have no relation to the same numbered channels on your speedlights.

PocketWizard Plus II transceivers are the easiest to use and the least expensive of the PocketWizard lineup. They are called transceivers because they both transmit and receive radio signals so you can use them from the camera or remotely to fire your flashes. Plus IIs also include a Mode switch, which allows you three distinct settings: Local (fires only the flash connected directly to the PocketWizard), Remote (fires only the remote flash connected to a PocketWizard), or Both, which fires both the Local and Remote flashes together. With Plus IIs, you can set up different speedlights on the individual channels to fire separately, or you can set them to the same channel to have them fire simultaneously.

MultiMAX transceivers are far more sophisticated. They offer a range of 32 frequency channels and much more timing and firing control. They also sport a Quad-Zone Triggering mode that allows you to fire four different flashes either separately, together, or in any combination of the four. I especially love this feature when shooting a wedding reception or speaking event where I place speedlights around the room to provide as many looks to the light as I can. I can even assign a remote camera to one of the four channels and fire it along with the other flashes.

The latest MultiMAX units include a USB connection for upgrading the firmware by using free companion software called PocketWizard Utility that automatically connects to the Internet to look for upgrades when you plug it into your computer's USB port.

The latest PocketWizard incarnations are the MiniTT1 and FlexTT5, along with the new AC3 Zone Controller, which allow full use of your camera system's smart TTL features that photographers have been clamoring for since PocketWizards debuted. The TT5 is powered by two AA batteries and the TT1 uses a CR2450 coin cell. The AC3 requires no battery and piggybacks to the MiniTT1 transmitter's hot shoe for greater fine-tuning of the light output between multiple TTL flashes. With the new ControlTL software platform, used to upgrade the unit's firmware or customize specific settings, these new TTL-capable radio slaves make taking off-camera flash photos as easy as slide in, turn on, and shoot.

The new models include HyperSync, which allows the fastest sync speed over wireless radio devices, and even faster shooting rates than the camera manufacturers' proprietary wireless systems.

The new TTL system includes 52 wireless channels, including 20 ControlTL channels designed to transmit speedlight control signals and 32 channels that are the same as

earlier PocketWizard units and are now called Standard channels. ControlTL supports both Canon (E-TTL II) and Nikon (i-TTL) wireless remote flash systems, including the sending of the flash control commands over radio signals for longer range and improved firing reliability.

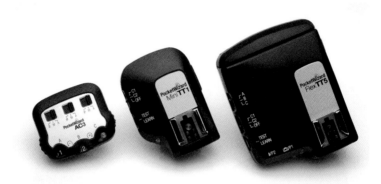

6.12 The new TTL system from PocketWizard is designed to work with Canon and soon Nikon wireless TTL flash systems. Pictured here is the AC3 Zone controller (left), the MiniTT1 transmitter (middle), and the FlexTT5 receiver (right).

PocketWizard has released the AC3 Zone controller to rave reviews and when writing this book I was fortunate to try one out in beta condition. The AC3 connects to the MiniTT1's top hot shoe to provide up to six stops of lighting control in TTL or Manual flash modes. The AC3 has three switches and three control wheels, where the switch controls the operating mode for that zone and the corresponding wheel controls the flash exposure compensation or manual power level, depending on the operating mode selected. The beauty of working with the AC3 Zone controller is that it allows the photographer to make quick remote speedlight setting adjustments wirelessly right from the camera without having to walk around to each individual light unit.

RadioPoppers

RadioPoppers became a reality in 2007 when Arizona wedding photographer Kevin King sought to provide a better way to add reliability to his line-of-sight wireless flash system. He set out to find a way to fire his speedlights wirelessly, yet still retain all the effectiveness of using TTL, groups, ratios, and high-speed sync. The RadioPopper

lineup has grown over the last few years with several new products that allow you to utilize every feature and function on your speedlight.

When set to slave or remote modes, your speedlights need to be able to "see" the master or commander units in a direct line of sight in order to process the smart TTL signals and operate the flashes properly. This can be a real challenge when there are doorways, people, or other objects in the way of this communication. The infrared light from your speedlight only travels in a straight line, but it can bounce around and work when shooting in a confined space. Using radio signals to communicate between the camera and flashes is a better solution because they are omnidirectional and don't need to be directly in line with each other to operate. Enter RadioPoppers.

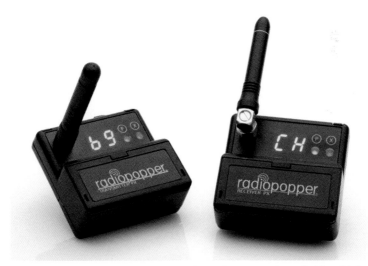

6.13 The RadioPopper system consists of a transmitter (left), which connects to a camera-mounted flash or your speedlight system's proprietary transmitter, and the receiver (right), which connects to your speedlight with a handy bracket that comes with the receiver.

RadioPoppers use an inventive method of converting the optical signal from your master unit to communicate with your remote speedlights and are lightweight and extremely convenient to use. The RadioPopper transmitter sits on top of your master flash or optical system transmitter and instantaneously senses and converts the unit's TTL, group, and ratio instructions into a radio signal. It then sends the signal to the receiver connected to the speedlights, which decodes the information back to an optical

113

signal and fires the flash. The speed at which all of this happens is mind boggling and the communication between the units is extremely accurate.

The RadioPopper line of wireless remote transmitters and receivers for your speed-lights are a pleasure to work with and incredibly reliable. Along with the RadioPopper transmitter you can control all your remote speedlights right from camera using your remote flashes set as slaves. RadioPoppers are reliable, have outstanding working distance, and each runs on two AAA batteries.

Unlike PocketWizards, RadioPoppers can only be used to trigger flashes and have no function to fire remote cameras. This is only a concern to photographers who require both functions in their everyday work. I use both systems depending on the require-ments of the shooting situation or location I'm working in or how involved my lighting setup needs to be. My speedlight's TTL system now has expanded workability, allowing me to place remote flashes around corners or behind walls yet still retaining all my flash systems features. RadioPoppers and PocketWizards are the cream of the crop when it comes to wireless triggering of flashes, and I would not head out for an assignment without either one of them.

Speedlight Accessories

One way to really tailor the light from your speedlights the way you want it is to add some accessories designed specifically for your model flash. The Internet abounds with videos and tuto-rials about how to make your own accessories for your specific flashes, and this is fine if you have the time and the inclination. Alternatively, there are readily available accessories for your speedlight that can help you get better light from your flash and more

6.14 The Sto-Fen pop-on diffuser is convenient to use and creates great soft light. Be sure to get the one that fits your model flash.

professional results. The following is by no means a complete list of all the accessories available but rather some products and tools I have found useful in many picture-taking situations when using flash to light subjects.

The first accessory you might consider using is the Sto-Fen model pop-on diffuser for your particular flash. The Sto-Fen diffuser is a piece of custom-molded frosted plastic that covers the flash head and extends beyond the lip of your flash by about 3/4 inches. It softens and scatters the light and pro-

6.15 An off-camera shoe cord such as the Nikon SC-28 pictured here allows you to move your flash off-camera yet still retain all your camera system's advanced TTL and high-speed sync capabilities.

vides better skin tones. Softer light is much better to shoot portraits in. Nikon offers their own version for their flashes, which accomplishes the same effect. If you need to use gels, particularly CTO or green, Sto-Fen makes them in orange and green as well, so that you don't have to tape a gel on before using the standard frosted Sto-Fen model; just put the colored one on instead.

You may want to consider the TTL off-camera shoe cord for your particular brand of camera. This is the easiest way to get your flash off the camera for more directional, dramatic lighting to portraits products and scenes. These proprietary cords retain all the advanced TTL functionality of your cameras and speedlights and can be ganged up for even greater distance. You can also use a flash bracket that has a rotating platform for the camera with the off-camera shoe cord to keep the flash above the camera whether shooting horizontals or verticals. These cords are a great solution to getting your flash off of the camera until you can afford a speedlight transmitter or radio slave system.

Professional travel, fashion, and music event photographer David Honl of Honl Photo has created the Professional Speed System, a collection of lightweight, durable, and affordable lighting modifiers for shoe-mount flashes. He is always introducing new prod-ucts to make the location speedlighter's job that much easier.

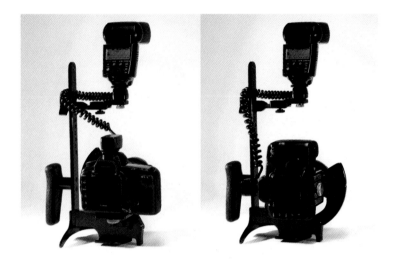

6.16 A flash bracket with a rotating platform for the camera keeps the flash centered over the lens whether you are shooting in a horizontal or vertical format. This one is manufactured by Custom Brackets (www.custombrackets.com), but equally satisfactory flash brackets are made by Stroboframe and marketed by the filter company Tiffen (www.tiffen.com).

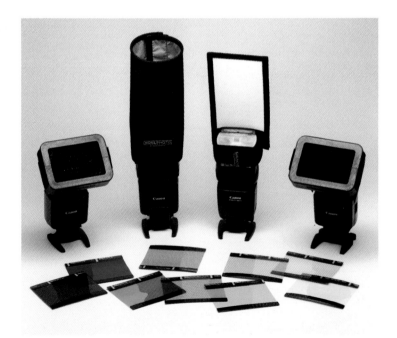

6.17 The Honl Professional Speed System includes gels, grids, a snoot, and a bounce card reflector all based on the Speed Strap mounting design.

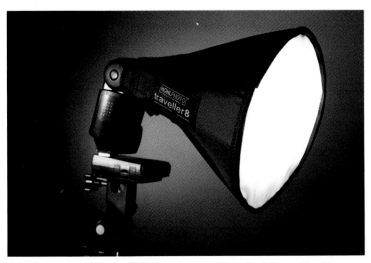

6.18 Recently introduced, the Honl Photo Traveller8 is an 8-inch collapsible softbox in a round configuration that produces an exceptional quality of light and pleasing round catchlights in the eyes.

Designed to universally fit all shoe-mount speedlights, these versatile accessories from Honl Photo provide photographers with an assortment of practical tools to shape, mold, bend, and color the light.

The Honl Speed System consists of an assortment of grids, snoots, gobos, and gels that attach quickly and easily to any shoe-mount flash via the Speed Strap, a simple, nonslip Velcro strap that wraps around the flash head without the use of annoying adhesives. The Speed System allows you to use

6.19 I took this portrait of my assistant Aaron using a speedlight fitted with the new Traveller8 collapsible softbox. Another speedlight with a blue gel and a ¼-inch grid attachment adds visual interest to the background.

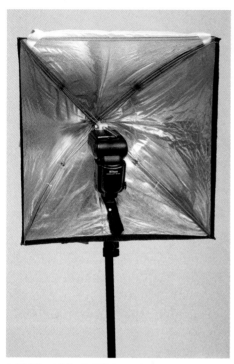

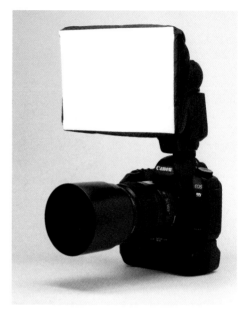

6.21 The Micro Apollo softbox attaches to your speedlight via Velcro strips or the Honl Speed Strap, reduces red eye, and softens the light by expanding the surface area of the flash to make the light source larger.

6.20 The 16-inch Mini Apollo softbox attaches to an umbrella bracket that connects to your light stand. Shown here with the softbox front panel removed and a speedlight mounted, you can rotate the head and fire the flash into the back of the softbox to further soften the light.

studio-style lighting controls in the studio or on location. They are lightweight, take up very little room in your gear bag, and are easy to use. The Traveller8 softbox was created to provide a collapsible, round softbox that provides an exceptional quality of light and pleasing round catchlights in the eyes. You can find out more about the complete line of accessories available for your flash at www.honlphoto.com.

Lighting equipment manufacturer F.J. Westcott markets a special Speedlight Kit, which is sure to raise the quality of the lighting from your speedlights. The Mini and Micro Apollo softboxes are great for creating beautiful, soft light. I use the Micro

Apollo softbox for camera-mounted flash to reduce red-eye and soften the light when I want to stay mobile for quick-shooting events and the Mini Apollo when I want to take the time to set up the stand and a wireless remote flash.

I have also had great success using light shaping tools from LumiQuest (www. lumiquest.com) and photographer Gary Fong's Lightsphere products (www.garyfong store.com) when shooting weddings, parties, and social events because they modify the light from the speedlight to provide a soft, studio quality of light on location.

In addition to these accessories, traditional studio lighting modifiers can be adapted for speedlight use and specially designed versions for speedlights are available from a number of sources on the Internet. These items and more are described in greater detail in Chapter 7.

Close-up Photography with Speedlights

Although any speedlight could actually be used with macro lenses for successful close-up photography, many photographers who are serious about this type of work opt for special flashes designed specifically for that purpose. These include twin light flash arrangements and ring flashes.

Both Nikon and Canon offer twin light flashes for close-up work. These

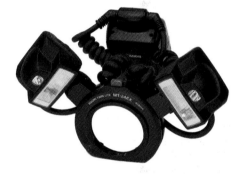

6.22 Specially designed speedlights for close-up photography include a twin light flash setup for close-up macro work. Each of these flashes mounts to a ring on the front of your lens or filter threads via an adapter to bring the flash unit close to your subject and produce beautiful, soft light.

speedlights attach to the lens of the dSLR and are positionable to a certain degree, to light both the subject and the background. Full TTL and ratio control are available with both units. Canon users can choose from the MT-24EX Macro Twin Lite Ringlite Flash or the MR-14EX TTL Macro Ring Lite Flash, and Nikon shooters have the R1C1 Wireless Close-Up Speedlight Flash that uses an SU-800 Commander transmitter unit or the camera's pop-up flash to operate the flash with full iTTL control. All units include a built-in

modeling/focus light that allows for proper positioning of the speedlights on the subject and aids the autofocus system in low-light situations.

If you are interested in using flash for your macro, micro, and close-up photography, I encourage you to check online for a wide array of third-party ring flashes and adapters. Two of the more popular versions of adapters to make any speedlight a ring flash are the Orbis Ring Flash (www.orbisflash. com) and the ExpoImaging Ray Flash (www.ray-flash.com). These two units

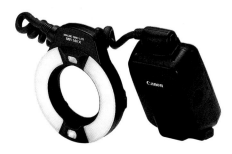

Photo courtesy Canon, Inc.

6.23 Ring flash speedlights attach to the lens or filter threads via a special adapter and include modeling/focus assist lamps to illuminate the subject for positioning and close focusing.

can be attached to any speedlight you may already own and offer shooting versatility and a conveniently efficient light source for photographing extremely small subjects.

Lighting Equipment

As you become more adept at reading and seeing light, you can create beautiful qualities of light whenever you want. Several tools and light modifiers exist to help you reach that goal. They allow you to manage the light, bend and shape it, change the quality or color, or soften or diffuse it so you can get the exact light you need to realize your vision for the shot. This chapter describes the tools you need when setting up a small home studio for portraits and products or creating a go-anywhere flash lighting kit. Some of these items may already be familiar to you, and if you have ever had a professional portrait taken in a studio you may recognize some of them from the photo session. You can make many of these tools yourself in some fashion or another and the Internet abounds with information to help you.

Shot in the studio for wildlife artist Ryan Wilhite, this image of a bronze bull elk sculpture utilizes several light-modifying tools, such as grids, gels, and softboxes to achieve the desired effect. Exposure: ISO 100, f/9, 1/100 second.

Light Modifiers

Light modifiers refer to anything that molds, bends, shapes, diffuses, colors, or reflects light. Studio pros and film crews have been using these tools forever to make light do what they want, when they want. When filming a movie, you can't wait for a sunny day, you have to create it. Light modifiers do just that.

The light modifiers described in this chapter are easily available and work for studio flash, monolights, and small flash speedlights, and for that reason come in many sizes. Several can be adapted to work with each type of flash. The following sections look at several types of these tools that help dial in the light you use to make your images.

Umbrellas

Photographic umbrellas are probably the easiest light modifiers to use and are often the first choice for photographers looking to improve the quality of their light. In fact, umbrellas come with nearly every lighting kit assembled by manufacturers, unlike softboxes or other lighting modifiers. They come in many sizes and operate just like their rain-shielding cousins. A photography umbrella is simply a regular umbrella with a reflective or translucent covering. You find any number of commercially available brackets to marry your flash, umbrella, and stand together for a relatively affordable price.

Typically, depending on the type of umbrella you're using, you set the umbrella to the left or right of the subject you are photographing, aim your flash unit into it, and point the open side directly at the subject. Moving the umbrella closer to the light source by shortening the umbrella shaft amplifies and narrows the light source, while moving it away spreads the light over a greater surface area of the umbrella and thereby softens it. Multiple umbrellas can be used to provide broader lighting coverage for larger groups.

7.1 A stand-mounted 45-inch convertible umbrella attached to an Alien Bees monolight flash

The three main types of umbrellas to choose from are:

▶ **Standard.** The most common type of umbrella has a black outside covering to trap any light spilling out from the back of the umbrella with an inside surface coated with a reflective material that is usually colored white, silver, or gold. These are designed so that you point the flash into the umbrella and bounce the light back onto the subject, resulting in a soft, diffused light source.

▶ **Shoot-through.** Other types of umbrellas are manufactured out of a translucent nylon material that enables you to fire your flash through the umbrella, producing a quality of light much like that of a softbox. You can also use this type of umbrella to bounce the light back onto your subject.

▶ **Convertible.** This umbrella has a white, silver, or gold lining on the inside and a removable black cover on the outside. You can use these umbrellas to bounce light or the white version can be used as a shoot-through when the outside covering is removed. This is probably the most economical type to purchase when you consider it's like getting two umbrellas in one.

Photographic umbrellas come in various sizes usually ranging from 25 inches all the way up to 12½ feet. The size you use depends on your lights, the size of the subject, and the degree of coverage you want. For standard headshots, portraits, and small to medium products, umbrellas ranging from 25 inches to about 40 inches supply plenty of coverage. For full-length portraits and larger products, a 45- to 72-inch umbrella is generally recommended. If you're photographing groups of people or especially large products, you may need to go beyond the 72-inch umbrella or add a second light with an umbrella of the same size.

The larger the umbrella, the softer the light falling on the subject is. Generally, the small to medium umbrellas lose about 1½ to 2 stops of light over straight-on flash. Larger umbrellas generally lose 2 or more stops of light because the light is spread out over a larger area. Smaller umbrellas tend to have a much more directional light than do larger umbrellas. With all umbrellas, the closer the umbrella is to the subject the softer the light is.

If you are just getting started with light modifiers, umbrellas are the way to go. They fold up nice and small, are simple to use, are relatively inexpensive, and attach to the light stand with a small bracket available at any photography store for usually around $30.

Choosing the right umbrella is a matter of personal preference. Some criteria to keep in mind when choosing your umbrella include the type, size, and ease of transport. Just remember standard and convertible umbrellas return more light to the subject when bounced. On the other hand, shoot-through umbrellas lose more light through the back when bouncing, but are generally more affordable than convertible umbrellas and produce beautiful light.

Softboxes

As with umbrellas, softboxes are used to diffuse and soften light from a strobe unit to create a more natural rendering of faces, products, and still lifes. Softboxes range in size from small 6-inch boxes that you mount directly onto a speedlight flash to large boxes that usually mount directly to a studio strobe. Softboxes come in a variety of shapes, too — anywhere from large, rectangular-shaped softboxes to very skinny strip banks that produce thin highlights and very directional light, to square and even octagonal boxes.

Once you decide to use flash off-camera for better light, you need some place to put it and some way to modify the output quality. You might consider a medium-size softbox that is mounted, along with a flash, onto a suitable light stand. For a medium-size softbox, you need a sturdier stand to prevent the lighting setup from tipping over, especially outside where even the slightest breeze can send a softbox flying like a kite. F.J. Westcott and Manfrotto manufacture a range of stands that work well, set up easily, and are lightweight and highly portable.

Softboxes provide a more directional and controllable light than umbrellas do and are usually more efficient, meaning they contain the light with less spill. Softboxes are usually closed around the light source with Velcro tabs thereby eliminating unwanted

7.2 A stand-mounted Photoflex Half Dome strip bank softbox attached to an Alien Bees monolight flash

light from bouncing back toward the camera. The diffusion material on the front of the softbox evens out the light and affords less of a chance of creating hotspots on your subject. A *hotspot* is an overly bright spot on your subject usually caused by bright or uneven lighting. Many softboxes also include a removable baffle of diffusion material inside to further soften the light emitted.

A few softboxes also offer versatility in the way the front panel attaches to the softbox and permits the photographer to control the spill rate of the light. A large Velcro strip on the front edge of the softbox allows mounting the front panel flush or recessed. Flush mounting creates a gradual fall-off to the light while recessed mounting tightens up the edge of light.

7.3 This photo shows the different ways of mounting the front diffusion panel on some softboxes, recessed mounting on the left and flush mounting on the right.

Softboxes are generally made for use with larger studio strobes. They attach to these strobes with a device called a *speedring*. A speedring is specific to the brand and model of lights to which they are meant to attach. Speedrings allow you to rotate the softbox while it's attached to the light source.

Softboxes for studio lighting come in a variety of sizes ranging from squares to rectangles to strip banks. Most photographers use standard square or rectangular softboxes. As with umbrellas, the size of the softbox you need to use is dependent on the subjects you plan on photographing. Softboxes can be taken apart and folded up pretty conveniently — many of them come with storage bags that you can use to transport them.

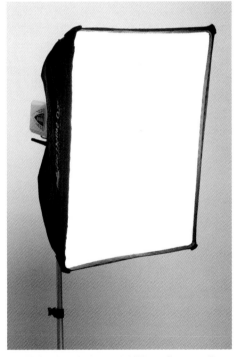

7.4 This stand-mounted Photoflex medium softbox shows the flush-mounted front panel attached to an Alien Bees monolight flash.

125

Octagonal softboxes

Gaining in popularity recently is the octagonal softbox, named for its somewhat circular eight-sided construction. The largest studio units often contain an elaborate mounting system, but most use the same speedrings as softboxes.

The ones that work well for monolights and small speedlights utilize an umbrella-type system with a closed back to contain the light and add to the efficiency of the flash unit.

These octagonal light modifiers mount to speedrings or to a stand the same way an umbrella does and they generate a wraparound quality of lighting. They usually come in sizes larger than softboxes to create soft light over very large areas. Many photographers regard the octagonal softbox very highly for its large wraparound quality of soft light and for the way it produces pleasing round catchlights in the eyes.

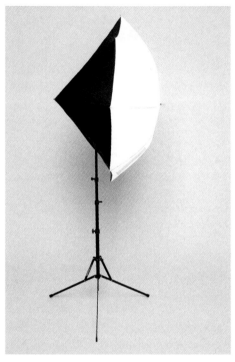

7.5 A stand-mounted Halo octagonal softbox from F.J. Westcott

Beauty dishes

A beauty dish is a type of light modifier gaining in popularity lately that provides a soft, flattering light for portraits and products as a distinctive alternative to the widely used softboxes.

A beauty dish is a large, wide, round reflector that is mounted directly to the flash head and includes an internal light baffle and often an optional diffusion cover. The light from the strobe strikes the internal baffle first then is deflected into the dish which then directs it toward the subject. It creates a somewhat directional, concentrated

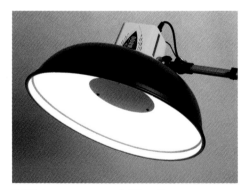

7.6 A boom-mounted Alien Bees monolight connected to a beauty dish

source of light, but very even, without the bright hotspot in the center, normally produced by standard reflectors.

Some beauty dishes come with a diffusion cover that secures them to the main dish and inside, a shield over the light source to diffuse the direct light from the flash. Beauty dishes are often used to shoot glamour-type portraits. One of the main benefits, other than the quality of light they produce, is that they create very appealing, perfectly round catchlights in the eyes.

Ring lights

Another type of flash is called a ring light or ring flash, which has a circular construction that includes a hole in the center to place the camera lens through. This produces a wraparound type of lighting. Ring lights were originally created to produce even lighting for close-up dental photography. They have since become available in a range of sizes and a ring light attachment is even available for your speedlight.

7.7 An Alien Bees ABR-800 studio ring light with modeling bulbs turned on. In the very center, the camera lens can be seen in the opening.

Photographers choose a ring light for its ability to provide even illumination across the subject with a minimum of shadows. Because the flash is all around the lens, all the shadows are filled in and the ring light is said to produce *shadowless lighting* unless the subject is fairly close to the background. In this case, the ring light produces a soft shadow around the subject on the background.

Because the lens is very close to the subject in macro photography, the size of the ring light has a considerable effect on the lighting of the subject. By appearing very large compared to the size of the subject, the light produced by the ring flash will strike the subject from many angles and thereby fill in and soften any shadows that may be present.

The ring flash enjoys wide popularity in portrait, fashion, and wedding photography for the unique effect of the lighting and the soft shadow produced when the ring light is used as the key light source. You can enhance or decrease this effect by moving the portrait subject closer or farther from the background. Ring lights can

also be effectively used as a fill light to subtly open the shadow areas of a portrait when they are powered at 1 to 2 stops under the main or key light in your setup. A popular trend in wedding photography is to set up a ring light at the reception hall with a camera attached to a foot switch to allow guests to take their own pictures, photo-booth style.

Reflectors

Reflectors are specially fitted rings that fit on your flash unit and contain the spill of light, or they can be free-standing panels that kick light back into the side of your subject opposite the main light source to soften and open the shadows on that side. Adding a reflector to your natural-light portraits can quickly raise the quality of lighting on your subjects. They do not kill the shadows completely, but merely add light to the shadowed areas to provide more information and detail.

Commercial-quality reflectors have been available for years, but you don't need a store-bought reflector to make good light. A reflector can be almost anything that is white, silver, gold, or colored that bounces light back into your photo with the intent of opening the shadow areas and lowering contrast. For years, I used simple, white Foamcore panels from an art supply store that were durable, lightweight, and sturdy. Over time, when these started looking shabby from use but still performed well, I replaced them with professional ones.

Several versions are well suited to location work. Many suppliers manufacture systems that include a reflective material stretched around a shock-corded PVC pipe frame that folds up for easy transport. With a short trip to a home improvement store and a fabric store you can easily make your own with a hacksaw and a sewing machine. Common sizes are 4 feet × 4 feet, 4 feet × 6 feet, and 4 feet × 8 feet.

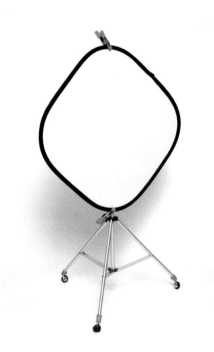

7.8 Commercial-grade collapsible reflectors are easy to set up and transport and are a great complement to natural light or studio flash. They come in white, silver, and gold. The one shown here is connected to a studio stand.

Another style that is great for location work, portraits, and small products is called a collapsible or pop-open reflector. These consist of reflective material that is white, silver, or gold and stretches around a spring steel frame that collapses to a quarter of its size. There are also many versions that include materials in kit form to convert the reflector to a gobo or diffusion panel or to change the type of reflector color you wish to use to silver, white, or gold. They may take a little wrestling around with when you first open them to figure out how to get them back in their cases, but once you do, it's pretty easy from then on. White produces the softest light, silver adds more specularity and a slightly harder edge, and gold adds pleasing warmth to the shadowed areas of the subject.

The opposite of a reflector is a flag: something that blocks light from hitting an area of the photo, the subject, or the face of the lens. They can be made from any opaque material that will not allow light to pass through it. Barndoors are another type of flag that connects directly to the light source and includes four adjustable panels to tailor the light to fall just where you want it to and keep it off of areas you don't want illuminated.

Diffusers

A diffuser can be anything that breaks up spectral light rays and scatters them into different lengths and different directions. Diffusers produce softer lighting effects, less contrast, and greater falloff, which is the transition line between highlights, diffused highlights, and shadows. Clouds are natural diffusers when they float between you and the sun. You notice softer light on cloudy days, weakly defined shadows, and far less contrast than on bright sunny days.

Other types of diffusers are panel type or collapsible, similar in construction to the reflectors described previously. When shooting outdoor portraits, I often use a collapsible 42-inch diffuser from Photoflex to soften and even out the mottled light pattern that comes through trees. I might also set it up on a stand and fire a flash through it when I need a broad light source. A reflector can also be used to fire your flash into to spread and soften the light. When you're locked into using uncooperative natural light, a diffuser can be your best friend.

A homemade diffusion panel is basically a frame made out of PVC pipe with a reflective or translucent material stretched over it. You can run a ¼-inch bungee cord through the pipe to keep all the pieces together, just like the professional ones. Because the PVC frame can be disassembled easily and packed away into a small bag for storage or for transportation to and from the location, it makes it a handy addition to the portable studio.

Commercial diffusion panels are usually 4, 6, or 8 feet tall and have a base that allows them to stand up without a light stand. The diffusion panel is placed in front of your light source, most commonly the sun or a flash unit. With flash, you can move the light source closer to the diffusion panel for more directional light or farther away for a softer and more even light. For a full-length portrait, I often place two flash units behind the panel, evenly spaced near the top and bottom of the panel. If you are shooting outdoors, you can use the diffusion panel as a "cloud" to soften the light. This is a great technique to use in bright sunlight or in mottled lighting, such as under a tree, to even out the light between the highlight and shadowed areas.

A diffusion panel can also work as a reflector when used in conjunction with another light source. Diffusion panels can be purchased at most major camera stores at a fraction of the price of a good softbox, but it's just as easy to make your own.

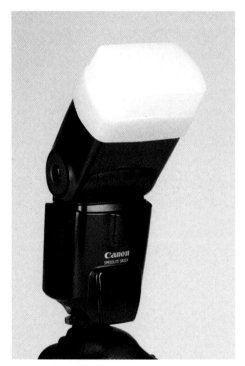

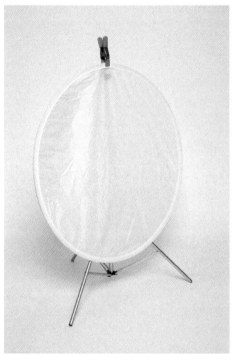

7.9 The Sto-Fen pop-on diffuser. Be sure to get the one specific to the model of your flash.

7.10 A stand-mounted 42-inch collapsible diffuser from Photoflex. These units are sometimes interchangeable with reflectors and can do wonders outdoors in terrible light and create beautiful studio-quality lighting almost anywhere.

Gels

If you have been to any type of stage, music, or theater production, you have seen colored gels in action. Colored gels are thin, transparent pieces of polycarbonate or polyester that are attached in front of the light source and are used to either color the light for dramatic effect or to color correct the light from the flash to match the ambient light.

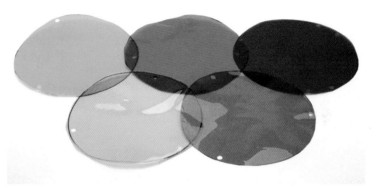

7.11 Gels come in a wide array of colors and sizes. Colored sheets can be cut to the size you need.

Gels are used in photography for two main reasons: for color correcting the light output of your flash to match the ambient light temperature, or adding colored gels to spice up the scene or background of the photo. Adding gels to the flash cuts light transmission depending on their strength, so you should be sure to apply them to your light sources before taking exposure readings.

You can find sheets of gel material in specific colors in most theatrical supply houses and pro camera shops. Top manufacturers include Lee, Rosco, and Honl Photo.

Grids and snoots

Grids are metal or plastic devices that are placed between the light source and the subject to direct the light to a specific spot and nowhere else. This adds a spotlight effect to your images that can look very dramatic. Grids come in a variety of sizes, measured by degrees, and are usually honeycombed or circular in design.

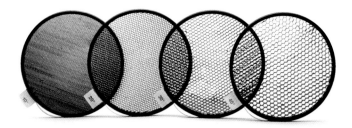

7.12 Grids produce concentrated pools of light in whatever shape they are made, usually round or honeycombed, and fall off very quickly. Different size openings produce different size illumination areas. Shown here are grids in 10-, 20-, 30-, and 40-degree configurations.

Snoots are devices that reduce the light beam to a smaller angle. Usually made of metal, studio flash snoots can add dramatic lighting effects to faces, products, and backgrounds. For small speedlights, almost anything can be used to make a snoot, usually foam or cardboard. I have even seen some pretty good ones made from discarded Pringles cans and mac and cheese boxes. Let your imagination run wild!

You can use snoots and grids in two ways: to make concentrated spots of light and to keep light from falling where you don't want it.

Cookie cutters

A cookie cutter, gobo, (short for "go-between") or cookaloris, is a type of mask that is used to create an abstract pattern on an otherwise plain background. The effect evokes light filtering through lace curtains, light streaming through the leaves on a tree, or a specific pattern. A cookie cutter can be fashioned from any opaque material, usually fabric, cardboard, or a thin piece of plywood. It has random shapes cut out (hence the name) and clamps to another stand to allow you to position it to

7.13 Studio flash snoots are metal and attach to the flash in several ways. This image shows a Bogen/Manfrotto snoot on the left and a Speedotron snoot on the right.

create the background pattern you desire. Moving the cookie cutter in relation to the light source, subject, and background changes the personality of the lighting pattern on the background.

**7.14 A cookie cutter is placed on a stand between the light source —
in this case an Alien Bees monolight — and the background, adding
a distinct patterned look of dappled light to the background.**

When setting up the cookie cutter, the closer it is to the wall, set, or background, and farther it is from the light, the sharper and more defined the shadow is. Moving the cookie cutter away from the subject or background and closer to the light source makes the resulting shadow areas less defined and more abstract.

Flags

Flags are used to control the spill of light, usually to keep light off a certain part of the scene or to prevent light from striking the lens, which can cause diffraction and degrade the contrast of an image. Flags can inexpensively be made from black cardboard or Foamcore board and cut to a convenient and workable size. Several manufacturers include a two- or four-sided device called a barndoor to their lighting product line, which is another type of flag to control the light spilling from the flash unit. Barndoors or flags facilitate shaping of the beam of light from the flash and prevent the distinctive scatter of light created by the light source lens from spilling into areas where it is not wanted.

Backgrounds and Background Stands

I always consider the background to be a very important element in each of the kinds of photos I shoot whether they are portraits, products, events, or macro work. Even in sports photography and photojournalism, the background can often make or break the shot.

Portrait and studio photographers have several options regarding backgrounds for their subjects. You could use a room setting and just throw it way out of focus by using a large f-stop setting. Regardless of how you create it, a simple background to support your portrait is key to keeping the viewer's attention on your subject and making it stand out. Today, backgrounds come in a wide array of colors and materials, and you are only held back by your imagination. The following sections discuss some of the types of available backgrounds and their applications.

Seamless paper backdrops

Seamless backdrops got their name as a way to distinguish them from older canvas or muslin backgrounds that usually included a visible seam in their construction. The most common types of seamless backdrops today are made of paper.

Seamless paper backdrops are inexpensive and come in a wide range of attractive colors. Standard rolls of background paper range in size from 3 feet to 9 feet wide in rolls that are 36 feet long. Twelve-foot-wide rolls are also available in limited colors for those times when you need a large area to shoot a rock band or large group, for example. The great thing about using paper as a background is that when it develops footprints, or gets dirty or scuffed, you can cut that piece off and recycle it or use the other side for smaller still-life shots.

7.15 Seamless paper backgrounds, stands, and cross-members can be transported to and from portrait locations outside the studio to create a studio look anywhere.

It's always best to store your seamless paper backdrops vertically instead of horizontally if you can to avoid them developing a washboard effect over time.

Starting out, it's a good idea to obtain a roll of neutral gray seamless paper. You can use this color for just about any subject without worrying about the color of your subject clashing with the background. White paper is ideal for photographing subjects when you want a very clean look, just like many of the product shots used in this book. A black background is good for making your subject pop so that it appears to be the only thing in the shot, which is often desirable with lifestyle products and jewelry.

To keep your background kit to a manageable size when you travel, it's often more economical to buy larger-size backgrounds and cut them down to the size you need with a hacksaw — your photo store can probably do it for you. This way you can cut down the background to fit a case or bag you're already using for your stands, as long as it provides adequate coverage for your portraits. Lately, I've noticed several photographers using snowboard bags to transport their backgrounds and stands with great success.

TIP When using white, gray, or black seamless backgrounds, I often use gels on a flash head behind the subject, aimed at the backdrop to create a background color. As previously mentioned, gels are pieces of colored polyester that you place over the light source in order to change the color of the light. Theatrical supply houses and pro camera shops usually stock a wide assortment of gel colors.

Muslin backdrops

Muslin is a durable, inexpensive, lightweight cotton material that can be folded, rolled up, or crammed into a stuff sack and still perform well as a background. When used for backdrops, it is usually dyed a few different colors with a mottled pattern to give the background a look of out-of-focus texture. You can purchase muslin at most well-stocked photography stores or online. If you have very specific needs, there are companies that dye muslin fabric to a custom color of your choice.

TIP The Internet abounds with sources and ideas for backgrounds and some top suppliers are Denny Manufacturing (www.dennymfg.com) and Owen's Originals (www.owens-originals.com).

You can drape muslin over your background cross-member or easily tack it to a wall. Muslin is very versatile, and although it's much more suited to portraits, it can sometimes be used successfully for product shots as well.

Canvas backdrops

Canvas backdrops are very heavy duty. They are usually painted with a scene or a mottled color that is lighter in the center and darkens around the edges, which helps the subject stand out from the background. These types of backdrops are almost exclusively used for portraits or still-life photography.

When considering a canvas backdrop, in addition to the weight factor, you should consider the cost, as they are fairly expensive. Although you can get them in lighter-weight, smaller sizes, they cannot be folded and must be rolled up, and you must take care when transporting them. I have several that I purchased years ago from a local artist, but I usually only use them in the studio because of their size.

Background stands

Most background stand kits have three pieces: two identical stands and a convertible crossbar. The crossbar slides into a roll of paper or other backdrop material and is held up by the stands. The crossbar has two mounting holes, one at either end, which slide over a support pin on the top of the stands. The crossbar is usually

7.16 Muslin backgrounds compress to a very small size, making them ideal for location portraiture. This 10 × 20-foot muslin background easily fits into this 8 × 14-inch stuff sack.

7.17 Hand-painted canvas backgrounds create one-of-a-kind portrait looks.

adjustable from 3 to 12½ feet to accommodate the various widths of backdrops. The stands are adjustable in height up to about 10½ feet. Most kits also come with either a carrying case or a bag for maximum portability.

There are varying degrees of quality in background stands, and the sturdier the stand, the more expensive it is. For a portable studio, a decent medium-weight background stand kit suffices. Having a couple of studio set weights or bricks covered with black gaffer's tape secured to the stands helps keep everything rock-solid. You don't want your background stand falling over and possibly injuring your portrait subject.

Light stands

There is no way around it. You want the most stable stand you can find, but you have to be able to move it around quickly and don't want it blowing away in the wind. Plus, it has to fit in your case, alongside the umbrellas, and be lightweight. This is no small order.

Enter the Manfrotto 5001B Nano Retractable Compact Light Stand that is perfect for supporting speedlights on location. Surprisingly strong for such a small size, the stands extend to 6.2 feet and fold down to 19 inches, which makes them easy to fit into a location case like the Think Tank, Lightware, or Tamrac versions that I use.

I may never attach a monolight to one of these stands in the studio, but their light weight makes them perfect for speedlight support and in a pinch I have used them on location with a moonlight taking extra care to weight it down. F.J. Westcott has a Speedlight kit that contains a slightly sturdier stand, the 750 Photo Basics 7' Light Stand that permits the use of a larger softbox or octagonal softbox and can easily handle monolights or studio strobe heads. Whichever one you decide to use, just remember to stake or weigh it down. All that light weight has a downside, too.

Space Considerations

If you are fortunate enough to be able to dedicate a place in your home for your portable studio, you are that much more ahead of the game. Being able to test and retest lighting setups allows you to work smoother and faster once you do have someone sitting in the chair posing for you or have a lot of objects to shoot in a short time.

Depending on the type of photography you plan to do, space considerations often come up fairly quickly in the plan. If you intend to do full-body portraiture including a hair light, you need a good 10 feet of height at a minimum, and less for seated portraits.

A flash setup makes it easy to do tabletop, macro, and still-life photography with a minimal amount of space and can also perform well with larger subjects; but remember, the larger your subject, the larger the background needs to be. Everything expands from the camera's eye proportionally; a four-person rock band can easily require a 12-foot background.

Setting up for indoor shoots

One thing to consider when setting up indoors is finding a space wide enough to accommodate the background and stands. Remember that although your backdrop may only be 6 feet wide, the stands extend 2 or 3 feet beyond that. Next, you want to be sure that you have enough room in front of the background to be able to move back and forth, even with zoom lenses, to enable you to frame your picture the way you want it.

Portraits

When photographing portraits indoors, you want to use lenses with a medium to longer focal length. A lens in the 85-150mm focal-length range is ideal because it compresses the scene slightly and keeps you a comfortable working distance away from the subject but not so far away he or she cannot hear your posing suggestions.

I also like to select an aperture between f/8 and wide open, depending on the intent of the image, in order to throw any distracting details in the subject or the background softly out of focus.

If you use a long focal-length lens to photograph a standard head-and-shoulders portrait, you need at least 15-20 feet or more from one end of the studio to the other. You also need 10 feet between the camera and the subject, 2 or 3 feet behind the camera for you, and anywhere from 3 to 6 feet between the model and the background to be sure the model isn't casting shadows on the backdrop because of your lighting placement.

Be sure the area is wide enough to accommodate both the model and the lights comfortably. You want to have enough width to be able to move the lights closer or farther from the model to fine-tune your light if need be.

Small products

The ideal way to light a small product is to place the main light above and a little behind the product, or on the sides. This simulates a natural light, and creates a

slight rim light that helps separate it from the background. The next step is to note where the shadows are and to fill them in if you feel the need. You can either use an additional flash as a fill light, or you can bounce or reflect light from the main light into the shadow areas. Small, round, and inexpensive makeup mirrors work great in this capacity.

Remember to pay attention to details when you work with small subjects. Dust can take on gargantuan size, and scratches and imperfections in the surface of the object can be highly noticeable. Canned air is great for removing dust from your setup right before you shoot. It also works great on bugs when they sneak on to the set!

For more information on product lighting see Chapter 13.

Setting up for outdoor shoots

Putting together a studio lighting kit ensures that you have beautiful light wherever you go. With the small flash speedlight system, you can bring your lighting gear just about anywhere and never have to worry about plugging in for power. When shooting outdoors, you have none of the space restrictions you have inside. Outdoor shooting is an altogether different ballgame that has its own advantages as well as obstacles that must be overcome.

Using your flash on-camera, you'd likely use the sun as your main light, set the flash for fill light, and shoot. If you use your flash units off-camera with stands and modifiers like umbrellas, softboxes, and octagonal softboxes, you need to set them up as level as you can whenever possible or use weights or stakes to hold them down. When you use a softbox or umbrella, it's also a good idea to be very conscious of the wind. Wind can take the entire assembly and send it flying into the next county. Many photographers purchase used fitness weights at yard sales, wrap them in bubble wrap, run a loop of rope through them, and hook them on the light stand's adjustment knobs, a solution that works well. Protect your gear at all costs and take the necessary precautions.

When shooting outdoors, the same lighting styles and looks I covered previously can be applied, but you still need to pay extra particular attention to the sun's position — where it is now, where it's going, and where it's going to set — and plan accordingly. Different types of sunlight all have different qualities and different color temperatures:

▶ **Bright sunlight.** Bright sunlight can cause serious problems with exposure when using flash. When in bright sunlight, your camera may not be able to select a shutter speed that's higher than your camera's rated flash sync speed if it detects a speedlight is attached. You may need a higher shutter speed to achieve a proper fill-flash exposure even at your smallest aperture.

The way to solve this problem is to move your subject into a more shaded area or utilize High-speed Sync mode if your camera and flash offer it, which enables you to shoot at speeds higher than the normal sync speed of the camera when using speedlights. This is very convenient if you're shooting an outdoor portrait and need to use a wider aperture for less depth of field, which then requires a fast shutter speed. High-speed Sync mode causes the flash to emit a series of lower-power flashes that coincide with the movement of the shutter across the digital sensor. The drawbacks to high-speed sync are that it diminishes the distance range of the small flash and consumes battery power faster. Most manufacturers' High-speed Sync modes can be used all the way up the maximum shutter speed of 1/4000 or 1/8000 second if your camera offers it.

▶ **Cloudy sunlight.** This lighting occurs when it is overcast but you still have slight shadows. This is wonderful light to photograph in, and is comparable to the light from a good softbox. All you may need to do is use your on- or off-camera flash to add a little fill light and a CTO gel to add some warmth.

▶ **Open shade.** Open shade is when your subject is in shade but there is clear light and blue sky overhead. In harsh sunlight, I try to make any shady area work, but the light may be so soft that it has gone dead with poor contrast and bluer light. You now can set your flashes much closer to the range they were designed for.

When using light stands outdoors, having sandbags or fitness weights on hand to prevent the wind from blowing them over is highly recommended. Sandbags are commercially available through photography stores, or you can easily make your own. And you can always find fitness weights at yard sales, right?

Traveling with Your Lighting Equipment

When you decide to start traveling with your lighting gear, your first consideration is getting a durable case for your equipment that protects everything and is still easy to

carry. Your delicate flash units may be compact and built for years of service, but they still need to be properly cared for when packed and transported.

Myriad styles, colors, and sizes await you when you begin to search for the perfect case or bag to store and transport your precious gear. From the simple Domke camera bag that was the staple of photojournalists for many years, gear containers have morphed into fanny packs, backpacks, and gear belts to store every last bit of equipment you need to produce quality photos. You want gear containers to be sturdy and well padded.

The following list outlines a few good resources for quality protection for your gear.

▶ **Lightware.** These folks have for decades been making professional photo gear cases using a variety of lightweight, shock-absorbing materials. Their uber-protective gear bags protect many more times their weight. They also look clean and professional, much better than a cobbled together set of odd camera bags. They can be found at www.lightwareinc.com.

▶ **Think Tank Photo.** This company offers a huge array of smart gear packs, airline cases, bags, and photo accessories for the traveling photojournalist and always comes up with new products. Its Be Ready Before the Moment philosophy inspires airport cases and bags that are especially well received by photographers who need to know their gear is safe, even on extended trips. Think Tank's Web site is www.thinktankphoto.com.

▶ **Pelican cases.** You've seen some version of these cases in nearly every James Bond movie. The company Pelican says its cases are "unbreakable, watertight, airtight, dustproof, chemical resistant, and corrosion-proof." They are built to military specs and are unconditionally guaranteed forever. A standard Pelican case holds two camera bodies, a wide-angle to medium zoom, a telephoto zoom, and two small flashes and all the attachments. It can be found at www.pelican-case.com.

▶ **Shoulder bags.** These are the standard, time-tested camera bags you can find at any camera shop. Materials have changed significantly and the new bags come with user-configurable Velcro dividers and pads. Bags come in a multitude of sizes to fit almost any amount of equipment you can carry. I use Think Tank, Tenba, Tamrac, Domke and Lowepro bags. All three should be easily found in your local camera shop.

► **Backpacks.** Backpack camera bags have grown in popularity, as a new wave of participatory photography has attracted today's image-makers and backpack bags make it that much easier. Many offer laptop carrying capabilities that make it effortless to have everything in one case. The Tenba DB17C backpack that I use can hold two camera bodies, a wide-angle and medium zoom, a 70-200mm telephoto, two speedlights, a battery pack, a 15-inch laptop, and all the plugs, batteries, gels, sync cords, slaves, and other small accessories that go along with my gear.

Action and Sports Photography

Of all the areas of photography, probably no other depends on the decisive moment for its power more than action and sports images. Nothing pleases photographers more than capturing the action at a peak moment with the right camera settings, whether it's at a professional sporting event or their child's Little League game. Sports and action photographers often deal with shooting in somewhat unfamiliar venues with limited access, unflattering lighting, uncooperative subjects, and unpredictable weather. Successful sports and action photography depends on working with the available light of the venue. This chapter provides useful tips, setup considerations, and special equipment ideas to help you get the images you want when shooting fast-breaking sports and action subjects.

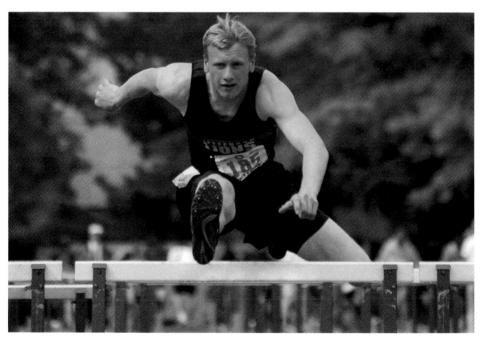

At sporting events I am always on the lookout for uncluttered backgrounds to make the sports hero stand out, often not an easy task. Exposure: ISO 400, f/6.3, 1/1600 second.

Preparation and Considerations

To shoot successful sports and action photographs, choose a background and shooting location that is not distracting and makes the subject the star. The background ideally should complement the action either in color or tonality or be rendered out of focus by aperture selection. Look at the covers of popular sporting magazines, newspapers, and Web sites, and you see how important the background is to those memorable images.

This is not always an easy task. Often there are trash cans, people, or fences in the way that can seriously detract from making your subject stand out. How clean a background is and whether background elements help define and support the subject can make or break sports and action images. A lot of the time, this depends on the access you're allowed at the venue and where you can shoot from, but you can learn where to begin by watching sporting events on television to see where the pros shoot from. They've chosen those positions to give themselves the backgrounds they need while keeping the focus on the sports star and the moment.

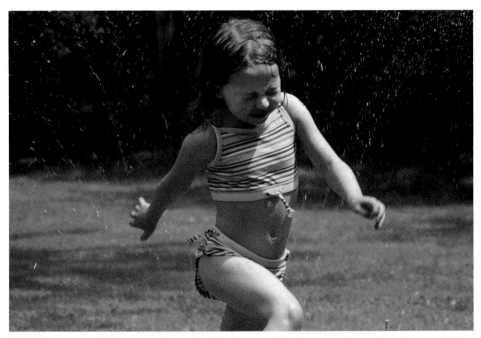

8.1 Flying water droplets against a dark background tell a story of summertime sprinkler fun. Don't overlook the background as a powerful storytelling element in your action photos. Exposure: ISO 200, f/9, 1/320 second.

Once a good working location and background are established, it's time to consider the camera settings to utilize the light you have to work with. Many digital cameras now have presets that include Sports or Scene modes (usually depicted by a running man icon) that are a great place to start when taking action pictures, but you can do a much better job by taking control of all the camera's exposure controls yourself. This preset gives more importance to shutter speed to ensure you get a sharp shot. If your camera or lens includes it, you should also activate your lens's internal stabilizing features, referred to as Image Stabilization (IS) in Canon lenses and Vibration Reduction (VR) in Nikon lenses. This further aids getting tack-sharp images from the day's events. Faces are very important in action and sports pictures and you always want to get them as sharp as possible.

Aside from these features, you can also utilize the shooting technique of panning to further decrease motion blur with your moving subjects. Panning refers to tracking the moving subject with your camera lens as it moves horizontally across your field of view. When done correctly, the subject should be in sharp focus while the motion of the camera blurs the stationary background. This technique is great for showing the illusion of motion in a still photograph or reducing the effect of a busy or cluttered background. While panning, you can also use a slower shutter speed to exaggerate the effect of the background blur. It can be a little difficult to nail sharp images when panning the camera, so plan on shooting lots of images. With more and more practice, your number of keepers rises substantially.

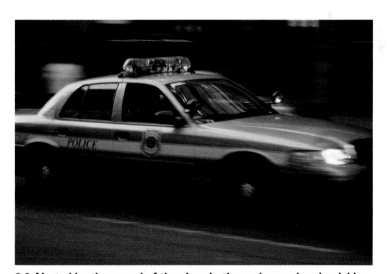

8.2 Alerted by the sound of the siren in the early evening, I quickly made a shutter adjustment, raised the camera to my eye, and panned as the police car screamed past. Exposure: ISO 500, f/5.6, 1/50 second.

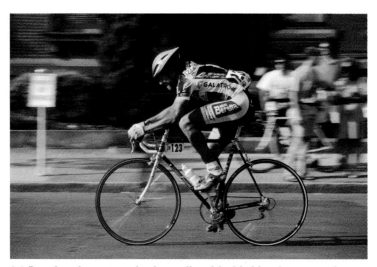

8.3 Panning the camera horizontally with this bicycle racer reduces the distracting effect of the elements in the background and captures the racer in sharp focus. Exposure: ISO 500, f/5.6, 1/50 second.

For many sports photographers, shooting at fast shutter speeds produces incredible images of fast-paced action successfully. Today's digital cameras continue to push the boundaries of technology with fast shutter speeds up to 1/8000 second to capture the shot at the peak of the action. In addition, when you shoot in the camera's Continuous drive mode, you are better positioned to capture the decisive moment of the play or action over several frames. Top-of-the-line pro cameras are renowned for their faster frames-per-second rates, but the latest entry level dSLR cameras deliver anywhere in the neighborhood of 3.5 to 7 frames per second, which is workable for most types of sporting events. By cramming more images into that 1-second time frame, the odds are higher that you get far more images of the peak action.

For anyone who appreciates fast action, shooting sports can be one of the more exciting and rewarding genres of photography. You have certainly seen sports photos that made you stop and simply marvel at human achievement or power or grace. To be able to produce such arresting imagery requires some special access to be sure, but also a certain sensitivity for the sport at hand and an ability to think on your feet while working that peripheral vision, too, to see it all and capture it.

Preparation is the key to capturing the shots you want, images that define the sport, the players, or the moment. Getting close to the action requires access that you need

to set up beforehand by talking with the coaches, officials, or location staff. A friendly smile can go a long way toward getting you where you need to be. Sports are really no different than portraiture in the sense that you want to fill the frame with your subject, which is not an easy task when that subject is engaged in competition or streaking toward the basket, goal, or finish line at top speed.

8.4 An interesting effect occurred in the image when shooting this day-glo red race car behind the catch fence at the Indianapolis Motor Speedway. Panning the camera slightly combined with the brightness of the red paint made the fence almost disappear against the car. Exposure: ISO 100, f/8, 1/250 second.

When deciding what equipment I'm going to bring to a sporting event, my main consideration is mobility so I can quickly get to where I need to be to make the shot. You want to able to relocate to the other side of the court, field, or track when the action moves there.

Here are some general gear suggestions for shooting sports and action events:

► **One or more dSLR camera bodies.** The best-case scenario is having two dSLRs, one fitted with a short zoom or wide-angle lens and another with a telephoto, depending on the event. For most beginning photographers, that might be impractical, but having two cameras allows you to compose a wide range of images quickly and not miss a shot.

▶ **Telephoto zoom lens and extenders.** If you watch sports on TV you see these guys with giant telephoto lenses along the sidelines. They need those big, heavy lenses with large apertures to get close to the action for crisp, clear images. A zoom lens in the 70-300mm range handles most sports when you are shooting some distance away from the action. Closer shots demand bigger glass in the 400-600mm range. Extenders or teleconverters specific to your brand of camera can increase or even double the length of your zoom lens, but this comes at a price. You lose a stop or two of light and a small amount of sharpness in the final image.

▶ **Tripod and monopod.** When shooting still images, having a lightweight but sturdy tripod is indispensable, particularly when you're shooting in low light. In addition, a versatile ball head with a sturdy quick-release plate allows you to remove the camera quickly to take shots you don't need a tripod for. A monopod is really great for supporting the weight of a big telephoto lens and a necessity when shooting sideline sports because tripods are usually not allowed. Although a monopod does not replace a tripod in making the camera rock solid, it does provide a high level of mobility and a reasonably stable shooting platform.

▶ **Waterproof case or other camera protection.** A large majority of sports and action photos I take are in outdoor locations, often in uncooperative weather. I make sure to keep my camera dry and dust free at all times. That means changing lenses in dust-free environments, using rain protection, and keeping equipment in gear bags when not in use. For certain events, where dust or moisture could be an issue, such as motorsports, beach volleyball, or surfing, be sure to also have lens cleaner, a towel, or cleaning cloths handy. Pelican (www.pelican-case.com) makes a full line of waterproof cases for photography equipment, and StormJacket (www.stormjacket.com) makes waterproof camera and lens covers for shooting in inclement weather that come in several sizes and colors.

▶ **Memory cards sufficient for the duration.** The number of memory cards that you carry depends on how many images you typically shoot and the length of the event. It is very easy to shoot over a hundred photos at my daughter's soccer games and I don't want to run out of storage space and miss getting shots of the high-five lineup after the game.

▶ **Spare camera and flash batteries.** If your batteries give out, you're sunk. For cameras, I usually have one or more charged batteries in my gear bag as insurance. If I'm using flash, I have a few extra sets for it as well. Also, if I'm going on an extended trip, I bring along a battery charger.

▶ **Personal amenities.** During sporting events, there are often periods of downtime where you need to take a break from shooting. Having a snack, bottle of water, comfortable clothing, and shoes help you stay loose to be ready to shoot at a moment's notice. For several sport shoots I also bring along a 5- or 6-gallon plastic bucket. I can stuff a camera bag in it when walking to the field, stand on it to shoot over a fence, or use it as a stool when there's downtime between games.

▶ **Laptop computer or portable storage device.** Backing up images on site, either to a laptop or a handheld hard drive, is an essential part of the workflow, especially if you're traveling for an event. A laptop is also convenient if you need to upload images to a client server, blog, or Web site and/or print images on site.

8.5 A surfer rides a late-afternoon wave in Hawaii. Notice how the fast shutter speed freezes the water droplets and the spray in midair looks sharp. Sandy or moist environments like this can wreak havoc on a camera's delicate electronics and optics, so keep a soft white towel handy to remove dust and to keep the camera cool by reflecting heat when not in use. Exposure: ISO 200, f/4, 1/800 second.

These items can go a long way toward making your sports and action shooting more fun and enjoyable, but you still have to deliver the goods in terms of imagery. Spend some time working with your camera's white balance presets and Kelvin settings or perform a custom white balance for the lighting conditions you find yourself in. Getting the color spot-on in the field saves a lot of time later on not having to color-correct all of the images in your computer's image-editing program.

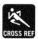

See Chapter 1 for more info on setting a custom white balance.

Lastly, consider the trade-off between shooting in RAW or JPEG formats. It may make sense when shooting some sports where you need to immediately upload images or turn over a disk of images right away to choose one over the other. While a RAW image file is larger and yields the most image data, it takes longer for the camera to transfer from its buffer to the storage card, and can ultimately keep you from shooting because the camera's buffer is full. For horse racing or motorsports, for example, shooting JPEGs might make more sense because it allows you to shoot longer bursts of continuous frames that can be written to the memory card that much faster. Try shooting your favorite sport in both formats to see if this is an issue for your style of shooting. If it's not, then I recommend shooting in RAW format for expanded image processing flexibility.

See Chapter 2 for a more detailed breakdown of image file formats.

Practical Pro Advice

Over the years, several techniques have proven themselves useful time and time again. Keep these ideas in mind the next time you're shooting sports or action-style events:

▶ **Know your fundamentals.** There are no retakes and second chances are rare when shooting many types of sports and action events. Know your equipment thoroughly before you begin to shoot, so you are not messing around with buttons and dials, trying to figure out how your camera works on site instead of concentrating on the action in front of you.

▶ **Do your homework.** Know the key participants, the rules of the game, and the schedule of events. Find out if the event is being videotaped and how that affects your ability to move around the field or venue. Also figure out if any areas of the location are off limits, where the best action might happen, and, of course, have a general idea of the shots you want to make beforehand.

▶ **Use your widest aperture.** By shooting with the largest aperture your lens is capable of, you solve two potential problems. The largest aperture allows you to shoot with a higher shutter speed and the shallow depth of field blurs the background, putting more emphasis on the subject.

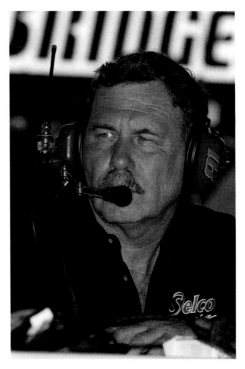

8.6 The race car crew chief checks the scoring monitor to see what position his driver is in. For sideline shots like this it's usually okay to use flash, but you want to check with any official or coach before attempting to use flash for the live action because it's usually not allowed. Exposure: ISO 100, f/8, 1/250 second.

▶ **Check your shutter speed.** Periodically check your camera to make sure you are shooting with a fast enough shutter speed to get sharp images with no blurring of the action. Review the image on the camera's LCD monitor and enlarge the image all the way to check for sharpness. There is nothing more depressing than to think you are shooting sharp images and then get them into your computer at home and find that is not the case. Make sure that the shutter speed is at least 1 over the focal length of the lens. That means if you're shooting with a 200mm lens, shoot at 1/200 second or faster, a 300mm lens, 1/300 second or faster, and so on. The longer the focal length of the lens, the faster the shutter speed needs to be to prevent camera shake, so that handholding the camera does not show itself as blur in your picture. To raise your yield of sharp images, avoid shooting any moving action at less than 1/250 second.

▶ **Shoot both traditional shots and creative variations.** You don't want to take the same photos over and over, so avoid shooting from the same place or with the same zoom setting every time. Moving around the action can provide ideas for more interesting camera angles, subjects, backgrounds, or compositions.

▶ **Look for small stories within the larger one.** Many events have lulls when it seems like nothing is going on. Let your vision wander beyond the sidelines. These are great times to look for the details of the sports or action you're covering. Close-ups of the gear or faces or hands of the competitors all make great subjects that tell a more complete story of the event and a wide or midlength zoom lens in the 24-70mm range is perfect for these types of images.

▶ **Stay out of the way.** Be sure you're not getting into anybody's way or a judge's sightline. It can be dangerous for you and the participants. Be aware of the field boundaries and know where you can and cannot go. No photograph is worth injuring yourself or another person in trying to get the shot, and no photograph is worth getting booted from the event for not following the rules or boundaries. Be especially careful at track events where discus, shot put, and javelins are all flying through the air and because timing equipment may be in use. Avoid walking across finish lines, even during lulls between races.

▶ **Lock in your settings.** Once you pick your shooting location, shoot a few images before the action starts to get a feel for the lighting conditions and how that plays out on your LCD monitor screen. Use a preset White balance setting that closely matches your event's lighting environment or perform a custom one. Avoid using an Auto white balance setting and try locking in your exposure settings with EV lock. Better yet, switch to Manual mode and control all the camera's exposure options when you can.

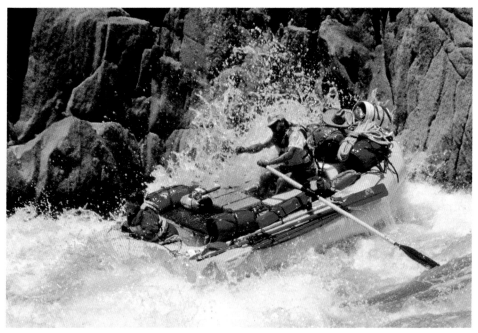

8.7 A fast shutter speed freezes the motion of the water in midair, delivering crisp results and visually separating the rafters from the darker Grand Canyon wall in the background. Exposure: ISO 100, f/8, 1/500 second.

▶ **Practice your technique.** Action photography requires a skill set that is different than that of a portrait photographer. Be prepared to shoot a lot of images. After you get comfortable with the type of event you're shooting, you learn to antici-pate where the action is and anticipate the peaks.

▶ **Don't stop shooting.** There are great moments to be captured after the play is over and the photographer who keeps looking and shooting gets those shots. Stay focused on the participants for that emotional response after the play that can sum up the whole game in one shot.

Obtaining Permission

When photographing people, it's generally a good idea to ask if they mind if you take their pictures. This is especially true when photographing someone's chil-dren other than your own. You should always find a parent or guardian and ask permission before photographing their kids.

Generally, I keep a pad and paper in my camera bag and I ask for a mailing or e-mail address, and I offer to send them a copy of the photo, either in print form or as an electronic file.

If you're planning to publish your photographs or use them on the Web, it's also mandatory to have secured a photo release, also known as a model release form. Depending on the language on the form, when signed by the person you photo-graphed, this document allows you to use the image for publication and any other use that you wish. If your subject is under the age of 18, you must have the parent or legal guardian sign the release form.

Many sample photo release forms are available on the Internet. Read them care-fully to choose the right one for you.

Concert and Event Photography

For the beginning photographer, concert and event photography can seem like the easiest thing in the world to shoot. There is action swirling all around you and the colors, sights, and sounds can be highly exhilarating. Everywhere you point your camera it seems, is an awesome photo just waiting to happen. How hard can it be to capture this genuine excitement, you might think, when all you have to do is set the camera to Program and shoot? Taking that approach may get you a few good shots of the action, but with a little forethought, planning, and careful consideration of the lighting qualities, your event images can quickly improve from good to great. This chapter aims to provide you with lighting tips and advice that in turn give you the confidence you need to make spectacular images at your next concert or special event.

Being sensitive to the nuances of the stage lighting can help you plan better times to shoot as the event unfolds. By shooting a few frames and then checking the camera's LCD monitor for the image review and histogram, you can make exposure adjustments on the fly to quickly record optimal images. Exposure: ISO 800, f/4, 1/40 second.

Preparation and Considerations

The most successful approach to concert and event photography (and by event I mean anything from a family member's birthday party to parades and conferences) is to know what to expect in terms of the lighting. You need to consider where the event is held, whether it is indoors or out, and what time of day or night it's scheduled to take place. By knowing these particulars, you can plan what equipment to bring to boost the quality of light you find there.

9.1 For most events, I like to get warmed up by shooting some overview images that show the lay of the land and then focus on smaller details. On an overcast day with very flat light this street scene from last summer's Multnomah Days parade was captured just before the parade began. Exposure: ISO 800, f/2.8, 1/60 second.

Daylight events

For daytime outdoor events, most likely you shoot with available light, and if it is in the middle of the day, you have lots of it. The problem with all this light is not the amount but the quality and the direction, which is from straight overhead. This lighting condition can create shadows where you don't want them and inaccurate exposures if not considered beforehand. By carefully thinking about the light, where it looks good, and where it doesn't, you can begin thinking about camera settings, angles, and subjects and how to go about making the best images you can.

9.2 Pepe and the Bottle Blondes perform at an outdoor concert. Microphones are an especially vexing problem for concert shooters because they are almost always in the way of a good shot! You have to wait until the performer moves away from them or choose an angle where they do not block the performer's face. Exposure: ISO 100, f/4, 1/125 second.

Events that occur outdoors during the day are a good opportunity to bring an external flash unit to learn to use it as a fill or fill-in flash. Fill flash helps bring out definition and clarity, especially in conditions of bright overhead or indirect lighting. Speedlights are small and lightweight and don't take up much room in your camera bag, which makes them ideal to help give your lighting a little boost. When using flash as a fill light, remember you don't want to overpower or even match the ambient light level, so set your flash compensation to -1 stop or more depending on the results you get on your camera's LCD and histogram. This creates a very natural one-light-source photo with good shadow detail.

When shooting at events, I often want to feel like a participant and not just a cool, detached observer. To that end, I pick camera settings that give me the most flexibility in exposure range, color, and final output. I also want to travel light so I can move around freely looking for the best light and camera angles. Beginning with the camera, here's a checklist for quick shooting at daytime outdoor events:

▶ **Use a low ISO setting.** I always recommend using the lowest ISO setting you possibly can to avoid noise and get the sharpest images with the best color. As the day progresses and the light begins to diminish, increase the ISO to maintain proper exposures at your desired shutter speed and aperture settings, particularly if you notice any blurring or movement of your subjects in the images.

▶ **Use a large aperture.** Depending on the nature of the event, it may be wise to use a larger aperture around f/2.8 or 4 to minimize the depth of field of a busy background or allow you the use of a faster shutter speed. Street fairs and parades abound with action and color that make for very busy, scene-stealing backgrounds and fast-moving subjects. A large aperture affords you faster shutter speeds to freeze the action.

▶ **Shoot in RAW format.** RAW format allows you the greatest range of processing latitude in regard to exposure and color settings and also the largest file size. If you need to shoot quickly, don't want to spend too much time with color balance settings, and don't mind the extra step processing the images, then RAW is the way to go.

9.3 Always be on the lookout for details and image ideas that help tell the story of the event. After photographing the start of the race, I made this image of the winner's victory medals near the finish line. Exposure: ISO 400, f/8, 1/50 second.

▶ **Use Programmed Auto mode for daylight events.** Programmed Auto mode selects less extreme exposure settings for aperture and shutter speeds in daylight shooting scenarios yet allows you to shift the program from faster to slower shutter speeds or to larger or smaller apertures depending on your desired intent. Changing the settings adjusts them both equally so that the exposure is the same but the depth of field/stop action qualities are different.

▶ **Use a monopod for longer focal-length lenses.** Chances are you want to move around shooting lots of different kinds of pictures at events using lenses ranging from wide-angle to medium focal-length to telephoto zooms. Using a

tripod can confine your position, but using a monopod, especially when shooting with longer lenses, increases your mobility as well as the probability of sharp images. Monopods are lightweight and easily transportable. Make sure the one you purchase can extend all the way to your standing sightline or even a little past, so you won't have to bend down to look through the viewfinder.

▶ **Use a flash for fill light.** Brightly lit scenes can create shadows in all the wrong places, and your camera's onboard pop-up flash or an external speedlight can help to fill them in and even out your exposures. The flashes should not over-power the natural daytime light and should be set to expose just slightly under the ambient light exposure value by at least 1 stop of light. Alternatively, use your flash's Through-the-Lens (TTL) exposure system for hassle-free flash exposures.

Low-light events

Most shows occur at night and indoors, which changes my approach to shooting with the light at hand. It's all about being flexible. This is where using your camera's white balance presets or performing a custom white balance will aid greatly in getting accurate color. Just be aware that there are usually several types of light in these venues, so you have to make the most of your camera's capabilities by trying different white balance presets or performing a custom white balance.

9.4 A proud father takes a picture of his daughter competing in a hula hoop contest. With my camera set to Fluorescent white balance, I happened to capture his flash firing at the exact moment I pressed the Shutter Release button. Exposure: ISO 1600, f/5.6, 1/15 second.

Many venues and bigger-name bands often have a "3-song rule" that you're allowed to take photos during the first three songs of the show from the orchestra pit or special photographers' section. If this is the case, you may need to arrange for credentials ahead of time and you have to shoot quickly. You may have to forego that jumping-off-the-piano shot for another concert, show, or performer.

For smaller venues, there may be no choice of background, so I try to shoot from both sides of the stage. Performers with guitars present the photographer with a nice triangular composition that looks good for tight shots.

NOTE In situations where venues or performers do not allow flash photography, use the fastest lens you have and use the lowest ISO possible while still maintaining a shutter speed that equals 1 over the focal length (for example 1/200 for a 200mm lens) or faster to ensure crisp focus.

9.5 I shot this photo from the dance floor at a recent concert downtown. A high ISO setting allowed me to capture the bright colors of the stage lighting while adding a minimal amount of digital noise. Exposure: ISO 1600, f/4.5, 1/125 second.

The biggest challenge I find is establishing a base exposure that still retains detail in the highlights of performers as they move in and out of the strong spotlights on the stage. To this end, I'll use spot metering to get a good exposure of the performer. I also experiment with white balance settings even though I might be using flash. With strobes, I've gotten great results with Auto and Tungsten white balances, so I alternate between the two as stage lighting changes to establish which is best. A lot of

times the stage lighting is warm and tungsten color balance cools things off a bit yet still produces pleasing skin tones.

Even though I shoot in RAW format I always take a bit of extra time and strive to get the images dead on in-camera. I may have to quickly upload the photos to a client when I don't have the luxury of taking the time to correct the images on the computer. Photoshop is great; it's just that time spent there oftentimes can't be part of the workflow.

At concerts, I use the Auto Exposure (AE) Lock by setting the exposure on the brightest highlight area of the main performer. Alternately, you can use the Spot meter to determine the exposure of the face. For all indoor events on a stage, I shoot at the lowest ISO that I possibly can set and still attempt to get 1/125 second at f/2.8 with my lens. With the high ISO range of some newer dSLR cameras, I'm excited about shooting concerts now at exposure combinations not possible previously. Experiment with your camera's high ISO setting and review the images while at the event. The highest ISO setting of your camera will usually have some visible noise, even on the LCD monitor if you enlarge the image to its max. Keep coming down in ISO value until you can produce images with a tolerable amount of digital noise and still maintain your desired shutter speed and f-stop.

9.6 Local clubs and smaller venues are great places to try out your photo techniques before moving on to larger stages such as the one in this shot from a Steel Pulse concert. Exposure: ISO 1600, f/5. 1/5 second.

Practical Pro Advice

In order to effectively capture definitive images, it's helpful to know the music, story line of the musical, or lighting changes so you're ready when the lights come up or go down. This is easy if you get to shoot the same show twice or follow the band to another venue the next day, but many times that's often not feasible. You are pretty much at the mercy of the lighting or stage designer, but you can learn a lot about lighting for your photography by attending shows. Fog and theatrical smoke may set a mood and look great onstage, but they rob you of contrast if your subjects or performers are enveloped in it. Behind performers, smoke looks awesome.

Another lighting consideration is the special effects used in the show. Watch for the timing of pyrotechnic displays to find the right moment to shoot. Fire displays affect your exposures, so be sure to check your camera's LCD monitor and histogram for any exposure problems after a few frames. Most of today's cameras include a feature called a highlight warning that alerts you to areas of the image that are grossly overex-

posed. This would be a good time to turn it on. When you review images on the LCD monitor of your camera, these areas blink from white to black. You can avoid these "blinkies" by increasing your shutter speed or lowering your ISO. It's generally okay if these areas are small and don't appear on the main subject.

Try looking for angles where the performers are looking good and fit the rectangular frame even if you have to crank the camera sideways. Good composition adds to the dynamic. Musicians move around a lot into good and bad backgrounds, and lighting conditions change constantly. Similar to shooting pictures of kids, event photography requires shooting a lot and letting go of chimping after you check those first few exposures. Keep your eye to the viewfinder and keep shooting. A memorable image can happen in a fraction of a second.

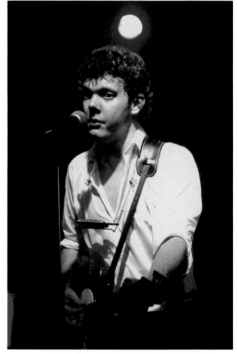

9.7 Steve Forbert makes eye contact with the photographer while backlit by a blue spotlight that separates him from the background. Exposure: ISO 200, f/5.6, 1/3200 second, with an EF 70-200mm f/2.8L USM lens.

Here are some things to consider next time you plan on shooting a concert or event:

▶ **Call the venue before you go.** Be sure to call to ensure that you are allowed to bring your camera in. If photography is allowed, ask about using flash. Today, it's almost always up to the band. Know what time the concert starts, whether there's a warm-up band, intermission for the main act, and so on. Details count, so make sure you have as many as you can.

▶ **Use Manual exposure mode.** Programmed Auto exposure mode is great for daytime events, but for evening events it's better to set the camera to shoot in Manual mode. Decide on an acceptable exposure and leave it alone. The intensity of the stage lighting will vary and a few shots may not be properly exposed. Although much of the stage will be dark, any automatic camera modes will compensate for all this darkness and overexpose your spot-lit performers. Switch from Programmed to Manual as less light becomes available. For nighttime concert shooting, Manual is the way to go.

▶ **Start with a base exposure.** Set the ISO to 800 or 1600 if your camera can handle it without producing too much noise in the images. Today's dSLR cameras keep getting better and better in the ISO department, and if your camera includes a high-ISO noise reduction feature, use it. Set the shutter speed to match the focal length of your lens, open the aperture all the way, and shoot a few test frames to see where you are in terms of exposure. If it's still too dark, you may just have to wait until the stage lighting gets brighter to shoot.

9.8 Motivational speaker Lou Radja works the audience at the Photo of the Year Gala in Portland. Because Lou moved around a lot as he was speaking, I chose to shoot with a medium 24-70mm lens and quickly zoom in when I had a clear shot of him. Exposure: ISO 1250, f/3.2, 1/40 second.

► **Go with the flow.** Watch the stage lighting. When it changes, make exposure adjustments. When the lighting is low, and your aperture is wide open, slow down your shutter speed, increase your ISO, or adjust a combination of those two settings. Conversely, when the lights come up, scale back the ISO setting or switch to a faster shutter speed.

► **Know your equipment.** When the band hits the stage is not the time to learn which button or dial changes your ISO or exposure settings. Thoroughly familiarize yourself with your equipment beforehand so you can quickly make exposure adjustments on the fly. Use the illuminated LCD on top of your camera if it has one or pack a little key chain flashlight to help locate extra batteries, lenses, and so on, in your bag.

► **Experiment.** Don't be afraid to try different settings and longer exposures. The blur of any body parts will look dynamic as long as the face is sharp. Center your subject in the frame and try using slower shutter speeds and zooming in or out while the shutter is open. Look for a unique vantage point from which to shoot.

► **Use your peripheral vision.** Pay attention to your surroundings when you shoot events, especially those that require special permission, and make sure you stay out of the way of people putting on the show. In addition, respect the people who paid to get in and don't spoil their good time by standing in front for a long time or using excessive flash. Remember the audience members and make sure your photography doesn't hinder their enjoyment of the show.

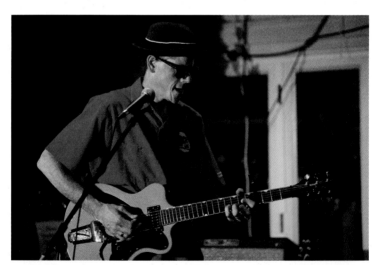

9.9 Singer and lead guitar player Bill Sterling of Three Finger Jack. Most venues and bands do not allow flash, but this one did. I set up a speedlight in the corner, zoomed the flash head all the way to its longest setting, and fired it with a RadioPopper transmitter and receiver. Exposure: ISO 2000, f/2.8, 1/50 second.

Landscape and Nature Photography

Successful landscape and nature photography involves seeing the light before making the exposure and submerging yourself in the natural beauty of your surroundings. It also pays for you to be flexible enough to switch gears and shoot something else when the light is not working to your satisfaction for your particular subject matter. Knowing when to add a reflector or additional light source is also an important skill.

Being sensitive to the time of day and what nuances of light you have at your disposal are key to coming back with images you can be proud of. Knowing what shooting modes to use and having the right gear are important, too, whether you're on a short hike or an extended vacation to some exotic location.

A rock-bound turtle about to take the plunge into the stream. Exposure: ISO 500, f/5.6, 1/400 second.

Preparation and Considerations

Landscape and nature photography is one of the best ways to bring many shooting disciplines together to create the best images you can. The wide array of subjects, the unpredictability of weather, and the simple pleasure of immersing yourself in the natural world are irresistible lures.

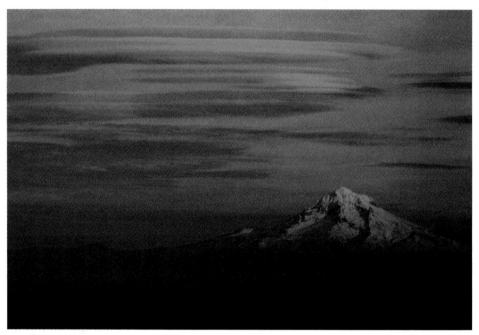

10.1 Lenticular clouds over Mount Hood in Oregon fill the sky after sunset. Exposure: ISO 640, f/8, 1/250 second, -1EV.

Before you go out into the field and learn landscape and nature techniques, look at some gear that can make your job much more enjoyable. Here's my list of gear recommendations for shooting landscape and nature images:

▶ **Tripod and/or monopod.** A lightweight but sturdy tripod such as those from Bogen/Manfrotto, Gitzo, and Cullman are indispensable to shooting rock-solid landscape and nature images. In addition, a versatile joystick or ball head with a sturdy quick-release plate increases the steadiness and speed of shooting, and is near mandatory for shooting with long lenses and exposures. If you want to shoot a lot of macro or panoramic imagery, you may need a tripod designed specifically for those types of photography.

10.2 The three types of tripod heads I use when shooting landscape and nature photos all have quick-release mounting plates. The three-way pan/tilt head (on the left) allows individual adjustments of pan, tilt, and height positions. The joystick (in the middle) and the ball head (on the right) provide quick adjustment of all axes to compose and shoot quickly changing compositions.

▶ **One or two dSLR camera bodies.** Ideally, you should have a backup camera with you in case anything goes wrong. This is especially important in inclement weather and in locations where the camera is exposed to blowing dust, sand, rain, or heavy moisture. You may, of course, pass on bringing the second body for local shooting. But if you spend any time packing, driving, or hiking to a location only to experience a problem with your gear, your time and the trip are wasted.

▶ **Weatherproof camera case.** Keeping your camera equipment warm and dry will benefit you in many shooting situations. Moisture can wreak havoc on your camera's ability to focus or get a clear shot especially when coming inside after skiing, snowboarding, or photographing a swim meet. Toss a few desiccant packets that come with all kinds of packaging into your camera bag to keep it dry on the inside too. Some can be dried out in the oven or microwave and used again and again. Storing the camera in a weatherproof case until it warms up avoids condensation forming inside the camera.

▶ **Memory cards.** The number of memory cards that you carry depends on how many images you typically shoot and the length of your hike or shooting session. I usually carry a variety of SanDisk or Lexar cards in sizes ranging from 2GB to 8GB.

10.3 Time exposures like this late-afternoon shot of the Delaware Raritan Canal require a sturdy tripod and a remote switch to trip the shutter. A polarizing filter was also used to add contrast and saturate the colors. Exposure: ISO 100, f/22, 8 seconds.

▶ **Spare camera batteries and battery charger.** Live by the battery, die by the battery. Especially in cold weather that reduces the shooting time for the battery, it's important to have plenty of spare batteries available. Keep the batteries covered with the supplied cover. In cold weather, place fresh batteries inside your jacket and near your body to keep them warm.

▶ **Laptop computer or portable storage device.** Backing up images on site — either to a laptop or a handheld hard drive — is an essential part of the workflow throughout the day. Unless I have to, I won't delete images from the memory cards after loading them onto the computer or handheld device until I have burned a CD or DVD so that I have two copies of the images at all times.

▶ **Remote switch or interval timer.** A good companion tool when using a tripod, a remote switch or interval timer replicates all functions of the camera's AF/ Shutter Release button to insure vibration-free operation for macro or timed exposure work. The remote button must be pressed halfway to focus, then all the way to take the picture. It also works with the camera to keep the shutter open for even longer Bulb time exposures for subjects such as star trails and nighttime cityscapes. An interval timer allows you to shoot sequential photos that depict action and can be used to make a video clip of all the images, approximating animation.

For vacation, travel, or long-distance landscape work, some additional items to consider include:

▶ **Cellphone and/or GPS location device.** A GPS unit will also allow you to store coordinates of favorite locations and geo-tag your image files with longitude and latitude values that are retrievable in many image browsers.

▶ **Notebook and pen.** Write down your impressions of the area, especially first impressions that can help you define your creative inspiration of the place and, subsequently, your approach to shooting.

▶ **Plastic bags.** These are useful for storing anything and everything in inclement weather and keeping your sensitive electronic gear dry.

▶ **Multipurpose tool.** This valuable tool can solve all kinds of unexpected problems in the field, from camera repair to fixing clothing or camping gear malfunctions.

10.4 It's all about mood with landscape and nature photography. While Mount St. Helens smolders in the background, soft afternoon side lighting illuminates these foxglove flowers positioned in front of a darker pine tree for greater visibility and contrast. Exposure: ISO 200, f/5.6, 1/1250 seconds.

Essential filters

The most useful filters in landscape and nature photography, often referred to as *outdoor* photography, include the circular polarizer, neutral density or split-field neutral density filters, and a few warm-up filters. Here's a brief overview of each type of filter I use:

▶ **Polarizer.** Polarizers deepen blue skies, reduce glare on nonmetallic surfaces to increase color saturation, and remove spectral reflections from water and other reflective surfaces. Polarizers come in two flavors, linear and circular. Linear polarizers are used on film cameras that do not have an autofocusing system. Circular polarizers are specifically designed for use with autofocus cameras because they allow the autofocusing beam to pass through unobstructed to achieve focus.

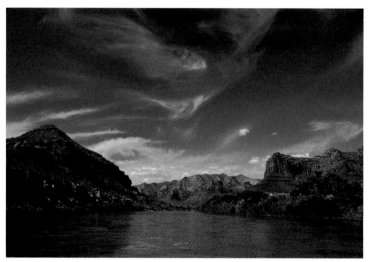

10.5 The polarizing filter, when rotated properly, adds contrast, yields deep blue skies, reduces reflections from surface glare of foliage, and saturates landscape colors, as in this shot from the Green River, Utah. Exposure: ISO 100, f/11, 1/250 second.

A circular polarizer attaches to the lens, and you rotate it to reduce reflected polarized light. Maximum polarization occurs when the lens is at right angles (45°) to the sun. With wide-angle lenses, uneven polarization can occur, causing part of the sky to be darker than other areas of the sky. Pass on the polarizer when making panoramic images as the unevenly toned sky it produces may be difficult for the software to blend easily.

▶ **Neutral density filters.** Neutral density (ND) filters work like sunglasses for your camera. When photographing waterfalls, for example, even at your lowest ISO setting you can't use the slow shutter speed/aperture combination you'd like to because there's way too much light. ND filters allow you to still get the shot by cutting the light transmission. They come in various strengths in 1/2 stop increments up to 8 stops to allow you to shoot longer exposures in bright environments.

▶ **Variable neutral density filters.** Singh-Ray's Vari-ND Variable Neutral Density Filter (www.singh-ray.com/varind.html) allows you to continuously control the amount of light passing through your lens up to 8 EV (exposure values), making it possible to use narrow apertures and slow shutter speeds even in more brightly lit scenes to show the fluid motion of a waterfall, the motion of clouds, or flying birds. The filter is pricey, but it is a handy addition to the gear bag.

▶ **Graduated neutral density filters.** These filters allow you to hold back a bright sky from 1 to 3 f-stops to balance foreground exposure. They are usually half clear and half neutral density and are used in lens-mounted trays where you slide the filter up or down, depending on your composition. They are available in hard or soft transition types and in different densities. With this filter, you can darken the sky without changing its color; its brightness is similar to that of the landscape and it appears in the image as it appears to your eye.

10.6a While exposed properly, the top unpolarized image of an oak tree and the sky shows little color intensity. Exposure: ISO 200, f/11, 1/125 second.

10.6b In the bottom image, rotating the polarizing filter properly adds color intensity and contrast to the yellow oak tree leaves, reduces surface reflections from foliage, and deepens the blue sky. Exposure: ISO 200, f/11, 1/80 second.

▶ **Warm-up filters.** Originally designed to correct blue deficiencies in light or certain brands of film, warm-up filters correct the cool bias of the light, and you can use them to enhance the naturally warm light of early morning and late afternoon. Warm-up filters come in several strengths, such as the 81 (weakest), 81A, 81B, 81C, 81D, and 81EF (strongest). For greatest effect, combine a warm-up filter with a polarizer. You can also apply the warm-up effect during image editing in Photoshop or other software programs that offer those adjustments.

Shooting landscapes and nature in natural light

Natural lighting effects change throughout the day, from dawn to dusk. By knowing the predominant characteristics as the day progresses, you can use the changing quality, color, and intensity of light to your advantage.

Look for strong side lighting, either early or late in the day, to emphasize details and show texture at its best. Take the time to study your subject from many different angles with your camera to your eye, to see were the light falls on it. Once you locate the optimum angle and point of view for your camera, go ahead and marry the camera to your tripod. Finding that view with only your camera is a faster way of working than wrestling with your tripod trying to find a workable composition.

However, finding the light is only half of the story. Exposing so that the light is rendered as it appears to the photographer's eye is the essential second half of the story, along with ensuring that the color is rendered accurately.

Presunrise and sunrise

In predawn hours, the cool blue and gray hues of the night sky dominate and create a soft, shadowless light. This is the time to capture subtle, moody images of landscape formations, bodies of water, and close-ups of hoarfrost or dew on leaves, grass, flowers, and insects. I also look to capture the fog or mist that tends to hang low over valleys and water. At these times I am mindful of photographer Eliot Porter's quote that "Sometimes you can tell a large story with a tiny subject" and look for reasons to break out my close-up gear.

 See Chapter 15 for more information on macro photography.

Contrast is low as the sun's crepuscular rays (sometimes referred to as "god beams" or "angel beams") are scattered by clouds, trees, and atmospheric dust as they cut through the atmosphere at a low angle. Landscape, fashion, and portrait photographers often use the light available during and immediately after sunrise. During sunrise, tall structures such as buildings and trees are lit by the sun while the rest of the landscape appears cool and shadows are filled in by light from the sky.

In broad terms, both sunrise and sunset register in approximately at 2000Kelvin (K). The Kelvin degree scale measures the color temperature of light with the lower temperatures appearing reddish or warmer and the higher temperatures appearing bluer or cooler. To get the best color, you can set a custom white balance, which is detailed in Chapter 1. If you are fortunate enough to have a color temperature meter, then setting

the K white balance option to the color temperature meter reading provides the best results. If you are shooting RAW images, you also can adjust the color temperature after capture in the proprietary software that came with your camera, Adobe Camera Raw, or Adobe Lightroom, making your field work just a little bit easier.

10.7 Sunrise over Sunfish Pond, New Jersey. Warm rays of the sun begin to light up the morning sky. Exposure: ISO 100, f/11, 4 seconds.

Early morning to midday

As the sun rises in the sky on a typical clear day, the quality of light becomes more intense as the angle between the sun and earth increases, allowing more light rays to pass through the thinner earth's atmosphere. The color temperature also rises and loses its warmth to become white as it heads toward 5500K. The first two hours after sunrise typically provide ideal light for nature, landscape, and travel photography because the contrast isn't too extreme, the color temperature is still a bit warm, the sky is bluer because the sun is still close to the horizon, and long shadows reveal texture and depth in the landscape.

During midday hours, the warm and cool colors of light equalize to create a light the human eye perceives as white or neutral. On a cloudless day, midday light often is considered too harsh and contrasty for landscape shooting and produces flat and lifeless results. However, midday light is effective for photographing images of the graphic shadow patterns of solid objects, architecture, flower petals, and leaves made translucent by backlighting with the sun, and natural and man-made structures.

For midday pictures, the Daylight, Cloudy, or Open Shade white balance settings on your camera are good choices to start with.

Presunset, sunset, and twilight

Immediately before, during, and following sunset, the warmest and most intense color of natural light occurs. The predominantly red, yellow, and gold light creates vibrant colors, while the low angle of the sun creates soft contrasts that define and enhance textures and shapes. These sunset colors create rich landscape and cityscape photographs. The warmth of light at sunset is different from sunrise because the sun is striking more things in the landscape such as dust and pollution in the evening and less so in the morning. As a result, morning light is more clear and neutral than evening light because the dust has settled to a certain degree and the air has become clearer overnight.

10.8 Midday is a great time to break out that wide-angle lens and look for compositions that work with the sun directly overhead. Washington State's Takalak Lake. Exposure: ISO 800, f/14, 1/500 second, -1 EV.

The last hour before sunset, the Golden Hour, brings even lackluster scenes to life. Once again, long shadows stretch to reveal texture and detail, particularly when the sun is at a right angle to the camera.

With the sun below the horizon, light is reflected onto the landscape from the sky. This is a good time to use long shutter speeds to record movement in the landscape area, whether the movement is water washing up to the shore, people passing by, or trees and grasses swaying in the breeze. The first 30 minutes after sunset is an ideal time to capture the soft pastel sky colors reflected in a still lake or on the ocean.

For more on exposure compensation, see Chapter 2.

10.9 This vineyard row was used to create depth and a vanishing point in this otherwise flatly lit landscape during a cloudy midday. Compositional techniques can overcome the flattening effect of the ambient nondirectional light. Exposure: ISO 400, f/8, 1/3200 second, +1 EV.

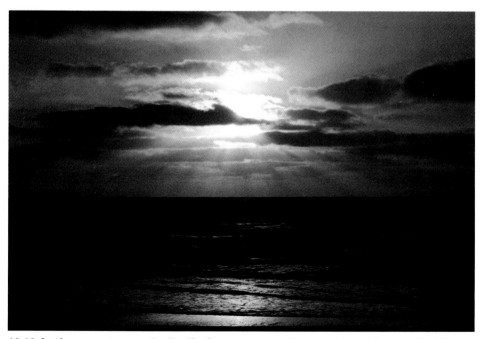

10.10 As the sun sets over the Pacific Ocean, crepuscular rays fan out from behind the clouds. Exposure: ISO 800, f/7, 1/8000 second, -2 EV.

10.11 Often, the sky can be ablaze with color *after* the sun has set. This sky scene from Hubbard, Oregon, greeted me as I was leaving a commercial shoot location and headed home. Exposure: ISO 400, f/2.8, 1/800 second.

Practical Pro Advice

Here are some of the techniques that you can use when shooting outdoor images:

▶ **Focus one-third of the way into the scene.** This technique approximates hyperfocal focusing, and though it is not as accurate, it works reasonably well. For sweeping landscapes where there's no obvious center of interest such as a person, object, or wildlife, focus the lens approximately a third of the way into the scene. The depth of field for distant subjects extends approximately twice as far beyond the point of focus as it does in front.

▶ **Pre-visualize the image.** If you're shooting a sunset scene, decide if you want to capture foreground detail or show trees, hills, and buildings as silhouettes. If you want to show foreground detail, meter the foreground directly by excluding the sky and sun from the viewfinder, and then use a neutral density graduated filter to tone down the sky so that it isn't blown out. If you decide to let

the foreground go to silhouette, include less foreground in the frame by tilting the camera upward slightly to feature more sky. Or switch to a telephoto lens, and pick out one or two elements, such as trees or a building, to silhouette.

▶ **Research before you go.** Most landscape photographers agree that you can never do too much research on the place you're traveling to before you leave. The more you know about the area, what its defining characteristics are, and what areas the locals frequent, the better the chances that you will come away with unique images that capture the spirit of the locale.

▶ **Learn how to photograph rainbows.** To capture the strongest color of a rainbow, position the rainbow against a dark background such as stormy clouds, a hill, or trees. You may have to drive several miles to do this. Being in the right place at the right time and having your camera with you will increase the odds you'll get better pictures of rainbows. Preparation, perseverance, and a little bit of luck can help too. You can underexpose the image by about 1/3 or 1/2 f-stop to increase the intensity and saturation of the colors.

10.12 The combination of the strong diagonal shape of the flower juxtaposed with the strong diagonal shadows in the background gives this image a visual tension and depth. Late-afternoon side lighting creates pleasing texture in this columbine flower and the graphic shadows in the background. Exposure: ISO 320, f/16, 1/125 second.

▶ **Use side, back, or cross-lighting.** Frontal lighting is often chosen by inexperienced photographers who only see the subject and not the light falling on it. Front light creates images that lack texture and depth because the shadows fall away from the camera and out of view. Instead shoot so that the sun is on one side of the camera with light striking the scene at an angle. Side lighting provides the strongest effect for polarizing filters given maximum polarization occurs in areas of the sky that are at right angles to the sun.

▶ **Include people in the landscape.** People added to landscape images provide a sense of scale and perspective. Many times, the scale of subjects in the natural world is difficult to perceive without an easily recognizable object such as a person to give a reference point.

▶ **Find new ways to capture iconic landmarks.** Some landmarks such as the Grand Canyon have been photographed at every angle, with every lens, and in every light possible. Spend some time thinking about how to get a fresh take on iconic landmarks to make your images distinctive.

▶ **Use a lens hood.** You can avoid lens flare by keeping lenses clean and using a lens hood to prevent stray light from striking the front lens element. Alternatively, you can also use your left hand to block light from refracting inside your lens.

▶ **Use selective focusing for creative effect.** The opposite of maximum depth of field is choosing to render only a small part of the scene in sharp focus using limited depth of field. This technique is effective with any lens set to a wide aperture with a close subject as the point of focus while the rest of the scene is thrown well out of focus. The falloff of sharpness is increased as the magnification increases and the aperture gets larger.

▶ **Meter a bright sky.** To get a proper exposure for a bright sky, meter the light on the brightest part of the sky using your camera's Spot metering mode. If the sun is above the horizon, take the meter reading without the sun in the frame and from an area of the sky that is next to the sun.

Night and Low-Light Photography

Just because the sun is setting and light is quickly fading does not mean you have to pack up your camera gear and stop shooting for the day. Actually, the fun is just beginning. This time opens up an exciting realm for creating low-light and nighttime photography. This chapter gives you the insights you need to make dazzling images in low or almost nonexistent light of a wide range of subjects and scenes. I also discuss several techniques for shooting special scenes such as firework displays and nightscapes, as well as tips for shooting High Dynamic Range and infrared photography.

The nighttime Seattle skyline was photographed handheld with a small camera from Queen Anne Hill. Even though I strongly recommend using a tripod and remote switch for shots like this, I didn't have them with me at the time and had to compensate with camera exposure controls. Exposure: ISO 1600, f/4.5, 1/1.7 second.

Preparation and Considerations

Many photographers who participate in my workshops and classes relate to me the classic story of attempting night and low-light photography a time or two, being displeased with the results, and giving up and moving on to other types of photo work. Their reasons for abandoning night photography vary. For some, the final images are not representational of the scenes they photographed. Others grow frustrated because they have a limited working knowledge of the vast recording capabilities of their digital cameras. Although it's true that the longer exposures and higher ISOs required for this kind of photography can add an intolerable amount of digital noise to some of the images, advancements in camera and software technologies have made reducing that noise easier and more streamlined as well. Many of today's camera manufacturers have included low-light noise reduction at higher ISOs as a menu feature in their latest model cameras. Check to see if it's included in your camera's functions and if it is, turn it on now as you begin to explore this exciting way of capturing light.

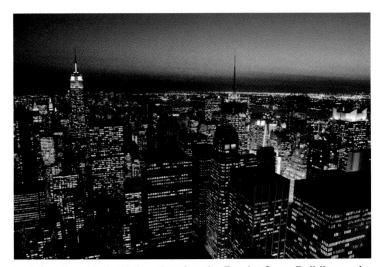

11.1 The New York skyline showing the Empire State Building and Times Square, photographed handheld from the top of Rockefeller Center looking southwest. For the best results when making images such as this, always use a tripod and remote switch. I didn't have them with me at the time and had to use a high ISO, large aperture, and a slow shutter speed to get a sharp image. Exposure: ISO 1600, f/2.8, 1/25 second.

Making images at night or in low-light situations can be vexing for many photographers. To do it right, you need to develop an awareness of the subtleties of light and the ability to estimate an exposure because your camera's built-in light meter was not

totally designed to meter low levels of light falling on the sensor over longer expo-
sures. Add to this awareness some supplementary equipment, and you are well on
your way to shooting great images long after the sun has left the sky.

The first issue you need to consider when shooting low-light or night images is
whether you want to shoot handheld or use a tripod. That single factor determines
what options and camera setting flexibility you have at your disposal for the shooting
session. I shoot loads of nighttime images both ways, but it is always my first consid-
eration if I should use a tripod or not. Having a tripod along creates many more oppor-
tunities to get perfect exposures and also eliminates camera movement, allowing for
rock-steady images. If I want to stay highly mobile and don't want to incur the added
weight of carrying a tripod along, I may pass on making long exposure images unless
I can find something secure to place my camera on. In that case, I would use my cam-
era's self-timer mode to trigger the shutter.

Should you decide to use a tripod, it's a good idea to go to your location early, before
the sun sets, to scope out your scene, get into position, and set up your camera.
Many cameras include an illuminated LCD on the top that shows all the exposure set-
tings lit up to help you see. If your camera doesn't include this feature, a small mini-
flashlight works just as well. With your camera set to Scene mode and securely
fastened to your tripod, follow this approach to get started:

▶ **Set the ISO to the lowest native value on your camera, which is usually
 ISO 100 or 200, and focus the lens on your subject or scene.** You can use
 your lowest ISO because you use longer exposures to make up the difference in
 the light-gathering capability of your camera, and this technique helps cut down
 on extraneous digital noise in the image. The longer you shoot and the darker it
 gets, the more you have to bump up the ISO, but this is a good place to start.

▶ **Set your camera to Manual mode and start with an aperture of f/11 or f/16.**
 This ensures an adequate focus and depth of field in case you are slightly off on
 focusing because of the low light levels. An added bonus of using a small aper-
 ture is that any spectral highlights in the scene such as street lights, holiday
 lights, or traffic signals appear in the photo as star points, an added zing to make
 the picture pop. The in-camera light meter's effectiveness is limited in extreme
 situations such as this and should be regarded as only a starting point. You can
 get much better results by shooting a few test frames and reviewing your expo-
 sures on the camera's LCD monitor.

▶ **As the light level diminishes, change your exposure settings.** If you are not
 using a tripod, you will have to slow down your shutter speed, increase the aper-
 ture setting, or raise your ISO setting to be able to shoot handheld. Be sure to
 review the image on your camera's rear LCD monitor to ensure you're getting

the exposure you want, paying close attention to your camera's histogram display. The histogram may be weighted toward the left or darker side. This is perfectly okay because you want your low-light or nighttime images to have more dark tones to look authentic.

11.2 This image was shot handheld from the DJ's station at a summertime outdoor wedding reception. A screw-on cross-screen filter was used to produce the star points on the decorative mini-lights. If I had used a tripod, a small aperture setting would have produced a similar effect. Exposure: ISO 1600, f/2.8, 1/30 second.

As with all other kinds of photography, you always have three options in low-light and nighttime shooting situations to control and manage the light that strikes the sensor in your camera: changing the ISO to amplify the digital sensor signal, opening the aperture to allow more light to reach the sensor, or leaving the shutter open for a longer period of time. It's the proper mixture of these three ingredients that makes up the recipe for producing dynamic images in lower light levels.

Using high ISO settings handheld

I consider ISO settings to be the least romantic of the camera's exposure controls, and aperture and shutter speeds much more powerful tools to determine the creativity of your pictures. At the same time, the ISO has to be properly set to allow you the flexibility and broadest range of using the other two controls creatively, which is why I usually set this value first.

Using high ISOs allows you to use a proper shutter speed to ensure that any moving subject is sharp and not blurry in the final image. The challenge in these instances is to establish the slowest possible shutter speed you can use and still freeze the action. For performers on a dark stage or people standing fairly still this is around 1/60 second, but you have to be careful because anything slower than this may lead to blur of the subject, even if you are using a tripod. For more active subjects an even faster shutter speed is necessary. Set the ISO just high enough to achieve the shutter speed you need to stop the action in the scene.

As digital technology improves, most popular camera manufacturers have greatly increased the usable ceiling on ISO ranges, allowing reduced noise or noise-free images at ISO values unheard of only a few years ago. My latest camera is capable of producing images at 25,600 ISO, which I rarely use, but it's comforting to know I have access to this astoundingly unbelievable technology, once considered nearly impossible.

11.3 A tugboat sits idle along the bank of the Willamette River with the Portland skyline in the background in this nighttime shot. Exposure: ISO 3200, f/22, 2 seconds.

Using large apertures handheld

While I strongly recommend using a tripod and remote switch or cable release for nighttime images, it is not always convenient to do so. In several examples earlier in this chapter, that was exactly the situation I found myself in. That did not stop me from making images because I knew I could let a large amount of light into the camera by using my largest aperture for each particular lens. The largest aperture you have depends on the lens you are using, and with variable aperture zoom lenses this value becomes smaller as you increase focal length.

The only disadvantage when using your largest aperture is a loss of depth of field, although this is usually not much of a problem with cityscapes and images that are all focused at infinity. For other types of images where you have a foreground element, use a flash to illuminate it or be sure to focus on the most important part of the photo, because limited depth of field means that everything behind and in front of the focus point is rendered out of focus.

11.4 A large aperture was used to keep the focus only on this baptismal font detail and caused the stained glass window in the background to go softly out of focus. Exposure: ISO 3200, f/2.8, 1/400 second.

Long shutter speeds

For photographing many nighttime or low-light subjects, an easy solution is to extend the time the shutter is open, allowing more of the available light to reach the sensor. This is a good method to employ with stationary objects such as architecture or cityscapes. You simply keep dialing down the shutter speed until you achieve an acceptable exposure based on the camera's LCD monitor image and histogram. The camera's sensor has the ability to record way more light than you can see with your eyes, but for this type of work it needs longer exposures in which to do so. Most cameras' built-in light meters do not accurately measure light over long exposures

consistently, so for this reason it's wise to stick to Manual exposure mode when shooting with slow shutter speeds. In addition, longer shutter speeds always necessitate the use of a sturdy tripod and a remote switch or self-timer for optimally sharp images.

Another cool thing to photograph with long shutter speeds is light trails of traffic, planes, firework displays, and amusement park rides. As the illuminated object streaks through the frame, it leaves trails of light from its path. In order to create successful light trail photos, use a slow enough shutter speed to make the individual lights look like streaks of color in your photo. If you only used a medium or short shutter speed, the object wouldn't move very far and the streaking effect would be very short. When you leave the shutter open for an extended period of time, the object has time to move across the width of the frame creating long light trails. It's best to contrast these light trails visually with something stationary in the frame to give the photo some context.

11.5 Cities are great places to look for and photograph light trails. This light rail train streaks through the scene and looks ghost-like as it crosses the intersection. Exposure: ISO 250, f/22, 15 seconds.

Employing long shutter speeds is a great way to handle subjects that do not move, and some interesting effects can be realized when you photograph this way. However, there are a few downsides to shooting longer exposures you may need to consider:

▶ **Noise.** With most cameras, digital noise is evident in images shot with longer exposures even when using low ISOs. This is not so much of a problem if you print small-size prints or use the images online, but it is readily apparent when you make larger-size prints. Noise Ninja (www.picturecode.com) is a very afford-able software program that is the industry standard for reducing excessive noise in digital camera images or scans.

11.6 Do you see any people in this shot from the Trenton, New Jersey, train station? In the time it took to make this exposure about 20 people walked between my tripod-mounted camera and the train as I held the shutter open for 1 minute. Because no one paused in the frame, the low-light level and long exposure time combined to render them invisible. If you look closely at the very far-left edge of the frame, you can see a slight blur of people exiting another door of the train. Exposure: ISO 100, f/22, 60 seconds.

▶ **Movement.** Over long exposures, anything moving that stays in the frame is blurry. Any action in the frame, or even people standing still, may not be tack-sharp, creating an image situation many photographers refer to as *ghosting*.

▶ **Camera shake.** Even with the camera mounted on a tripod, tripping the Shutter Release button with your finger can cause the entire image to be blurry or soft. Also, while bridges can be great places to shoot pictures from, heavy traffic makes them vibrate and this is transferred to the legs of your tripod. If you need to shoot images from bridges or unstable platforms, use the fastest shutter speeds you possibly can to minimize any vibration and check the camera's LCD monitor at full enlargement to ensure sharpness.

Practical Pro Advice

Over many years of shooting pictures long after the sun has gone down, I have found certain techniques that consistently produce a high yield of stunning images. The two most important accessories for successful nighttime, low-light, neon, or firework displays are a tripod and a cable release or remote switch trigger. A tripod guarantees a rock-steady platform for the camera, necessary for sharp images over long exposures, and the cable release affords vibration-free camera operation. Add to these a camera that has the ability to lock up the dSLR's mirror prior to making the exposure. Locking up the mirror removes any vibration the camera may experience by the mirror flipping up to make the exposure. By using these tools, you are on your way to getting the sharpest images possible.

11.7 Remote switches or cable releases, such as the Canon RS-80N3 on the left and the Nikon MC-30 on the right, ensure sharp images by allowing you to trip the shutter without actually having to press the Shutter Release button on the camera and possibly vibrating the camera during the exposure.

11.8 Timer remote controls, also known as intervalometers, such as the Canon TC-80N3 on the left and the Nikon MC-36 on the right, allow you to take a series of photos at set intervals. You can use them to time a very long exposure.

Tripods come in many sizes, weights, and price points. The best tripod is one you take with you and use, so spend some time at a good camera shop with a wide selection trying them out. Take into consideration whether you plan to take it on hikes and day trips or just drive to the locations. Most tripod legs are made of aluminum, which provides an inexpensive camera support system, or carbon fiber, which while lighter than aluminum can be very expensive. Choose a tripod that can securely support your camera and lenses that also suits your budget.

Camera remote switches or cable releases also come in several styles. The two most popular versions, such as ones pictured in Figure 11.7, can handle both short and long exposures. The more expensive ones are called *intervalometers* or *timer remote controls* and can be programmed to take a series of photographs at set intervals, such as one shot every 10 seconds for 1 minute, or one shot every hour for 3 days. You can also use these to time a very long exposure. On most cameras the longest shutter speed available is 30 seconds, but the timer remote can be programmed to expose for whatever length of time your shot requires, whether it's a minute or several hours. Remote switches are indispensable for tripping the shutter without actually pressing the Shutter Release button on the camera. Check your camera body for a port to plug it into. Some manufacturers even have a small infrared triggering device, used for self-portraits and group shots predominantly, but which work well for nighttime photography, too. If your camera is not capable of accepting these accessories, you can always use your self-timer to fire the camera.

In addition, I suggest following these extra methods to get great low-light photos in challenging shooting situations:

▶ **Shoot the moon.** The moon can be a great extra light source for nighttime images. On a clear evening the moon can be very bright and helpful in illuminating your scene. For images *of* the full moon, remember it's daytime on the moon if it's all lit up so use the Moony f/11 rule, which suggests setting an exposure such as ISO 200, f/11, 1/200 second to record the details of the moon's surface.

▶ **Bracket your exposures.** In shooting situations where it's hard to read the light coming from many different light sources, bracket your exposures in full stops by shutter speed adjustments. This way, your focus and depth of field remain constant in case you decide to go the HDR route (explained later in this chapter) later on. Bracketing assures you get the exposure you want.

Moony f/11 Exposure Rule

The Moony f/11 rule is for shooting photographs of the full moon. To get details in the full moon and not blow it out as the main highlight of the image, the proper exposure is 1 over your ISO setting or 1/ISO. Be aware this rule is an approximation and is affected by atmospheric conditions such as smog, haze, and pollution. When the moon is at its half stage, add one stop of exposure by going to f/8 or slowing down your shutter speed by one stop. For a quarter moon go to f/5.6 or make the adjustments to your shutter speed instead. Keep in mind that too long of an exposure can blur the moon because of the earth's rotation, so use a tripod, remote switch, or self-timer to keep the camera steady and vibration-free.

▶ **Build your exposures for fireworks and lightning.** A neat technique for layering several fireworks and lightning strikes into one frame involves setting your camera to Bulb, then opening the shutter and using a black card to block the light from reaching your lens. When using this technique you can use a medium to small aperture and a low ISO setting. You take the card away quickly when the lightning strikes or fireworks pop. This way you can build several of these occurrences into one spectacular image.

▶ **Use the camera's LCD monitor to review your image.** A huge advantage in digital photography is the ability to quickly review the image you just made on the camera's LCD monitor and make adjustments for the next image. This single development alone has considerably sped up learning for new photographers to be able to get the shots they want properly exposed in a wide variety of lighting conditions.

My advice for shooting nighttime and low-light images is to have fun and yet be careful. No shot is worth putting yourself or others in danger. Many great subjects for this kind of work are found in urban settings, so be wise and keep your peripheral vision active, or better yet, bring along a friend and impress him or her with your nighttime photography skills!

Shooting infrared images

Infrared is a spectrum of light that extends beyond the range in which you normally see and can mimic the look of standard night or low-light images with unnatural relationships between the tonality of objects. Digital cameras actually have an infrared filter or blocker installed between the lens and the image sensor that only allows the

visible light spectrum to be recorded. Infrared photography records all the colors of the visible spectrum as well as some of the near-infrared wavelengths that are not visible. Infrared photography can also create a surreal moonlit or nighttime feel to images by producing dark skies and brighter than normal tones.

Although most natural objects strongly reflect infrared rays, no consistent relationship exists between the color of an object and the amount of infrared rays that are reflected. For this reason, many photographers are drawn to infrared photography as a means of creative expression for its surreal, other-worldly effects.

Infrared photography is often distinguished in landscape photography by extremely dark skies and an unnatural relationship between other colors in the visible spectrum. Foliage, for instance, along with clouds, appears as brighter values that make it stand out. To make infrared images, you need to filter out the visible light and only allow the near-infrared and infrared spectrum through to the image sensor.

You can achieve this effect several ways. The most expensive way that yields the purest results is to have a visible light-blocking filter installed in front of your digital camera's sensor to replace the camera's normal IR cut filter. Some photographers who shoot lots of infrared photos have this service performed on an older or spare dSLR body, but the downside is that camera can now be only used for infrared photography.

A more convenient method is to use an infrared filter (misnamed because they don't actually filter infrared) on your camera lens. These filters usually appear nearly opaque as black or deep red glass. Because they block most or all of the visible light, you need very long exposures, so you always want to use a tripod and remote switch. Focusing is critical, so compose and focus with the filter off because it is too dense to see through, then reapply it to your lens and make the exposure. Infrared light focuses at a slightly different point than visible light, so make sure that you use an aperture that provides adequate depth of field.

By far the easiest technique is to apply the approximate effect with software, such as Adobe Photoshop or Lightroom, which is the method I used to produce the wildflower image in this section. This way, you can apply the effect to any of your images to see if you like the results before spending any more money on the filter or costly camera modification.

Shooting High Dynamic Range (HDR) images

High Dynamic Range or HDR photography has become extremely popular for the way it replicates your eye's range of perceiving light in a single photograph. HDR images are created by merging a series of bracketed images in software programs that pick

the best tones of each of the selected images and combine them into one. Ideally, your bracketed images should include exposures that properly record the highlight, midtone, and shadow areas of the scene. This is often beneficial in nighttime scenes where it's difficult to establish an exposure that will accurately render the image. The proper exposure for darker areas of the image will blow out the highlights of light fixtures and buildings and as an added bonus can create some surreal and other-worldly lighting effects and tonality to your images.

You can create an HDR image with just two exposures, but for the full effect, I recommend using three to five images to give the software a greater range of tones to work with. Be sure to adjust your exposure by changing the shutter speed only and not the aperture. Changing the aperture between images results in varying depths of field and a soft-focused final image once the files are combined. Because you are combining several exposures of the same scene, a tripod is mandatory for sharp results, although the software includes some controls for reducing ghosting artifacts for foliage and water or moving objects or people.

11.9 This image of the Old Market Pub was created by merging five exposures in Photomatix Pro 3. Exposure: ISO 200, f/4, varying shutter speeds.

The most popular software for creating HDR images as of this writing is Photomatix Pro 3 from HDRsoft (www.hdrsoft.com). The software creates a tone-mapped HDR file by combining your bracketed images into one file that you can adjust further using several sliders to tweak the image to create the look you want. The final image can then be saved as an 8- or 16-bit TIFF file or as a JPEG.

Portrait Photography

Peleople are probably the most photographed subjects in the world simply because images of them — whether family, friends, or strangers — trigger so many emotions. Successful candid and portrait photography depends on many factors, but none is more important than the lighting and the setting. You may decide to work the natural light, use flash in a controlled environment such as a studio, or set up strobes outdoors. However you like to do it, managing and manipulating the light is paramount to making portraits that are satisfying to you and your subject. Using the time-honored skills of lighting, posing, and making a connection with the subject, photographers can create lasting images that have the potential to convey deep inner feelings. This chapter presents several styles of traditional portrait lighting for you to consider and some new ones, too, which enable you to produce honest portraits of life.

A quick snapshot of my daughter Brenna standing in front of a window in a hotel lobby with Seattle's Elliot Bay in the background. I dialed in -1 exposure compensation to darken the clouds and sky and made sure I was shooting at an angle to the glass so as not to get a reflection from the flash. Exposure: ISO 400, f/6.3, 1/2000 second.

Preparation and Considerations

There are many approaches to taking great pictures of people, whether you are shooting individuals, groups, or wedding photos, but in all cases it helps to have empathy for your subjects. The goal should always be to bring out their best looks and tell the viewer something about them.

After you decide on your subject, your first consideration is where to photograph him or her and how to handle the lighting. You may find yourself photographing someone in a gym, workshop, or office location that is foreign to you, so knowing how to get great light anywhere makes your job that much easier.

12.1 A casual outdoor portrait of Paul and Laurie Daly. I used one speedlight fitted with a Honl 1/4 CTO gel shooting through a small white umbrella on a light stand camera-right to kick some warm light into their faces. Exposure: ISO 50, f/4, 1/200 second.

The following is a small list of items to consider bringing along the next time you set out to take portraits:

▶ **One or two camera bodies.** The optimal solution is to have two camera bodies, one with a fixed, large aperture lens such as 50mm f/1.4 or an 85mm f/1.8 lens, and one with a telephoto zoom lens such as the 70-200mm f/2.8.

▶ **One or more flashes.** Off-camera flash used to create portraits provides exceptional light quality. Small flashes come in handy for portrait situations when you need to illuminate a background or add a rim or hair light to the subjects to separate them from the background.

> Telephoto lenses are ideal to start a shooting session with because they compress the image, help isolate the subject, de-emphasize the background, and generally create better images of people than a wide-angle lens does. Telephotos also keep you a respectful distance from the person you're photographing, who may feel uncomfortable with a closer approach. As you begin to build a rapport with your subjects and make them feel more comfortable with you and your abilities, they loosen up and allow you to move in closer.

▶ **Light modifiers.** When an assignment involves shooting individual portraits with flash, a handy portable lighting setup might include one to three speedlights mounted on stands with light modifiers, such as an umbrella, softbox, or grid.

▶ **Tripod and monopod.** Having a lightweight but sturdy tripod is essential. In addition, a tripod head with a quick-release plate increases the steadiness of shooting portraits, especially when using long lenses.

▶ **Silver and gold reflectors.** Collapsible round reflectors of various sizes are great for filling shadow areas and adding a sparkle to the eyes when shooting individual portraits.

▶ **Makeup kit.** Don't rely on your subjects to have their own makeup. Touch-ups of hair and makeup between shots are often necessary. Cosmetic blotters reduce shine from facial oil, a neutral-tone lip gloss adds shine to the lips, and concealer hides blemishes and dark circles under the eyes. Clothes pins and safety pins can help make loose garments fit better and remove wrinkles.

▶ **Portable background and stands.** Whether it's a roll of seamless paper or muslin, having a portable background that's easy to assemble and tear down for location portraits is exceptionally handy.

Practical Pro Advice

Here's a list of some of the techniques that I've found most useful in shooting successful individual and group portrait images:

▶ **Focus on the eyes.** They say the eyes are the windows to the soul, but if not, they sure are the most dramatic feature in portraits. With any animate subjects, as long as the eyes are in focus, the photo registers as sharp.

12.2 Raven Mead cuts up for the camera during her portfolio shoot. I kept the main beauty dish low to get under the brim of her hat, a yellow gel on the top light for separation, and a red gel on a flash fired into a gray muslin background. Exposure: ISO 100, f/8, 1/125 second.

▶ **Pay attention to hands and feet.** Hands especially are great to work into a portrait, but be mindful of their placement. Because hands and feet often protrude out in front of the face, they can look huge in the shot, so keep hands in proportion by turning them so the side of the hand faces camera.

▶ **Maintain proportions for kid shots.** Compose shots of kids from their eye level; this means you may have to get down on the ground with them to shoot. Shooting at their eye level keeps their heads in perspective and places them in their environment the way they see themselves.

▶ **Pose groups of people as you'd arrange music.** In this easy-to-remember analogy, you begin by placing the first person and then the next with an eye toward creating a pleasing blend of shapes and sizes within the frame. Create a natural flow from person to person in the group, as if the viewer is following a visual map. Focus on the middle row of the group and use a smaller aperture for greater depth of field than you'd use for individuals.

▶ **Use contrast for composition strength.** The viewer's eye is always drawn to areas of greater contrast — a light subject against a dark field and vice versa. In addition, the sense of sharpness of a photograph is increased by the skillful use of contrast.

▶ **Remember that kids rule.** The wise photographer works with the mood, energy, and flow of younger subjects rather than against them. Children often have short attention spans. Work quickly, but be flexible and engage them in the picture-taking process. If kids are included in groups, I save them for last and usually have them in the front, because this makes them appear more in proportion with the larger adults.

▶ **Engage with the subjects.** A primary means of human communication is with the eyes. If you're buried behind the camera, you run the risk of losing the connection with the subject. Use a tripod or come out from behind the camera frequently to give positive encouragement.

▶ **Show instead of tell.** Describing to other people how to pose is hard work. Instead of describing what you want them to do, move to their position and assume the pose or position that you want them to mimic. Portraits are best when the effort becomes a two-way street, so as you demonstrate, talk about your ideas for the portrait and also ask for the subject's ideas. Be supportive. Smile. Listen.

Studio portraits

As your interest in portrait photography grows, you may want to consider putting together a small lighting kit to use in a studio or on location. With the high ISO capabilities of today's digital cameras, you don't really need big, expensive studio lighting gear. These days, a studio portrait can be realized anywhere by taking along your speedlights, a background, and a few lighting modifiers. Creating a home studio provides a dedicated space in which to shoot and allows you to leave your lighting gear set up.

To create studio-type portraits, start with one flash as your main light and add other flashes as your budget allows. The lighting setup typical of most studio portraits includes a main light on the face, a fill light, hair or edge light, and a background light.

A steady trend in studio and location portraiture today is more of a lifestyle approach. Lifestyle shooting seeks to portray the subject in a natural setting that is typical for that particular subject, and when you are familiar with current cultural or musical trends you can use these styles to create unique and memorable portraits.

12.3 This studio portrait utilizes a three-point lighting setup: one main light for the face, a hair light, and a light for the background glow. Exposure: ISO 100, f/5.6, 1/100 second.

12.4 Office portrait of Web developer Jake Scott. The company wanted portraits that showed the owners working in their normal environment rather than studio head shots, so I composed a shot of him behind a laptop screen. The blue glow of the screen was actually simulated by placing a small flash on the laptop keyboard and aimed up at his face. Exposure: ISO 50, f/5, 1/125 second.

Outdoor portraits

Part of the fun of shooting portraits outdoors is that you usually have lots of room to work and you have plentiful options for backgrounds. My first concern with nearly any portrait is what the background is going to be, and from there, I build my shot forward to the camera. This is especially true in outdoor portraiture where I am using natural elements as the background. I create portraits for a wide range of final uses, and I am always mindful of what these uses are before I even take the first frame. Small speed-lights can be used to mimic the sun or create lighting that looks entirely natural in an outdoor portrait.

For a business portrait where I want to imply strength, power, and control, I might opt for starker lighting or a street scene with an office building or more polished background. For personality shots, I might try to capture a look or mannerisms that the subject's friends would say embodies his or her spirit, and then choose an uncluttered outdoor setting that complements that feeling.

Outdoor lighting presents many challenges similar to creating your light from scratch as in the studio. You must decide what the background is, where the subject should

be placed, and where to position your lighting or reflectors. The lighting should provide beautiful facial illumination and be appropriate for the subject's face, skin tone, and personality. Midday, direct sunlight is harsh light to work in and is guaranteed to produce dark shadows under the eyes, nose, and chin. I use a 42-inch round diffusion panel to soften the light when I have no alternative but to shoot in bright sunlight because of location or scheduling. I might also try to find an area where the subject is shaded from above, such as by the roof of a building, an awning, an alleyway, or a tree and use a small flash for fill or as the main light source. These locations soften the light on the face and keep the subject from having to squint into the bright sunlight. For fill light, I use a silver or gold reflector to bounce a little edgier light back into the face or a white reflector for softer fill.

12.5 A casual portrait of Paul and Laurie Daly, photographed in a local park with one speedlight zoomed as far as it would go to minimize the spill, firing through a small white umbrella camera left. Exposure: ISO 100, f/5, 1/160 second.

12.6 Jake and Tiffany photographed in Portland's Park Blocks for their engagement session. I chose to shoot under the trees because it was a bright and sunny day to cut down on the amount of available light I had to deal with in the shot. Exposure: ISO 400, f/5.6, 1/60 second.

Perhaps the ideal outdoor portrait light occurs on an overcast day. This gauzy light is diffused naturally by the clouds to provide a soft light source. While overcast light is flattering for all types of subjects, I've found it is especially flattering for portraits of senior citizens, women, and children. When it's too bright overhead, parts of the face fall into shadow and need to be perked up. A simple silver or white reflector in the right spot fills shadows and adds important catchlights to the eyes.

Alternately, open shade produced by large areas of sky on a sunlit day, where the light is blocked by an object such as a building or a tree, also provides soft light. When shooting in the open shade, be aware of how the shadows are falling, even though the light is soft. Then, to add a little bit of rim light to define shape and form and create separation from the background, a speedlight flash or 42-inch white, silver, or gold reflector off to one side of the subject really does an effective job.

12.7 My assistant Aaron holds a 42-inch collapsible Westcott white/ silver reflector to brighten the shadow side of our model, Rhonda, for this outdoor portrait. Exposure: ISO 500, f/2.8, 1/80 second.

If you're photographing a subject in open shade with a bright background, be sure to move in close to the subject's face and meter on the face (with the reflector in place), and then use the exposure from this reading to make the image.

Two beautiful times for outdoor portraits are the hours just following sunrise and preceding sunset. The low angle of the sun striking the subject's face provides dramatic

and very warm illumination. Watch your backgrounds and don't allow them to go too dark. Use reflectors, a piece of foamcore, a cooler lid — whatever's handy — to fill in the shadow side of the face and lower the contrast.

Night portraits

Once the sun goes down, you don't have to put your gear away and quit shooting portraits. The evening palette of colors is constantly changing, and as city lights come on, many different light sources come into play affecting the color balance.

When shooting portraits at night, remember that your onboard flash or external speed-light does not have enough power to properly expose the subject and the background unless they are very close. In order to get enough light to raise the background value, you may need to use a slower shutter speed than normal — a technique called *dragging the shutter*. You could also use a separate light unit for the background.

12.8 I used just two speedlights triggered with RadioPoppers to photograph artist and videographer Lyle Morgan in this scene. One speedlight was used for the main light placed inside a small FJ Westcott softbox, and another one was fitted with a Honl 1/4-inch grid attachment to create the pool of light on the background. Exposure: ISO 200, f/2.8, 1/200.

If you are using small speedlights to shoot night portraits, using a tripod is a good idea but not really necessary. The flash from speedlights has a short duration, around 1/1000 second, which effectively becomes your shutter speed for your subject. The background, which is probably soft anyway due to a larger aperture being used, won't suffer terribly and can even benefit from any motion blur.

Lighting modifiers are described and shown in Chapter 6.

Group portraits

The successful group photographer must also be a cheerleader, showman, and herder. Group photography can involve taking pictures of couples, families, or entire companies. With more subjects comes more responsibility to make everyone look good. Added to that is the challenge of getting everyone's attention, balancing the pose, and shooting quickly. Nobody likes to stand around for a group photo while the photographer messes around with his gear.

When setting up for groups, show up early, look for a good location or background, and shoot some tests before anyone arrives so that you are ready to go when they are. It's a good idea to be really clear on where the pictures are supposed to be taken and make sure you have permission to be there. One time I was all set up to shoot a group portrait of a golf team and the sprinklers came on automatically, soaking everything. Another time I was ready to photograph a baseball team when two other teams showed up at the last minute, demanding to use the field for their scheduled game. It pays to plan ahead.

Arranging people in geometric patterns, such as diamonds or triangles, works well when shooting a few people, but you can still be creative with a lot of bodies in the picture. Depending on how the photos were meant to be used, I have staged pyramids of cheerleaders, pig piles of soccer and volleyball players, and goofy shots of softball and basketball teams after the standard picture was taken, to the great delight of the participants.

As you stage the shot, try to have the most important people of the group in the center, whether it's grandparents on their anniversary day, a wedding couple, a child on her birthday, or a CEO at the year-end board meeting. If space is at a premium, attempt to position the others in the group so that they fall into *windows* — that cavity of space between two people standing shoulder to shoulder. This creates a pattern much like musical notes on a scale, giving each person some space around his or her face, and makes the eye dance around the image rather than zipping down a row of faces. The intent is to make everyone an individual and appear that way in the picture.

12.9 Dr. Ryan Mueller and his staff photographed in my studio for their office and brochure. The diamond arrangement works to make each individual stand out in a group photograph. Exposure: ISO 100, f/10, 1/100 second.

The size of the group really dictates how much lighting I need to expose the shot. For smaller groups, I may use one speedlight with a softbox or umbrella positioned directly over the camera or off to the side, and another undiffused flash opposite this light to create an edge light or fill.

For larger groups where I need all the power I can get, I may dispense with light modifiers altogether and use two or more speedlights or monolights. I aim them directly at the group from an approximate 45-degree angle and feather the light to overlap. If I'm indoors, I bounce several flashes into the ceiling for broad, soft, natural light.

Portrait Lighting Placement

When speaking about studio lighting styles it's best to keep these definitions in mind. Photographers speak of lighting setups by using terms like *key*, *fill*, and *bounce* to describe the lighting placement, the intensity of the light source, and how large or small the light source is.

▶ **Key.** The key or main light is the light that illuminates the subject and tells the story. It can be a shaft of sunlight, a reflected light source, cloudy sunlight, or a flash.

▶ **Fill.** Fill is any light that is reflected back into the shadow areas of a face or subject. The goal of fill light is not to kill the shadows completely but to add light to the shadowed areas and diminish some image contrast.

▶ **Bounce.** Anytime the light source is aimed away from the subject toward another surface to reflect light back onto the subject, this is referred to as bounce light. The light bounces off the surface, picks up whatever color it is, and scatters the light in the direction of the subject, producing subtle gradations of softer light.

The two basic types of studio lighting for making portraits are called *broad* and *short* lighting. You have probably already shot some portraits using these styles and not even thought about it.

Broad and short lighting

Broad (or wide) lighting refers to a key (main) light illuminating the side of a subject's face as she is turned toward the camera (see Figure 12.10). Short lighting is created when the key light is positioned to illuminate the side of the subject's face that is turned away from the camera, emphasizing facial contours, as shown in Figure 12.11.

Broad and short lighting techniques apply when shooting outdoors as well. You can use the same techniques when you shoot portraits outdoors and use the sun as your main light and a speedlight as a fill. Using sunlight as your main light source and positioning your subject to take advantage of these principals can produce flattering results for your outdoor portraits.

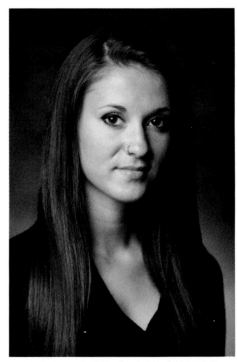

12.10 Adrienne Luba photographed in broad lighting. The main light illuminates the side of her face that is turned toward the camera. For this and all the following examples of Adrienne, a secondary light was added to separate the portrait from the background. Exposure: ISO 50, f/4, 1/100 second.

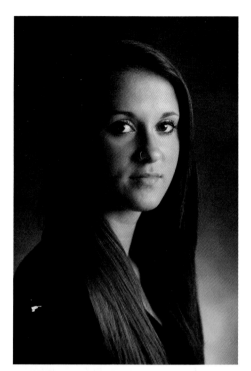

12.11 Short lighting illuminates the side of Adrienne's face that is turned away from the camera. Exposure: ISO 50, f/4, 1/100 second.

Front lighting

Front lighting is used to describe the technique of placing the light source directly in front of the subject so that any shadows fall away from the camera toward the background. From a camera-mounted speedlight or pop-up flash, this type of lighting is often the least flattering, compressing the subject and exacerbating any surface skin shine. But when used with diffused lighting sources such as a beauty dish, ring light, octabank, or softbox, this type of lighting is very forgiving and provides a beautiful, glamorous look. There are also many commercially available softboxes for shoe mounted speedlights and several plans for making a homemade beauty dish for your speedlights on the Internet that soften the light from the flash.

No matter where you place your lights or flash, consider these qualities of light when planning your shoot:

► **Diffused/soft lighting.** Much more desirable when you shoot portraits, soft lighting is produced by diffusing the main light source with plastic, fabric, or some other translucent material. This lighting quality helps soften the contrast and skin texture (a highly desirable effect) in a portrait. This technique provides much more natural lighting effects and produces realistic-looking skin and hair.

► **Bounced/angled lighting.** Bounced or angled lighting involves aiming your strobe into a reflective umbrella or toward the ceiling, moving the flash off of the camera to fire remotely, or using the previously mentioned wireless system. Bouncing the light off these surfaces scatters the light rays to strike the subject from many different angles, producing a softer, more diffused look to the image.

CROSS REF

See Chapter 6 for more information on setting up wireless flash systems.

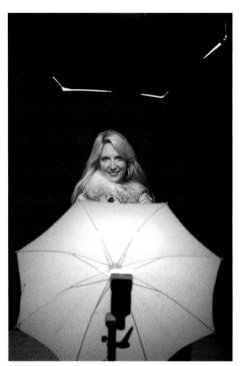

12.12 This shot shows my lighting set up for front lighting the model. My main light is fired into an octagonal softbox placed above the head about 6 feet away from her and the fill light is diffused through a small white umbrella just below her face from the same distance. The camera shoots through the gap between the two. Exposure: ISO 100, f/4, 1/160 second.

▶ **Mixing ambient or natural lighting.** You are often faced with mixing available light sources in a scene, whether from existing indoor ambient lighting or the natural light streaming from a window. You may need to add a colored gel to your flash to match the temperature of the existing ambient light.

Portrait Lighting Styles

Most portrait photography utilizes some interpretation of the following time-tested lighting styles. You have probably used these patterns already and just didn't know what they were called. When you set up to create portraits, these lighting styles, each with their own strengths and weaknesses, should be considered. I also explain briefly the shadowless lighting style that can be achieved with ring lights and several other commercial products.

Butterfly/Paramount

Also referred to as the Hollywood glamour style, this style of lighting is often used in model and celebrity photography. It gets its butterfly designation from the shape of the shadow that the nose casts on the upper lip. This technique can be used with the model looking straight into the camera, or used with the head slightly turned to one side. You achieve this type of lighting by positioning the main light directly above and slightly higher than the eyes in front of your portrait subject and a fill light just below.

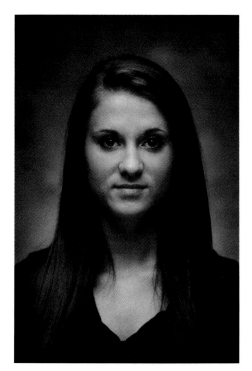

12.13 An example of butterfly-style portrait lighting shows the classic butterfly shadow under Adrienne's nose. Exposure: ISO 50, f/4.5, 1/100 second.

Studio photographers usually use a softbox, octabank, umbrella, or beauty dish to create this look.

This lighting style is also referred to as Paramount in some circles. It was used so extensively by Paramount Studios in Hollywood's golden age, that this lighting pattern became synonymous with the studio's name.

Loop

Probably the most commonly used lighting technique for portraits today, a minor variation of Paramount lighting. Loop lighting is achieved by lowering the main light and moving it more to one side of the subject. Make sure to keep the light high enough so that the shadow cast by the nose — the loop — is at a downward angle on the shadowed side of the face, yet low enough to create catchlights in the eyes.

In loop lighting the fill light is positioned the same height as the camera-subject axis. The fill is positioned so that it does not cast a shadow of its own to maintain the one-light look of the portrait. To be considered true loop lighting, the loop shadow from the nose area should not touch the shadow area on the side of the face. This is a very flattering lighting pattern I use all the time in the studio.

Rembrandt/45

Lighting your subject in the Rembrandt style mimics the lighting effect the old master used in many of his paintings to add dimensionality to the scene. It is similar to short and broad lighting but the distinction lies in the shadow of the nose touching the shadow on the shadowed side of the face. By placing the light this way, a small triangle of light is created on the side of the face in the most shadow, just under the eye.

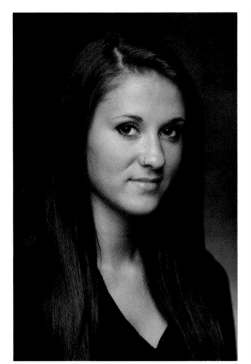

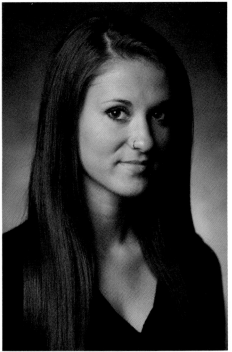

12.14 Loop-style portrait lighting.
Exposure: ISO 50, f/4, 1/100 second.

12.15 Rembrandt-style portrait lighting.
Exposure: ISO 50, f/4, 1/100 second.

The Rembrandt style is created by placing the light at a 45-degree angle, slightly higher than the subject but still low enough to produce a catchlight in the eyes.

Split

Placing the main light at a 90-degree angle to the subject throws the other side of the face into deep shadow and creates mood, drama, and a bit of mystery in your portrait. This technique gives the photographer less of a canvas to work with, as half the face is in shadow, but it can add great power to a portrait. Having a little concealer makeup or powder on hand to help your subjects look their best can reduce the probability of skin texture. This type of lighting from the side shows off any texture in the light's path and highlights any skin imperfections.

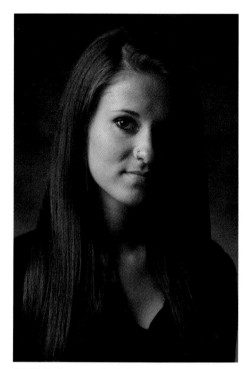

12.16 Split portrait lighting. Exposure: ISO 50, f/4, 1/100 second.

12.17 A portrait using the modified split/ rim lighting style Two speedlights were used for this image; one was placed in a Westcott octabank for the main, and the second, undiffused and slightly behind his left side, was used for the rim light. Exposure: ISO 100, f/4, 1/200 second.

Modified split/rim

This style of lighting involves adding a secondary light source to the split-lighting mix, often undiffused, to create a rim of light around the subject that separates him from the background. In Figure 12.17, a rim light is used to create separation of Aaron's hair from the dark background. This rim light can also be fitted with a colored gel to add some contrasting or complementary color to the image, while retaining all the separating qualities afforded by the position of the flash.

Shadowless

Several configurations of equipment get you into the style of shadowless lighting. Ring lights that encircle the lens are often used, or you can try positioning the light sources very close to the camera and above and below or to the left and right of the subject's face. Combined with setting the light output to equal ratios, shadowless lighting is very forgiving to skin tones and delivers a very modern, stylized look. Pay attention to makeup and skin detail when using this lighting setup.

12.18 This image of Adrienne shows an example of the shadowless lighting style produced by an Alien Bees ABR 800 ring flash. Exposure: ISO 100, f/8, 1/60 second.

Still Life and Product Photography

I n still life and product photography, lighting is the key to making the image, and thereby the product, sell. You use creative lighting to convey the feeling or lifestyle situation associated with the object being photographed. You can also use lighting to show or diminish texture, highlight color and form, and turn a mundane image of a shampoo bottle into something the consumer can't live without. In this chapter, you learn some simple lighting techniques for creating still life and product images for advertising, online auctions, legal documentation, or collection cataloging. Along with lighting, the design of the image and placement of the objects are equally important components that need to work together. When you add elements of design to your lighting, you strengthen the composition to make a complete statement.

This appetizer image was shot as a detail after photographing the entire platter on location for a catering client's brochure and Web site. A small studio was constructed in the client's kitchen to facilitate shooting quickly and provide lots of substitute models in case some were not camera-worthy. Exposure: ISO 100, f/11, 1/125 second.

Preparation and Considerations

Studio still life photography requires a lot more practical lighting technique than sports or fashion work, which are more spontaneous types of photography where the photographer reacts to action. With still life photography, the photographer creates the lighting from scratch or places the object to take advantage of natural or studio lighting. You can use almost any kind of light to light the product: window light, studio flash, or even a black light, which you see an example of later.

Photographers have to create the energy of the lifeless product with the many lighting modifiers at their disposal. It is a fairly structured discipline that involves problem solving to make the product look its best. For a beginning photographer, still life and product photography is a great way to jump in and hone lighting skills in a control-

13.1 Even a seemingly mundane subject such as this circuit board can be made to look exciting with consciously designed lighting. Exposure: ISO 100, f/22, 1/60 second.

lable environment. The small space required and low cost of tools and props used in this type of work make it a great activity to begin learning about light and what it does.

Shooting commercial products

When I set up for a product shot, the first consideration is usually what mood the photo needs to take on, either from a client or my own imagination, and how best to achieve it. This leads to selection of the background, lighting angle, colors, and composition.

The background is an important consideration when photographing products or still life scenes because it has to complete the composition and hold the subject. Having an uncluttered background in order to showcase your subject is often best although you may want to show the particular item in context the way it would be used. Once all these considerations are established, begin to place the items into the scene, paying close attention to the balance of the composition.

Diffused lighting is often essential in this type of photography. Studio softboxes in various sizes and configurations create large soft light and continuous highlights that cling to the edges of products like a second skin. The idea is often to light products naturally in a studio with a mixture of soft and hard light to create three-dimensionality.

13.2 You don't need a lot of fancy tools or much space to make great product shots. This handmade basket was placed on a glass table and illuminated only by soft window light striking it from the right-hand side. Exposure: ISO 400, f/5.6, 1/40 second.

Even with diffused lighting, some of the shadow areas may need some filling in. You can do this by using a second strobe as fill or by using a fill card or small mirror. Fill cards can be made out of a piece of white foam board (Foamcore) or poster board and are used to bounce the main light back into the shadows. You can also use silver and gold foil card stock purchased from an art supply house for higher intensity fill light. When you use two or more flashes, be sure that your fill light isn't too bright or equal to the main light or it can cause the image to have two crossing shadows, which looks unnatural. Remember, the key to good lighting is to make the object look sexy and desirable, promoting an emotional response within the viewer. That's why wristwatches are always set to 10:10 in advertisements. This position moves the hands away to show the watch's insignia and creates a subliminal smiley face in the mind of the customer.

Another great idea for quick shots of small products and items is the studio-in-a-box used with a few speedlights. There are several commercially available versions of this idea, but it is very easy to make your own. Any size box works for this, but I prefer a 16 × 16 × 16-inch box for the wide size range of products it can accommodate.

You simply cut the cardboard out of three sides of the box about 1 inch from the edge and lay it on the one remaining side with the open box top facing you. Tape some tracing paper, velum, or tissue paper over the squares you just cut out of the sides, add a piece of black or white tile or Plexiglas to act as your shooting surface and a piece of colored paper for the background. Position your flashes to fire from one or both sides, or from the top.

There are a number of other low-cost devices on the market that can be used directly on small flashes to provide modification and diffusion to the light. My favorites are the Lumiquest 80-20 light shaper, Gary Fong's Lightsphere, and the line of Honl Photo Speed System tools previously mentioned in Chapter 6, all of which attach to the flash head and modify the light to a very pleasing degree.

13.3 Shooting a product in a lifestyle situation involves featuring it in a realistic setting and may include props to aid the composition. This dishwashing liquid was placed on a countertop and shot toward an open window so that the hazy sun could backlight the frosted bottle. Exposure: ISO 400, f/8, 1/500 second.

13.4 Brushed aluminum Formica was used as the base and background for the handmade glass charm of a baby dragon to give a slick, clean look. Placement of one overhead strip bank softbox allows the Formica to sweep into the shadowed background area, placing emphasis on the artwork. Exposure: ISO 100, f/14, 1/100 second.

13.5 A square box can become a beautiful light studio for small products with this homemade studio-in-a-box. I also used a Canon Transmitter and the RadioPopper sytem to shoot advanced TTL flash to light the camera. Exposure: ISO 400, f/22, 20 seconds.

Shooting for online auctions

Shooting for online auctions may not require as much technical lighting expertise as a commercial product shoot, but the overriding principles of showing the item in its best possible way remain the same. Simple, clean backgrounds where the subject remains the star work best. Depending on the item, white, black, gray, blue, and red are the most popular background colors.

13.6 Twin lens reflex camera product shot by using two small flashes, RadioPoppers, and the studio-in-a-box. Exposure: ISO 100, f/22, 1/60 second.

Another important consideration regarding shooting online auction images is total honesty in the way the item is depicted. You can add marbles to soup to make the stock rise to the surface for a shot to illustrate a healthy lunch, but not for a shot where you are selling a particular brand soup. Do not use images you find online to sell your item. Potential customers want to see the item they will be buying, not some slick product shot of a brand new item. Likewise, any flaw, crack, chip, or scratch on an item you're trying to sell online should be shown with a picture or at least described accurately in the copy of the ad. Your potential customer will appreciate your honesty, and this will lead to more trust and a flawless feedback score. And if I find a significant flaw in the cosmetics or function of an item I've purchased in an online auction, I photograph it and send it to the seller for a possible price adjustment or return.

13.7 Positioning one small softbox above and slightly behind this handmade bead necklace creates a slight ghost highlight on the marble surface, mimicking the necklace's circular shape. Exposure: ISO 100, f/16, 1/100 second.

13.8. No matter how bad the condition of an item you want to sell online is, you must present it honestly to your potential customers. Found in a chicken coop, this photo shows a few post-war Lionel diesel locomotives in their pre-restored condition. Exposure: ISO 100, f/16, 1/100 second.

13.9 Fully restored, these locomotives are a thing of beauty to Lionel train buffs. Posting this image online to sell similar trains that haven't been restored would be totally dishonest and result in poor feedback. Exposure: ISO 100, f/16, 1/100 second.

Shooting food and beverages

Food and beverage photography possesses its own special set of circumstances that must be dealt with and is probably more challenging than other types of table-top work. There are lots of special tricks involved to make food and drinks look desirable. Photographers who shoot a lot of food and beverages know to use clear Lucite blocks for ice cubes because they don't melt. They mix a shortening, corn syrup, and powdered sugar recipe for fake ice cream because it won't melt, either, and they always tuck in the ends of spaghetti for a neater, organized appearance on the plate and often call on stylists specialized in preparing food for photography. Check for evidence of this technique the next time you're in the pasta aisle of your favorite supermarket.

Beverages have their own set of considerations. Drinks like wine, beer, or cola can appear nearly opaque when photographed. Prop up small pieces of silver and gold foil card behind the dark bottles to kick light back into the liquid toward the camera to brighten the drink's tonal value. Additionally, these cards provide a smooth, gradual falloff of light and prevent the viewer from seeing through the bottle to the background. Small, inexpensive makeup mirrors are also used in beverage shooting to place highlights directly where you want them or to lighten up deeply shadowed areas.

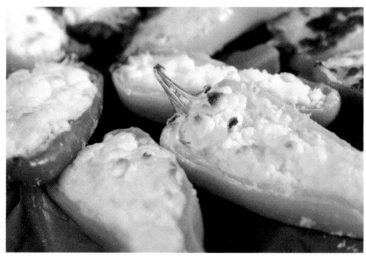

13.10 Limiting depth of field using a combination of close focusing and a medium aperture is a current style of modern food photography, such as in this shot of cheese-stuffed peppers. Exposure: ISO 100, f/9, 1/160 second.

Practical Pro Advice

For beginning practice, try using some personal items. Objects such as jewelry or watches, glassware, or tech items make great subjects to learn about lighting product photography. If you're interested in cooking, try photographing some of the interesting dishes you can prepare. Fruits and vegetables are always good subjects, especially when they have vivid colors or interesting texture.

Product photography is all about marketing the item. There are a variety of ways this is accomplished but the most common ones are adding a splash of color by using gels or using selective focus to pull the viewer's attention to a certain part of the image. Focusing the light from the flash on a specific part of the product can help to add a little more mystery to the image.

Here are some ideas to keep in mind when creating still life and product photography:

▶ **Keep the items clean.** Clean your items with window cleaner, household cleaner or use Armor All to improve surface shine before the product ever goes on set. Spray the cleaner on a lint-free cloth to clean the item rather than spraying it on the item directly. Wear cotton gloves available from a camera shop if you have to handle items with glossy surfaces to avoid getting fingerprints on the objects, and use a small wand or stick to position them on the set. Lighter fluid or Goo Gone is great for removing adhesive residue left over from stickers, price tags, and so on.

▶ **Keep it simple.** Don't try to pack too many objects in your composition. Having too many objects is distracting for the viewer, and the intent of your photo is diminished if the shot appears too busy.

▶ **Use items with bold colors and dynamic shapes.** Bright colors and dramatic shapes can be eye-catching and add interest to your composition.

▶ **Use speedlights.** Because of their small size and generous light output, speedlights are perfect for lighting small arrangements, still lifes or products. The tabletop stands that come with the speedlights are ideal for easily positioning the flashes around the set to light the subject. I rarely use automatic flash exposure modes in these situations, preferring to adjust the individual flash outputs manually for complete creative control.

▶ **Vary your light output.** Product photography really doesn't have to adhere too closely with natural lighting principals, and you see evidence of this every day in magazines, TV, and the Internet. Light the set in such a way that the product becomes the star, stands out from the background, and possesses the brightest highlights.

13.11 This is a studio photograph of a saxophone for a jazz musician's Web site. Exposure: ISO 100, f/11, 1/60 second.

13.12 A black light secured to a Mathews Arm with Velcro ties is all that illuminates these glowing fishing lures. Black velvet was used for the background to add to the composition and keep the attention on the lure. Exposure: ISO 1600, f/11, 1/15 second.

Other than the required product or arrangement of items, here is a list of things to use to make your images stand out:

▶ **The right lens.** Depending on your subject, different lenses produce different optical effects with hard geometric shapes. Lenses I use for product and still life photography include a 100mm f/2.8 macro, 50mm f/1.4 prime lens, a 24-70mm f/2.8 zoom lens, and a 70-200mm f/2.8 Image Stabilized zoom lens. Often, the camera angle or lens selection can make the object look askew, even when it's posed correctly. You need to tilt and adjust the product with small shims of cardboard, wood, or plastic so that it looks natural, yet hide the items you used to do this from appearing in the shot.

13.13 Product shot for a fishing lure distributor's Web site photographed under black light to only show off the product's translucent colors with fluorescent effects. Exposure: ISO 400, f/8, 1/4 second.

▶ **Surfaces.** You can collect various size surfaces for your product photography that work well for tabletop work such as tile samples; black, white, and colored Plexiglas; brushed aluminum Formica; along with different types of inexpensive wood panels that can be used to simulate desks and furniture. Seamless background paper rolls in various widths can be purchased from a photo supply house and come in a wide range of colors and are affordable and durable for many tabletop uses. Be on the lookout for interesting items you can use as a shooting surface, because it's the foundation of your shots and it's always great to have several options.

▶ **Use black velvet for total black backgrounds.** For tabletop work, black seamless paper does not photograph black enough for small objects. Use black velvet instead and pay critical attention to dust and lint that finds its way onto it. Use a lint removing roller from a drugstore or a loop of duct tape wrapped around your fingers to remove the dust and lint.

13.14 This semiprecious stone was photographed on a piece of black velvet placed on a sheet of glass. A small hole was cut in the velvet under the stone to let the light from a small speedlight positioned under the table penetrate the stone and make it appear to glow. Exposure: ISO 100, f/32, 1/60 second.

▶ **Canned air, Q-tips, and small brushes.** Once you have your shot set up, the last thing you want to do is ruin it by trying to remove a speck of dust, lint, or other debris from the setup. These items allow you to remove the intruder without disturbing your assemblage. Dust and clothing fibers can appear huge in a small jewelry image, so take the time to study your composition through the viewfinder to spot any foreign objects that should not be in the final shot.

▶ **Fun Tak temporary adhesive or floral adhesive spots.** Fun Tak is sold in most supermarkets and stationery stores as a method of putting up children's wall posters without using thumbtacks or pushpins. Its excellent sticky qualities make it ideal to hold items together or in position on a set for photography. It usually comes in very bright colors, so be sure to check for any visibility before tripping the shutter. Butyl, a black material for weather sealing automobile windshields, also does a good job of holding small items in place.

▶ **Monofilament fishing line.** Commonly known as fishing line or leader, monofilament is popular with studio still life photographers because of its strength, availability in all gauges, and low cost. It comes in many colors such as white,

green, blue, clear, and fluorescent, and is unsurpassed for hanging items in mid-air to give a floating effect in the photo. It is easily retouched out of the photo before publication to complete the illusion.

▶ **Mineral or castor oil for water drops and dew.** Real water evaporates and is very uncontrollable on set, while these oils stay put and last in position for days. Apply the oil with a small stick or paintbrush with an eye for design and as a way to add spectral highlights to areas that need them. Also, it's widely used to fake sweat on human subjects on top of a layer of baby oil.

Wedding Photography

As your sensitivity to lighting grows and your passion for photography becomes more evident to your family and friends, it won't be long before you're asked to shoot a wedding. This chapter offers tips to make sure you get the best images possible on the big day. Unlike almost any other genre of photography, weddings involve shooting all the major styles — portraits (the bride and groom), group shots (the wedding party and families), events (the ceremony), products (the shoes, place settings and gifts), still lifes (the flowers), close-ups (the rings), and action (the reception and dancing) — all in one day! Photographing a wedding can be an admittedly stressful yet thoroughly enjoyable experience that will keep you on your toes looking for great light and great images.

I always make sure to photograph the cake, flowers, and place settings to tell the story of the day. Exposure: ISO 100, f/3.5, 1/50 second.

Preparation and Considerations

Preparation can go a long way toward your final success, so here's a review of getting set up for a typical wedding day. It helps to become familiar with all the wedding locations beforehand to get a feel for the light at the time of day the wedding will occur, and to scope out some great shooting locations that offer good backgrounds or situations. You could also take a compass, smartphone, or GPS unit or a little point-and-shoot camera set to video mode to remind yourself what the lighting will look like and keep a list of cool locations.

14.1 The entire wedding party feels lighter than air in this fun shot before the wedding ceremony in Honolulu, Hawaii. Exposure: ISO 1000, f/8, 1/180 second.

It's also a good idea to know what time the sun will set for those weddings that progress from day to evening. By making a note of this and keeping an eye to the sky, you can quickly snag the wedding couple outside for a few minutes to make a dramatic, memorable sunset image without them missing much of the fun inside. Being comfortable in different locations and being able to switch gears on the fly are the hallmarks of great wedding photographers.

Packing your gear bag

What you decide to pack in your gear bag and how many cameras you bring depends on many factors, including the location and duration of the wedding and your budget. All equipment should be fully checked out the evening before, with batteries charged and flashes test fired. You just never know when gear will go down and believe me, it happens. You should always have backup gear available when shooting something as important as a wedding. Do not take a wedding on if you don't have backups; rent or borrow spares if necessary. Make sure you have an extra camera body, flash, and several memory cards with you to get all the shots of the day. Whatever equipment you decide to bring along, know its limitations and make sure it is in top condition and operating properly.

Because I'd rather not be changing lenses and possibly missing a key shot, I shoot with a minimum of two

14.2 Detail images like these wedding rings are an important part of telling the story of the wedding. I make sure to shoot lots of images in both vertical and horizontal formats to make album design easier later on. Exposure: ISO 1000, f/5.6, 1/125 second, +0.3 EV.

dSLR cameras and often add a third camera as a remote camera fitted with a specialty lens like a super-wide-angle or fisheye in an out of the way spot to capture a different view than where I'm shooting from. Make sure to synchronize the date/time stamps in the software of all three cameras beforehand. This makes the chronological sorting of images later in post-production easier. The two primary cameras I use are outfitted with a 24-70mm zoom lens and 70-200mm zoom lens. It's far faster to switch cameras than it is to change lenses. Not having to switch lenses during the wedding helps keep the camera's interior dust-free and raises the odds of shooting with the right lens at the right time. Here are my minimum recommendations for shooting a candid wedding:

▶ **One or more dSLR camera bodies.** You may also find a need for a third camera body with a greater fps (frames per second) than the primary cameras — ideal for fast action sequences like the first kiss, the aisle walk, and the bouquet toss.

▶ **External speedlight.** An external speedlight is a great addition to your kit when shooting portraits because of the flexibility it affords you. The onboard flash of most cameras is great for times when you are fairly close to your subject, but it is severely limited power-wise and doesn't provide much creative use of light. An external flash will help you with the heavy lifting when you are shooting creatively or with larger groups. You can connect the flash to the camera's hot shoe directly or use an off-camera TTL cord with a flash bracket. However, depending on the camera/flash system you use, you can also fire your flashes wirelessly, which allows for remote flash placement and far greater flexibility in managing lighting and shadow control. For detailed explanations about setting up wireless remotes for your flash system, check out my *Canon Speedlite System Digital Field Guide Second Edition* (Wiley, 2010), or J. Dennis Thomas' *Nikon Creative Lighting System Digital Field Guide Second Edition* (Wiley, 2010). Both books provide updated information on the ever-evolving world of wireless flash.

▶ **Tripod and monopod.** They may or may not be needed, but a lightweight but sturdy camera support is always a good idea for low-light photography. In addition, a versatile ball head with a sturdy quick-release plate increases the steadiness of shooting images with longer focal-length lenses.

▶ **Several memory cards.** The number of memory cards that you carry depends on how many images you'll typically be shooting and the length of the wedding day. Whether your camera requires CF (CompactFlash) or SD (Secure Digital) cards, be sure to bring more than you think you will need. I carry a variety of fast Lexar or SanDisk cards in sizes ranging from 2GB to 8GB.

▶ **Silver and gold reflectors.** Collapsible reflectors of various sizes, or a piece of Foamcore or white cardboard are great for filling shadow areas and adding a sparkle to the eyes when shooting individual bride and groom portraits.

▶ **Spare camera and flash batteries.** Even with the healthy life of the camera and rechargeable batteries, I still have one or more charged sets in my gear bag as insurance.

▶ **A laptop computer or portable storage device.** Backing up images on site either to a laptop or a handheld hard drive is an essential part of the workflow,

and if you're traveling for a wedding, it's even more important. The laptop also allows you to review the wedding day's images or provide an impromptu slide show for your bride, groom, and guests.

▶ **An assistant.** Once you use an assistant, you'll never do it any other way. Having another set of eyes to notice a detail you may have overlooked, holding a reflector or flash, getting the wedding party and families ready for the group shots, and adjusting the bride's gown are all prime duties for an assistant. When not needed by you, the assistant can become a second shooter to produce images from a different point of view.

14.3 Don't forget the groom; it's his day, too. Be sure to capture images of the groomsmen, boutonnieres, jewelry preparations, and refreshment time as the men get ready for the ceremony. Exposure: ISO 1600, f/4, 1/80 second.

Getting ready with the bride and groom

My first shots of the day, depending on the light, usually involve some location documentary images of the wedding setting, along with any signage that may help to tell the story of the day. From there it's on to the bride's dressing room for the getting-ready shots. This is a time to familiarize yourself with all the ladies in the wedding party and make a point to get all their names, which will help immensely later when you are posing the groups. One photographer I know writes all the women's names

on a Post-it note and sticks it on the back of the camera to help him remember their names. With all the emphasis on the bride and groom, being friendly to the entire wedding party can go a long way to getting fun, authentic images.

If the bride is not ready for some candid shots, this is a great time to focus on the details like the flowers, wedding dress embroidery, shoes, rings, jewelry, and invitations. Having a macro lens or close-up lens attachment along will allow you to accomplish this with ease. You can then move on to shots of the bride getting ready, getting makeup and hair done, and if included, positioning the garter. There may be a toast or two at this time, so be ready to capture the fun and nervousness getting the bride ready entails.

14.4 The groom's brother and best man edits his speech in the groom's suite for the reception toast later. Exposure: ISO 1000, f/2.8, 1/1000 second.

Next, move on to the groom's area where the mood is generally a little more relaxed. You can't forget the groom, and shots of him getting ready with his dad, brothers, sisters, and other family members might make great photo ideas. Many guys feel uncomfortable in front of the camera, especially on this day, so here's where your personality can really make great shots happen. Familiarize yourself with the guys, and capture the tying of the ties, adding the cufflinks, and pinning of the boutonnieres. Toasts, cigars, and gifts are often exchanged at this time, so be ready to take several images of those events too.

Through your preplanning session with the bride and groom, you should know whether the couple wants to take some photos together before the ceremony or wait until after it's completed. More and more, couples are forgoing the not seeing each other until the ceremony ritual to spend more time with each other and just savor all the beauty of the day. I try to make this moment special and find a suitable location with great light and have the wedding planner or other participants in the wedding help me set it up. This can be a moment of high emotion, so I am respectful to shoot with a longer lens that affords the bride and groom some privacy as they share this intimate moment.

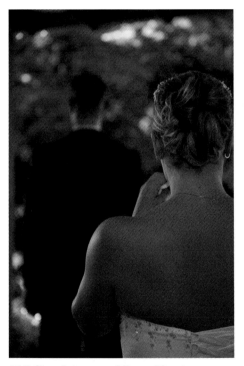 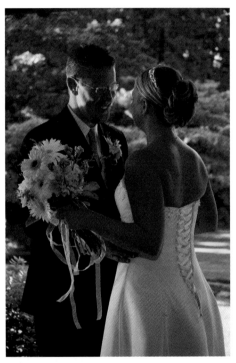

14.5 Amy tears up while waiting to see Joe in his tuxedo for the very first time on their wedding day. Exposure: ISO 800, f/5.6, 1/200 second.

14.6 Just minutes before the actual ceremony, the bride and groom get to see each other for the first time and share a very intimate moment together. I used a telephoto lens to keep a respectful distance away. Exposure: ISO 800, f/5.6, 1/200 second.

The ceremony

Of all the image-making you do during the event, the wedding ceremony is the absolute time when if you miss a shot, it's gone forever. A large majority of weddings take place in houses of worship where the lighting is low and the use of electronic flash is prohibited or often discouraged. This is where a camera with high ISO capabilities and lenses with apertures of f/2.8 and larger can be the wedding photographer's best friend. Use your longer focal-length lens to avoid being a distraction to the guests and wedding party. I usually position myself along the sides or front corners of the setting and keep flash use, if at all, to a minimum. Longer focal-length lenses in the 200 to 300mm range are also great for keeping you a respectful distance away while allowing you to still yield tight shots of the proceedings.

14.7 The bridesmaid holds her flowers while the bride gets ready for the wedding. Exposure: ISO 400, f/3.5, 1/100 second.

Good storytelling begins by establishing the scene, so you'll want to take several overall shots of the venue for both indoor and outdoor ceremonies and receptions and If there's a balcony, my assistant will shoot from there or we'll set up a remote camera with a wide-angle lens to make images of the overall scene. Remember the details,

look for interesting compositions and juxtapositions, and keep your peripheral vision active. This is also a good time to get images of parents and guests as they arrive and greet the groom and other family members. I will have already met with the officiates to know if this is allowed and what the sequence of events will be so as to position myself to be in the right spot at the right time.

It helps to peruse the program to see when and who might be speaking, singing, or playing an instrument as part of the affair. Family members and friends often perform these duties and you'll want to be sure to capture them looking their best.

Being aware of when the ring exchange, first kiss, and blessing will take place assures you will be able to capture those priceless moments to preserve forever. It's also a good idea to keep an eye on your camera's frame counter to make sure you have enough room on your memory card to carry you through the high points of the event. Carry your spare cards with you. You don't want to have to go to the back of the hall to your bag for more cards and miss something special.

14.8 Positioning a remote camera up in the organist's balcony and triggering with a PocketWizard yields a shot of the entire wedding party during the ceremony. Exposure: ISO 1600, f/2.8, 1/60 second.

The ceremony involves getting the best shots you can while mixing white balance, ISO, aperture, and shutter speed on the fly to produce great images. Here are some important methods for doing just that:

▶ **Set a custom white balance or use a suitable preset.** Even if you are shooting in RAW format, it still helps to have the images dialed in as best you can color-wise. Using a tungsten, fluorescent, or custom white balance is the way to go.

▶ **Set the ISO.** If indoors, I usually avoid using the highest ISO setting my camera is capable of, preferring to stay in the 800 to 1600 range, but outdoors this value can go from 800 to 100 depending on the amount and intensity of light I have to work with.

14.9 The groom salutes his bride at the ceremony's completion. Exposure: ISO 100, f/4.5, 1/320 second.

▶ **Shoot wide open.** Setting your aperture to its largest lens opening will afford you the opportunity to shoot with faster shutter speeds that you can safely handhold.

▶ **Set the shutter speed.** Checking the LCD after a few images, set the shutter speed to render the lighting in the scene the way you want it to appear in the final images. You can convincingly brighten up dark locations simply with shutter speed alone but when shooting handheld, try to stay at 1/60 second or above to prevent camera shake from spoiling your images.

For outdoor ceremonies, many of the previous methods hold true, but in these situations you may be dealing with too much light where you don't want it so be sure to use your speedlight for fill.

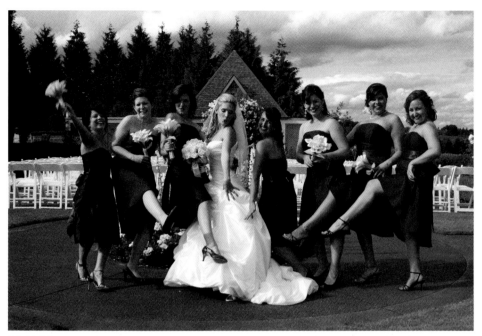

14.10 After you shoot some creative formals, don't be afraid to ask the bridal party to do some fun poses, too. Tiffany and her bridesmaids kick up their heels and show some leg in this lighthearted moment. Exposure: ISO 100, f/11, 1/80 second.

Once the ceremony has concluded and the receiving line is over, there's a tendency for everyone to relax a little, but the photographer must stay sharp and plan for the next phase of shooting — the formal portraits!

Shooting the formal portraits directly after the ceremony often makes the wedding flow more efficiently because guests can proceed to the reception while the wedding party remains at the site of the ceremony for a short photo session. I usually start with the largest groups and work down to the bride and groom, sending folks off to the reception once their pictures are taken. I don't want lots of guests standing around gawking while I'm taking the most important images of the day — intimate portraits of the bride and her groom.

Depending on the location and light, this is a good time to use one or two flashes, both indoors and outdoors. This is also where a ladder, reflectors, and speedlight

modifiers such as a small softbox or umbrella are invaluable and allow you to be a little more creative with your light. If you're using flash, you'll need to test the setup before the couple and family are called in for the portrait session. This is where your assistant or another family member can readily stand in to do a few quick test shots.

The reception

Once the stress of the ceremony is over, the entire wedding takes on a very different spirit and the photographer's work is to capture the carefree celebration. The sequence of events for post-ceremony activities varies widely and brides feel free to customize the activities to their personal preferences. For this reason, I meet with the couple well before the wedding day to prepare a basic shooting list to ensure that all milestone events are captured. This list might include the cake, rings, bride's shoes, place settings, floral decorations, grandparents or special guests, traditional dances, and any gag or intimate gift presentations that will happen during the reception.

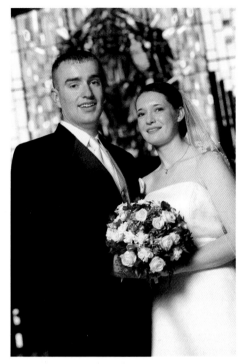

14.11 A speedlight on a small light stand shot through a 24-inch white umbrella off to the left and triggered with PocketWizards illuminates Jessica and Tom in the church after their wedding. Always be on the lookout for interesting backgrounds such as this stained glass window to add color and composition to your images. Exposure: ISO 500, f/5.6, 1/200 second.

Once again, I will perform a custom white balance for my cameras, set a fairly high ISO in the 800 to 1600 range and position a few flashes on stands around the room if that is feasible. I may gel the flashes to match them to the ambient light, or rely on them solely and let the room go warm. When the dancing starts, I'll jump down to lower shutter speeds to attain some motion blur of the swirling bodies and mix in some flash to freeze their expressions.

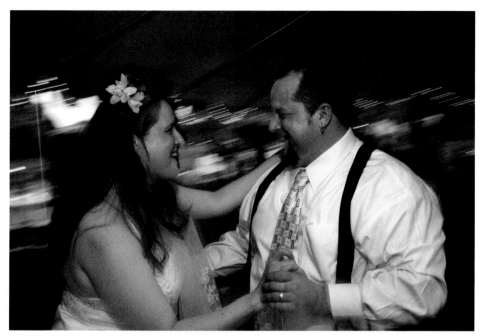

14.12 Using flash along with a slow shutter speed and intentionally moving the camera during the exposure gives this shot of Sarah and Dallas dancing some added pizzazz. Exposure: ISO 800, f/8, 1/8 second.

Practical Pro Advice

Wedding photography has changed a lot in the last ten years — everything from the poses chosen to the books, albums, and slide shows that capture the moments of the day to be cherished forever. Here are some words of advice that you may have heard already, and if not, you can use them for the next wedding that you shoot.

▶ **Get to know the couple before the wedding.** Every minute you spend getting to know the couple in advance of the wedding pays off in wedding images that can reflect their unique personalities and their hopes and dreams for the life they are beginning together. By the time of the wedding day, the couple should know you well enough to think of you as a new or old friend whom they welcome.

▶ **Call the wedding planner before the wedding.** If there is one, call the wedding planner and introduce yourself as the photographer. Wedding planners can make or break your day and their contribution to your shooting workflow can be immensely helpful. Get on their good side and stay upbeat and flexible.

▶ **Clearly set the expectations for photographs well before the ceremony.** During your meetings with the bride and groom, establish the style of photographs they want to receive when the big day is over. Discuss what look and feel the photos should take on and any post-processing techniques they may be fond of. Do they want color, black-and-white, or sepia-toned images exclusively, or a mix of all three styles? Do they want a photojournalistic or stylized fashion look to the images or a more traditional formal approach? These are all details to nail down well before the wedding day arrives.

▶ **Give the bride and groom breaks where they can relax for a few minutes.** This is also a good time to get more candid images of them kicking back and reflecting on the events of the day. No one likes to be "on" all the time and your sensitivity to this will be much appreciated.

▶ **In addition to a gear bag, consider including a second bag packed with anything that the wedding party members may forget.** Handy gadget bag items include hair spray, stick-on Velcro strips, makeup brushes, tissues, a Swiss Army knife, a nail file, a brush, a sewing kit, bug spray, aspirin, flat and Phillips head screwdrivers, a corkscrew, and Super Glue. Having a small lighter or striker in the bag will save time if candles are in the shot and you want them lit. Some candle displays are only for show, so always ask before you light them.

▶ **Know your audience.** Before the wedding ask the couple about any touchy relationships such as family feuds, divorced parents, and children, and have the couple decide how they want you to arrange the portraits in regard to these relationships. The last thing that you want to do is put a divorced mother of the bride with her ex-husband and his new wife for the family shot or feuding family members next to each other.

▶ **Be happy.** No one likes a grouchy photographer. So often it's true in photography and in life that you get back what you put in. You want happy people faces in your photographs; then that's what you have to display. Be magnanimous, agreeable, and flexible even if it kills you and keep smiling and shooting. The evening won't last forever, but everyone will remember the photographer with the sour mood.

▶ **Don't hold pictures hostage.** Even if you opt not to have an on-site slide show, get a selection of pictures to the couple as quickly as possible. And most photographers agree that showing the final proofs is better done in person with a digital projector than just posting a gallery on the Web or mailing them a disc.

▶ **Be everywhere and nowhere.** A tall order to be sure, and one that only comes with experience. Even though it appears to be a paradox, the photojournalistic approach of quiet observation and anticipating the peak action produces images of huge appeal like no other. My favorite compliment of all time, one that said it all, was, "Wow, how did you ever get that shot? I didn't even know you were there."

Wildlife and Pet Photography

Successful wildlife photography requires equal parts passion, stamina, and technical expertise. Many beginning photographers are drawn to this area of photography for its excitement and the desire to make beautiful and dramatic images of the natural world. Wildlife and pet photography can be an immensely satisfying pastime for photographers who possess a love for nature and the many species that inhabit this earth. This chapter gives you some things to think about when photographing wildlife or pets using natural light or flash. I explain preparation for these types of shoots, the lighting, exposure, and shooting modes to use to produce the best results, and the best equipment choices. I wrap up with some pro tips learned over time and in the field.

This Southern Masked Weaver was photographed at the Oregon Zoo with a 70-200mm zoom lens and a 2X converter. Exposure: ISO 500, f/5.6, 1/80 second.

Preparation and Considerations

Beginning wildlife and pet photographers must know the correct exposure and shooting modes to use. You can have the best equipment available, but if your exposures are not right on, your images will not matter to anyone. As I emphasize throughout this book, developing sensitivity to the lighting conditions and how light falls on subjects aids you to confidently make exposure decisions in those lighting situations that can fool and trick your camera's sophisticated light metering system.

I always recommend using the lowest ISO setting possible for the subject matter and lighting conditions. The speed of your subject may push you to the limits of your equipment's light-gathering capabilities and the only option left is to boost your ISO rating. Modern cameras, however, handle these adjustments with ease and are getting better all the time, delivering low-noise images at ISO ratings once considered impossible.

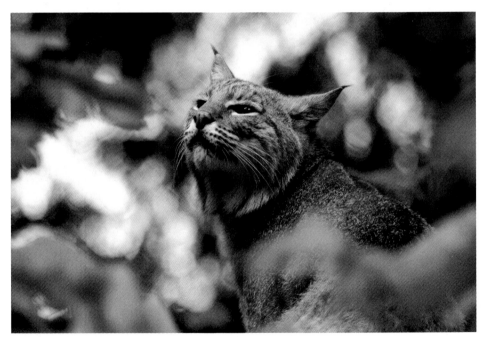

15.1 This bobcat was photographed behind a mesh screen that affects the background bokeh but not the subject. By shooting with a fairly large aperture and carefully composing to hide any man-made structures, you can approximate shots from the wild. Exposure: ISO 2000, f/5.6, 1/3200 second, -1 EV.

15.2 Lizards move around very quickly, so you have to shoot fast. A bit of flash perks up the beautiful colors of the lizard's skin. Exposure: ISO 3200, f/11, 1/20 second.

Many times, your wildlife photography is conducted in poor or low-light conditions, so it is critical to have a good working knowledge of your camera's controls and to be able to make quick changes to the exposure mix as the action develops or moves to different lighting scenarios. Many animals avoid bright sunlight and prefer to stick to the cooler and less obvious shadowed areas of their habitat. Some have evolved the ability to blend into the background of their natural environment, either as a defense mechanism or as a way to sneak up on prey. In either case, you still want a clean

15.3 Behind glass in the Oregon Zoo's bat lair, this bat was beginning to drowse after feeding. Exposure: ISO 3200, f/5.6, 1/60 second, -0.3 EV.

image of your subject that stands out against an authentic background. Proper expo-
sure and shooting modes are the ways to attain this and selecting an ISO setting that
allows you the greatest flexibility of camera controls is a good place to start.

Many outdoor photographers choose Aperture Priority mode for creating stunning
images of wildlife and pets. Aperture Priority mode is the fastest way of controlling
the subject to background focus ratio and depth of field to separate the wildlife from
the background. This keeps the subject tack sharp while the background, no matter
how busy, is reduced to a palette of pleasing out-of-focus tones. Lenses with good
bokeh characteristics are especially adept at producing this effect.

**15.4 Nice bokeh and a shallow depth of field place all the emphasis
on this little Boston terrier friend. Exposure: ISO 1000, f/5.6, 1/800
second, -1 EV.**

Shooting in Aperture Priority mode and setting the aperture to its largest lens opening
accomplishes two important aspects to making your wildlife or pet images stand out:

▶ **Limited depth of field.** For any particular lens, setting it to its largest aperture
(smallest number) will produce the least amount of depth of field, ideal when the
subject appears to blend into the background or when you want to minimize the

distraction of the man-made enclosures found in zoos. This shallow depth of field should still be deep enough to include most of your subject's body.

▶ **Fast shutter speed.** By shooting in Aperture Priority mode and using the largest aperture setting for your lens, you force the camera to automatically choose the fastest shutter speed available for that particular lighting level, ensuring you get the sharpest image possible of your subject. Shooting in Aperture Priority mode and using the largest aperture setting of your lens allows more light to strike the sensor in a shorter amount of time. You still need to check the camera's LCD to make sure the shutter speed selected is fast enough for your subject. Otherwise, raise your ISO speed and reshoot.

Your next consideration is metering mode and for this I recommend two: Scene metering and Spot metering modes if your camera has them, as most modern dSLRs do. There are times when each one will have benefits over the other and knowing when to use them helps you save time and get the results you look for. Knowing how each one reads the light will help you do this.

Here's a brief overview of the two modes I find most useful for wildlife and pet photography:

▶ **Scene metering mode.** This mode is best utilized when you are able to fill your frame with your subject and your lighting is even and consistent. Scene metering mode is a complex metering system whereby a scene is divided into zones. The overall exposure is based on evaluating each of these zones individually and taking an average of the total light readings. Once the light is measured, the camera determines the best exposure. Scene metering works best with differently toned subjects and situations where you have drastic changes in light levels in the frame. You may still have to adjust your exposure further in this mode when you work with a large bright or dark subject.

▶ **Spot metering mode.** Your camera's Spot metering mode usually covers around 5 percent of the viewfinder area. It takes a precise exposure reading only at the very center of the frame and ignores the rest of the scene's tones. Spot metering mode is helpful when there are extremes in the brightness areas of a scene or when a subject is backlit or is brightly illuminated and the background is dark. Spot metering is also highly beneficial for close-up and macro/micro photography.

15.5 Evaluative metering mode was used to photograph this African elephant feeding. Tight composition hides all the evidence of the zoo's enclosure. Exposure: ISO 100, f/5.6, 1/125 second.

15.6 Spot metering mode and flash were used to photograph this marsupial, held in its owner's hands. Exposure: ISO 1000, f/5/6, 1/25 second.

 Most camera manufacturers refer to their Scene metering mode by different nomenclature. Canon calls its Evaluative metering, Nikon uses Matrix metering, and Sony cameras employ Multi-segment metering. Choose the one that's right for your camera.

Although there is no better way to get great wildlife and pet pictures than knowing the traits and habits of your subject, using the right gear for the job can make your life easier, your ability to shoot faster, and your keeper images more plentiful. The following is a brief breakdown of equipment I take whenever the chance for wildlife photography is part of the plan:

- ▶ **Tripod or monopod.** A stable camera platform is mandatory for acquiring sharp images in the field. Having a lightweight but sturdy tripod such as those from Bogen/Manfrotto, Gitzo, or Cullman is indispensable. In addition, a versatile ball or joystick head with a sturdy quick-release plate increases the steadiness and speed of composing on the fly when photographing wildlife or quickly moving pets.

- ▶ **Fast telephoto lenses.** Many animals in wilderness and even in zoos can be difficult or too dangerous to get close enough to make a good image. For this you need a telephoto lens of at least 200mm, preferably 400mm or 600mm in focal length. The prime benefit of a telephoto lens is that it permits you to get optically closer without getting physically closer to your subjects by giving you a narrower angle of view. This narrow angle of view provides less coverage of the scene, allowing you to compose tighter shots and exclude distracting elements from the image. Fast telephoto lenses have a maximum aperture setting of f/2.8.

- ▶ **Teleconverters/extenders.** You can increase the focal length of almost any lens by using an extender. An extender (sometimes called a teleconverter) is a lens set in a small barrel, mounted between the camera body and a regular lens. Most manufacturers offer two versions, a 1.4X and 2.X, that are compatible only with certain lenses in the series. Extenders do not affect the minimum focusing distance of the lens they are mounted behind, but the magnification is multiplied by 1.4X or 2.0X, depending on the type used. For example, using a 2X extender with a 600mm lens doubles the focal length of the lens to 1200mm. Using a 1.4X extender would increase a 600mm lens to 840mm. Extenders generally do not change camera operation in any way, but they do reduce the amount of light transmission reaching the image sensor and along with that, some image quality loss.

15.7 These female lions at the Oregon Zoo took quite the interest in me as I was photographing them. Exposure: ISO 500, f/5.6, 1/1000 second.

▶ **Remote Switch.** A good companion tool when using a tripod, a remote switch plugs into a special port on your camera and replicates all function of the camera's AF/Shutter Release button to insure vibration-free operation for macro or timed exposure work. Identical to the Shutter Release button on your camera, the remote button is pressed halfway down to focus, then all the way down to take the picture. A remote switch is great to use when photographing wildlife because it allows you to be aware of your surroundings when working in the field and make eye contact with your pet to get its best expressions when photographing it.

▶ **Polarizer and neutral density filters.** A circular polarizer can enhance the saturation and color of certain types of skins and fur as well as reduce reflections on surfaces. Circular polarizers are specifically designed for use with autofocus cameras and come with a rotating bezel to secure the filter to the camera, allowing the filter to freely rotate to polarize the light.

▶ **Weatherproof camera and lens sleeves.** Some cameras sport extensive weatherproofing seals and gaskets around the battery compartment, memory card compartment, and all the camera control buttons. Some camera bags, such as those from Lowepro and Think Tank Photo, include water-repellant bags or sleeves that fold compactly and attach to one of the camera bag's interior compartments. For extremely severe weather, you can buy a variety of weatherproof camera protectors from Vortex Media (www.stormjacket.com).

▶ **Sound maker or whistle specific to the animal.** Lots of outdoor stores have bird or dog whistles or sound makers that attract a wide variety of wildlife. Use sparingly to attract animals, and then put them away so as not to confuse your subject into thinking there is food or a mate close by.

Much of the same gear I use for travel and landscape photography goes with me on wildlife shoots or when photographing pet portraits for friends. Keep these ideas in mind the next time you're stalking big game — photographically, of course!

Practical Pro Advice

Photographing your pet is a great way to get started in the realm of animal photography. Your little friend already is comfortable with you and you are both able to read each other's moods. Engage your pet or have someone else do it as you start noticing backgrounds that work for portraits. Have treats and snacks available and always reward good behavior.

I also recommend a trip to a zoo or wildlife reserve to hone your skills and get you in the mental zone of photographing animals in a more natural habitat. If you have a photo trip or safari vacation coming up where there stands a good chance of seeing some major wildlife, zoos are a great resource for practicing your wildlife photography skills and to make decisions on exposure and white balance.

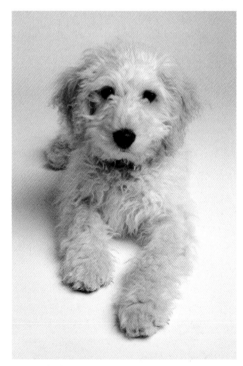

A trip to the zoo clues you in to how your camera technique is working for this particular genre of photography. Shooting in Continuous mode improves the chances of getting great shots of animal behavior, but is not very effective when using flash. Check to see if your zoo allows you to use flash when photographing the exhibits and if so, bring it along. You

15.8 Studio portrait of my dog, Barley. Exposure: ISO 100, f/8, 1/100 second.

want to switch to Single-shot mode when using flash to allow some gaps of time for the flash to recycle.To maximize the reach of your flash when photographing wild-life, most of the time you need to adjust your flash's exposure compensation setting when using a lens longer than 200mm. Most camera-mounted speedlights have a zoom range up to 200mm. This doesn't mean you can't use it with a lens longer than that. Adjusting the flash exposure compensation to add more exposure can get more range out of your flash if you are using it with a longer lens, but you may experience slower recycling times and shorter battery life.

Commercially available flash extenders like the Better Beamer (www.naturephotographers.net) extend the reach of your flash by a reported +2 f-stops of light over greater distances. Flash extenders attach to the speedlight's flash head, usually with Velcro or tape and contain a Fresnel lens positioned a few inches in front of the flash face to focus and condense the light for transmission over longer distances.

Whatever equipment you decide to take into the field, keep these ideas in mind for dramatic, compelling images of wildlife and pets:

▶ **Focus on the eyes.** Eyes are the most dramatic feature in pet and animal portraits. With any animate subject, as long as the eyes are in focus, the photo registers as sharp.

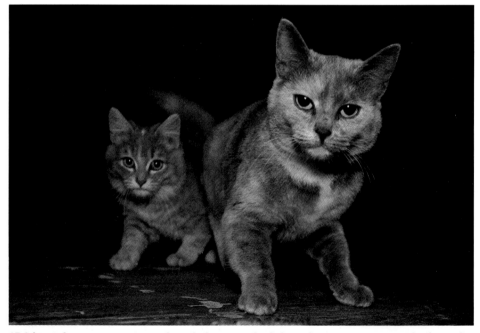

15.9 I got down on my stomach and photographed these barn cats on an angle through a glass door at night with a handheld flash. Exposure: ISO 400, f/2.8, 1/60 second, +1 EV.

▶ **Use contrast for composition strength.** The viewer's eye is always drawn to areas of greater contrast — a light subject against a dark field and vice versa. In addition, the sense of sharpness of a photograph is greatly increased by the skillful use of contrast.

▶ **Zoom your lens.** Whenever possible, zoom out to the telephoto setting to fill the frame with your subject. This allows you to remain inconspicuous to the animal, enabling you to catch it acting naturally and also helps limit the amount of depth of field the lens can produce.

▶ **Go low.** The same advice for photographing children applies to photographing wildlife and pets. Try shooting from their eye level to see the world from their perspective. This places them naturally in the environment without any distortion from an extreme angle of view. I recommend photographing pets this

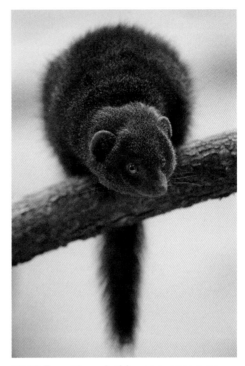

15.10 Even though this mongoose was behind glass and I was using flash, no reflections or kickback from the flash degrades the image because I was shooting very close to and on an angle to the glass. Exposure: ISO 2000, f/5.6, 1/40 second, +0.3 EV.

way because you can get some amazing portraits with only a 100mm lens. Have some treats nearby if you want to photograph the pet doing some stunts.

▶ **Get as close to glass or obstructions as you can.** Many times, especially in zoos and wildlife parks, the animals are behind some sort of barrier keeping the animal separate from the people. This is great from a safety standpoint but not from a photographic one. I have found that a good workaround for longer lenses is to decrease the camera-to-barrier distance to increase the barrier-to-subject distance. Focus so that only the subject retains any depth of field. If you are shooting at your largest aperture, the barrier or any imperfections in glass virtually disappear.

▶ **Be ready for action.** With active animals, try shooting in Shutter Priority mode to increase the likelihood of getting sharp images. To freeze the action, I start at 1/250 second and go up from there to attain crisp wildlife images. If your largest

aperture still prevents your camera from hitting those shutter speeds, remember to boost the ISO for more flexibility in choosing exposure settings.

▶ **Be careful.** Know the behavior patterns of the animals you're photographing and always be aware of their proximity to you. Even domesticated animals like horses and dogs can be intimidated if they do not know you. Keep your peripheral vision on alert and never get into situations without an escape plan.

Having the desire and passion for animal photography is a great place to start, but with that passion comes the added responsibility to do no harm to the insects, reptiles, or animal subjects that find their way in front of your lens. Respect what you are photographing. Learn all that you can about your subjects, their habits, feeding times, and behaviors because the

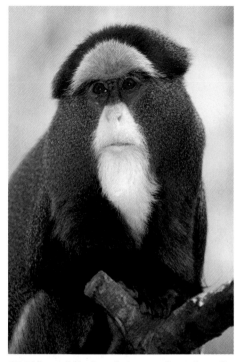

15.11 I used flash to bring up the value of this DeBrazza's monkey and to even out the exposure between the bright background and the low-lit subject. Exposure: ISO 500, f/5.6, 1/200 second, -0.3 EV.

more you learn about your favorite critters, the more picture-taking opportunities you think of and encounter. Also remember that no photograph is worth upsetting the safety and welfare of the animal or yourself. Leave the habitat the way you found it for all who come after you to enjoy.

Rules of Composition

Composition involves the conscious decision the photographer makes about where to place the objects in an image and the overall management of the scene within the frame. You want people to see your images and immediately get what your subject is and possibly how you felt about that subject. It is another form of communication on a very real level.

Ansel Adams used to speak highly of *previsualization* of the desired photograph and ultimately, the viewer's response, and said that image management determined whether what the photographer was trying to communicate was received as intended. By looking through the viewfinder and moving the camera around to see the relationship between the subject and the background and how it changes as you move, you begin to understand how the placement of objects is a powerful control of composition.

Along with the placement of objects in the frame, the photographer also must decide where the point of sharp focus will be and how deep it will be, or in other words, how much depth of field the image will contain. When viewing photographs, the eye tends to zero in on the items in sharp focus first, and this is usually where you want your subject to be. By learning to use the elements of composition and selective focus, photographers can create powerful images that communicate their inner feelings. Several camera techniques can be utilized to achieve this ideal.

This appendix explains the rules of composition. Granted, *rules* is a pretty strong word for creative types to mess with, so I prefer to think of them simply as visual guidelines for more well-constructed images.

At first, these concepts might seem strange and uncomfortable, like holding your camera a different way or composing scenes through a new lens, and you may struggle a bit with applying these rules to your style of photography. Just know that these are the foundations your best shots are built upon, and a conscious working knowledge of them is essential to creating more dynamic, compelling images.

AA.1 The irregular shape and sharp focus of this backlit maple leaf contrast nicely with the soft, out-of-focus linear lines of the glass block window. Exposure: ISO 1000, f/2.8, 1/800 second.

This appendix provides tools and techniques I use when a situation or location is not working or has been exhausted photographically. Mentally going through the list of ideas presented here can often yield new ways of looking at subjects, camera angles, lens choices, and the like. After all, I'm always on the lookout for ways to expand my style of photography.

Keep It Simple

Keeping your compositions simple is probably the easiest yet most important rule in creating powerful, memorable images. People are bombarded by images every day, which means that in today's image-rich world you have a very limited time to grab your viewer's attention. Keeping the image simple and uncluttered is a great way to do just that.

People are bombarded by images more and more every day for myriad reasons — to sell products, relate current events, or share family milestones — and eventually, image-overload can set in. You want your images to be clear and on point. Composing simple photos can go a long way toward this goal.

Ideally, your subject should be immediately recognizable to your audience. When considering a subject to photograph, I rarely come upon a scene wholly formed. This is why photographers make such a distinction, which may seem semantic or petty, between *taking* a photograph and *making* a photograph. It requires careful consideration of all the elements to make a truly memorable image.

AA.2a Noticing this raindrop precariously hanging on the edge of a raspberry leaf, I quickly set up a macro shot, making sure not to dislodge it. Under high magnification such as this, minimal depth of field is attained, resulting in the soft, out-of-focus look to the background placing all the emphasis on the focus point — the raindrop. Exposure: ISO 800, f/8, 1/60 second.

AA.2b After shooting a few frames, I improved my background when I noticed that if I moved my camera position to place the raindrop against a brighter leaf, the background kicked more light into the drop and created much better separation. Exposure: ISO 800, f/8, 1/60 second.

Once you realize what your subject is, the next task is to locate a background that *holds* or complements that subject. This often involves walking around the subject if possible and observing what happens to the background as you move. Suddenly, new ideas form and you may feel like you are looking at a totally different picture than the one you first imagined!

Try to come up with a background that has a different color or texture than your subject so as not to camouflage the subject by blending in. Having a brighter-toned subject against a darker background, or vice versa, is another way to make your subject command more attention. A simple background allows the eye to linger on the photographer's subject and provides the time to make an emotional connection with the viewer.

To create better photographs, it's helpful to learn to see the world and events before you as your camera does. The disconnect between what the photographer sees on the spot and the final photograph is where many photographers stumble. I advise students to spend more time seeing through the camera, looking at subjects they like, and learning the visual language and interpretations of their lenses.

Silhouettes

Whether conscious of it or not, many people respond emotionally to silhouettes in

photographs. An implied empty shape that only delivers minimal information about that shape adds mystery and often stark contrast to the image.

The basic approach to shooting silhouettes is to find a really dynamic background and then underexpose the shot by 1 to 2 stops. The images in this section show how silhouettes can add visual power and punch to your images.

AA.3 This silhouette of a water tower shows the rich, saturated colors and added contrast obtained when using a polarizing filter and underexposing intentionally by dialing in -2 exposure compensation to create a silhouette. I set my aperture to its smallest opening and allowed a tiny bit of the sun to peek around the water tower, which I knew would give me a small, visually interesting sun star. Exposure: ISO 100, f/22, 1/500 second.

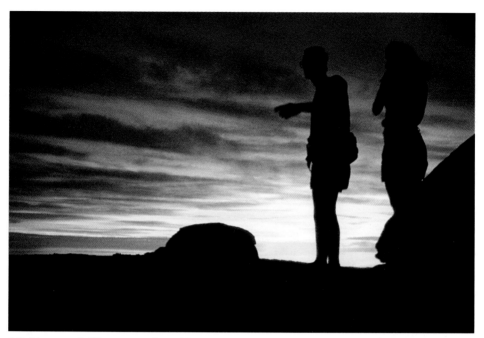

AA.4 I created silhouettes of my friends to add some mystery to this landscape by underexposing by 2 stops and shooting into the sky as the sun was setting in Arches National Park. Exposure: ISO 100, f/16, 1/125 second.

I often employ silhouettes when I have a great background but my subject has too much detail that detracts from the scene or contains information I don't want in my shot.

Limiting focus

Another way to simplify your images is to limit the focus range in the photo to only cover the subject, rendering any elements in front of or behind the subject out of focus. This is achieved by using a large aperture indicated by a small number such as f/2.8. Your lens's largest aperture fits this bill. See Chapter 4 for a detailed description of the many ways to handle depth of field.

By shifting the plane of focus this way, more time is spent looking at the photographer's intended subject and less on the background. This is a great technique to employ when you are stuck with a busy background, such as when shooting urban portraits, and items like architecture, trash cans, and signage all conspire to steal attention away from your subject.

AA.5 Everything except the engagement ring is purposely rendered out of focus by using a large aperture. Exposure: ISO 400, f/2.8, 1/500 second.

As you're considering lenses, the lens term *bokeh* is an important consideration. The term is derived from the Japanese word *boke* and means fuzzy. It refers to the way an out-of-focus point of light is rendered in an image.

Bokeh can make the out-of-focus areas aesthetically pleasing or visually unobtrusive, and the interpretation is almost entirely subjective. In general, you want the out-of-focus points of light to be circular in shape and blend or transition nicely with other areas in the background, and the illumination is best if the center is bright and the edges are darker and soft. Some

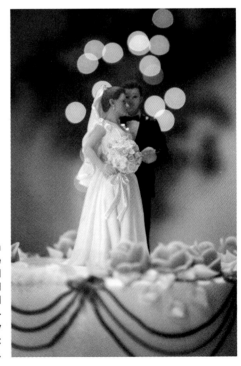

AA.6 This wedding cake topper was shot in a very small reception hall that did not have much to utilize by way of a background until I spied some mini lights wrapped around a ficus tree. Knowing a longer focal length lens would produce pleasing, out-of-focus light orbs in the background, I quickly lined up the elements and shot. Exposure: ISO 800, f/5.6, 1/30 second.

lenses with large apertures that include circular aperture blades enjoy a certain status in the bokeh world for the beautiful out-of-focus effects they produce on background or foreground elements. A detailed description of bokeh is beyond the scope of this book, but I urge you to experiment with your own lens's largest apertures and to research bokeh effects on the Internet to see the optical results for yourself.

The Rule of Thirds

One of the easiest ways to start on the path to better compositions is to move away from centering all your subjects within the frame all the time. You've seen unremarkable horizontal photos where one person's face is dead center in the picture, leaving lots of unused visual real estate on the top and sides. The face appears to float there in the picture. This can easily be solved by switching to a vertical composition and moving in, or composing the subject to the right or left of the frame to bring in more of the background or imply the subject's movement.

Perhaps the most well-known principle of photographic composition is the Rule of Thirds. The Rule of Thirds is evident in many other art forms, such as painting, drawing, and print making. The basic principle behind the Rule of Thirds is to imagine breaking your image down into thirds (both horizontally and vertically) so that you have nine sections or boxes with two lines vertical and two lines horizontal, each a third of the way across their dimension.

The lines and intersections create *sweet spots* for you to place certain elements of your image upon. The goal is to place your area of interest out of the center and either on the horizontal or vertical lines or on one of the four intersections of those lines and in this way, create more visual appeal and a better balance to the image within the frame. Any implied movement should face into the center of the image to keep the viewer's attention within the frame and not let the eye stray out of the picture.

Two techniques I find helpful when utilizing the Rule of Thirds are worth noting here. The first is to try to have any implied subject motion moving toward the center of the frame. This adds balance and a direction for the viewer's eye to follow. The opposite approach, where the subject is centered, may weigh the image down in that direction and give the photo an unbalanced feel.

The second technique applies when shooting landscapes with the sky as an element of the scene. If I have an incredible sky, I place the horizon on or near the lower horizontal line. If I have a blah sky but very good light, I move the horizon up to the higher horizontal line and search out some interesting element in the good light for my foreground.

AA.7 Composing the shot so as to place the duck in the upper-right intersection of the Rule of Thirds grid lines conveys the sense of open space. I left space in the frame for the duck's implied movement, shown in the circular ripples of the water mimicking the elliptical shape of the duck's body. Exposure: ISO 100, f/7, 1/125 second.

AA.8 Composing this shot to place the horizon in the lower third of the frame creates the feeling of open space and includes more of the beautiful colors of the sunset. The foreground dune grass falls to silhouette as I underexposed by 1 stop to intensify the quickly fading colors. Exposure: ISO 100, f/9.5, 1/125 second.

Field of View

Many times, better compositions can be achieved by merely moving the camera slightly up, down, left, or right. Distracting elements can be eliminated by taking a step or two back, forward, or to either side of the subject.

Lens choice is also an important step to consider in how it renders the background. Shooting a portrait with a longer lens will show less of the background because of a narrower field of view, assuming you are filling the frame with the subject. A longer lens will also require a greater working distance between the camera and the subject, which can add a level of comfort during the session. The greater magnification of the long lens will also create a shallower depth of field, ideal for portraits.

AA.9a A small aperture creates too much depth of field in the left photo of rhododendron flowers and a fountain. With so much of the scene in focus, the eye wanders around the frame and the impact of the flowers as the subject is lost. Exposure: ISO 800, f/32, 1/800 second.

AA.9b The potentially busy background in the park was controlled in the photo on the right by using a zoomed lens setting and a wide aperture. Changing from a small aperture to a large one created less depth of field in the shot placing more emphasis on the flowers. Exposure: ISO 800, f/5.6, 1/30 second.

To fill the frame with a shorter lens to the same degree as a telephoto, you must get physically closer to the subject and by doing so, more of the background will be included in the image. This creates more of the background to deal with in composition and also a greater depth of field to the image.

Controlling the field of view can also mean getting closer to your subject either optically by changing lenses or physically by moving in. Getting closer to flowers and inanimate objects might be easy, but doing so with other people may make some uncomfortable. This is when it's advisable to switch to a longer focal length lens to tighten up the frame.

Also, try not to fall into the habit of shooting all your images standing up, at your eye level. Children and other animate subjects look much more realistic when photographed from their eye level, not yours, capturing them in the environment from their point of view. Also, remember anything closest to the camera appears larger and any elements farther away appear smaller. That's the reason why many family portraits are often composed with the children in front and the adults in the back.

In order to get more heroic shots of people, I like to compose the shot with the camera about waist high, making them seem more towering and statuesque. By contrast, in tight situations where space is limited, such as a wedding cocktail hour, I use a wide-angle lens setting and try to shoot down on the bride and groom on the dance floor to show the setting and the decorations. Unique, interesting images are always the goal.

AA.10 Composing the shot so as to have the bobcat "looking" into the image rather than out of it creates a more pleasing photo and keeps the viewer's attention within the frame. Exposure: ISO 2000, f/5.6, 1/1250 second.

After getting the "safe" shots, go for the more offbeat camera angles. Don't be afraid to stand on tables or chairs (with permission, of course!) or get down and dirty on your belly to create a more interesting camera angle for your subject. Any personal embarrassment you may feel easily dissipates in a few minutes, but that great shot lives forever.

Leading Lines and S-Curves

Leading lines and S-curves are compositional tools that many visual artists, including photographers, have used to marshal the viewer's eye and control the flow of visual elements in the scene. Dual leading lines such as roadways or train tracks create an optical illusion that make the road or tracks look smaller as they lead away from the viewer toward a spot called the *vanishing point* where they appear to converge. This can have a target effect that creates depth and balance in an image. Leading lines can be strong diagonals in color, form, or solid objects that lead the viewer's eye into the frame toward some visual payoff such as a vista, an object, or the intended subject of the scene. By creating such strong lines of composition within the frame, the viewer's eye can't help but follow along.

AA.11 Train tracks become leading lines and create the illusion of disappearing into a vanishing point in this scene from the Columbia River Gorge in Oregon. Exposure: ISO 100, f/25, 1/20 second.

Three distinct line elements have qualities that are nearly universal and when used in creative composition, go a long way toward communicating certain feelings to your viewers. Horizontal lines such as those found in landscape photography convey a sense of calm and wide-open spaces, while strong vertical lines lend a classical, strong feeling of height and power to the composition. Strong diagonal lines in a composition can upset the linear conventions we are used to and give the image a sense of dynamic vitality and energy.

Similar to leading lines, curved lines or S-curves in a photograph take the viewer's eye into or out of the scene in a lazy, flowing way. They create a sense of depth by moving deeper into the scene in an undulating way, often with some sort of visual point as the target. S-curves can also increase the relative perspective of the scene, and photographers often use strong foreground elements to grab the viewer's eye and then lead it farther into the frame by curved lines or S-curves that cover a wide expanse of the field of view. An image with an S-curve composition usually draws the viewer's eye from the front, then into the middle, and finally toward the back of the scene.

Symmetry

Although I advise you to let go of the urge to always center your subject in the frame and employ the Rule of Thirds when possible, there are those times when a centered composition works best. You can also use symmetry with the Rule of Thirds to add balance to the photo. They are not mutually exclusive and are often used in tandem. This occurs when I shoot a business portrait or I want to just capture a person's expression or some other element for the strongest effect. Now I'm not suggesting that centering the face in the frame is ever a good solution, but when you vertically center the body or subject it adds balance to the image. The subject's face and body is centered on the vertical axis, but the eyes fall on the top third line, so it appears symmetrical, not totally centered. I also look for balancing colors in the background or some architectural items I can use to frame my subject. Balance is what you strive for, and sometimes putting the subject directly in the middle has the most powerful impact.

An opposite rule of composition to symmetry is the *rule of odds*. The rule of odds suggests that an odd number of subjects in an image is more interesting than an even number. I often employ this compositional method when shooting small groups, bands, or families, by placing one person closer, farther away, or higher in the frame. Tilting the camera as a shooting style to create this effect is in vogue now with wedding and portrait to convey a dynamic energy or lighthearted freedom to the composition.

AA.12 Doorways are great architectural elements to use to work symmetry into your scene. The fact that the composition is symmetrical causes anything not symmetrical in the photo to stand out such as Jon and Wendy. These doors created a nice "frame within a frame" for a full-length shot of them. Exposure: ISO 400, f/5, 1/200 second.

Finally, pay close attention to the edges of your frame. Avoid having bright colors or sharply focused objects directly on the edges of your picture. Areas like these give the viewer's eye an easy way out of the photo.

AA.13 I found these interesting brick steps for the background on a downtown walk during Wendy and Jon's engagement session and composed the shot by twisting the camera diagonally and placing Jon higher in the frame. Just a kiss of flash perked up the colors and added tiny catchlights to their eyes. Exposure: ISO 400, f/5, 1/200 second.

Resources

A t no other time has there been more information available on the Internet for beginning and professional photographers. However, with the vast amount of knowledge to be found on the Web, it can be frustrating sometimes to know where to begin to look. On the Web, you'll find conflicting or contradictory information on every topic. My approach is to look for experts on the topic, and once I find those who make sense to me, I take their advice and use it. If it works for me, then that becomes my method of working.

Although this is not an exhaustive list, I offer a selection of my favorite resources to help you learn more about the digital camera, photographic lighting, photography, and the photography business in general.

Informational Web Sites and Blogs

Nikon Rumors (http://nikonrumors.com). For followers of the yellow and black insignia, this Web site, not affiliated with Nikon Inc., keeps you up to date with news of pending releases, patents, and developments of anything that has to do with the world of Nikon.

Canon Rumors (www.canonrumors.com). Want to stay up on the latest rumors revolving around all things Canon? Then check into this Web site (which is totally unaffiliated with Canon, Inc.) for all the latest gossip. Be in the know and the first to know.

PixSylated.com (http://pixsylated.com). Created by California commercial shooter Syl Arena, PixSylated is a high-octane Web site devoted to the trends, tools, and techniques that are shaping the world of digital photography today, especially high-speed sync and other creative flash techniques, as well as color management.

Strobist.com (www.strobist.blogspot.com). As a photojournalist, formerly with *The Baltimore Sun*, David Hobby has created a groundswell movement of small flash devotees, the Strobist Nation, with his highly informative blog on small flash use. This site has lots of tips and tutorials on how to effectively use shoe-mounted flashes on- and off-camera. It's loaded with lighting ideas and do-it-yourself projects for making light modifiers for your small flash. Start with the Lighting 101 section and continue from there. It can be habit-forming: be prepared to stay up for some very late nights!

Digital Pro Talk (http://digitalprotalk.blogspot.com). This is an informational blog by David Ziser, a professional photographer from the Cincinnati area. He concentrates mostly on weddings and family portraits but also does stunning landscape photography. David offers up useful tech tips, lighting examples, and the background stories on some of his finest images.

Photo Business News and Forum (http://photobusinessforum.blogspot.com). For those in the business of photography or considering entering the field, this Web site contains essential information about current, relevant business issues facing photographers today. Maintained by Washington, D.C., photographer John Harrington, Photo Business News and Forum explores the best business practices, rights managements, and general and advanced business tips and techniques. Lively comment sections usually follow his insightful posts.

Photo.net (http://photo.net). Photo.net is an enormous Web site containing equipment reviews, forums, tutorials, galleries, sharing spaces, communities, learning centers, and more. If you are looking for specific photography-related information or are new to photography, this is a great place to start.

Sharing and Storing Images Online

PhotoShelter (http://photoshelter.com). This Web site contains stock photography from all over the world and a storage solution to store, manage, and sell your own stock photography collection.

Flickr (http://flickr.com). Flickr is Yahoo's photo-sharing Web site that allows uploading photos and sharing in its broad photographic community. Join groups, create sets and collections, and geo-tagging by adding your photos' locations to the world map.

Kodak Easyshare Gallery (http://kodakgallery.com). The Kodak Easyshare Gallery was one of the first photo-sharing Web sites. It offers online sharing, special photo printed products, and print orders that can be picked up at many chain camera stores and chain pharmacies.

Shutterfly (http://shutterfly.com). Shutterfly offers a full range of products, from free online storage to prints that can be picked up at Target stores. You need to keep your account active by making a purchase annually to qualify for the free storage.

Snapfish (http://snapfish.com). Owned by Hewlett-Packard, Snapfish offers online sharing and digital printing. You need to keep your account active by making a purchase annually to qualify for the free storage.

Phanfare (http://phanfare.com). Phanfare is a membership-based site and offers both monthly and yearly fees. It offers unlimited storage of images and videos. A wide array of photo Web pages and photo albums is available to display your images.

Online Photography Magazines

Digital Photographer (http://digiphotomag.com). This is a great online resource offering articles, hardware, camera reviews, features, how-tos, photo essays, reader photos, tips, and more.

Digital Photo Pro (www.digitalphotopro.com). This is a one-stop Web site for the latest gear reviews, profiles of the best in the business, techniques, software, business news, and contests.

Nature Photographers Online Magazine (www.naturephotographers.net). This is an online resource for nature photographers of all skill levels, with a focus on the art and technique of nature photography, as well as the use of photography for habitat conservation and environmental photojournalism.

National Geographic (www.nationalgeographic.com). Over 120 years old, "Big Yellow" is still going strong and supports critical expeditions and scientific fieldwork. It encourages geography education for all, promotes natural and cultural conservation, and inspires audiences through new media, vibrant exhibitions, and live events.

Outdoor Photographer Magazine (www.outdoorphotographer.com). This site provides a host of how-to articles, gear reviews, contests, forum community, and monthly columns by the best nature photographers working today.

Photo District News (www.pdnonline.com). The online business journal of the photo industry originally based in New York City, Photo District News offers insight into running your photography business in a profitable manner. This site offers news, features, gear, contests, resources, community, multimedia, and much more.

Shutterbug (www.shutterbug.net). Much like the popular magazine that comes packed with equipment reviews and news each month, the Web site offers a huge array of information about digital imaging, techniques, forums, galleries, links, and more.

How to Use the Gray Card and Color Checker

Have you ever wondered how some photographers are able to consistently produce photos with such accurate color and exposure? It's often because they use gray cards and color checkers. Knowing how to use these tools helps you take some of the guesswork out of capturing photos with great color and correct exposures every time.

The Gray Card

Because the color of light changes depending on the light source, what you might decide is neutral in your photograph, isn't neutral at all. This is where a gray card comes in very handy. A gray card is designed to reflect the color spectrum neutrally in all sorts of lighting conditions, providing a standard from which to measure for later color corrections or to set a custom white balance.

By taking a test shot that includes the gray card, you guarantee that you have a neutral item to adjust colors against later if you need to. Make sure that the card is placed in the same light that the subject is for the first photo, and then remove the gray card and continue shooting.

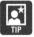 When taking a photo of a gray card, de-focus your lens a little; this ensures that you capture a more even color.

Because many software programs enable you to address color correction issues by choosing something that should be white or neutral in an image, having the gray card in the first of a series of photos allows you to select the gray card as the neutral point. Your software resets red, green, and blue to be the same value, creating a neutral midtone. Depending on the capabilities of your software, you might be able to save the adjustment you've made and apply it to all other photos shot in the same series.

If you'd prefer to make adjustments on the spot, for example, and if the lighting conditions will remain mostly consistent while you shoot a large number of images, it is advisable to use the gray card to set a custom white balance in your camera. You can do this by taking a photo of the gray card filling as much of the frame as possible. Then use that photo to set the custom white balance.

The Color Checker

A color checker contains 24 swatches which represent colors found in everyday scenes, including skin tones, sky, foliage, and so on. It also contains red, green, blue, cyan, magenta, and yellow, which are used in all printing devices. Finally, and perhaps most importantly, it has six shades of gray.

Using a color checker is a very similar process to using a gray card. You place it in the scene so that it is illuminated in the same way as the subject. Photograph the scene once with the reference in place, then remove it and continue shooting. You should create a reference photo each time you shoot in a new lighting environment.

Later on in software, open the image containing the color checker. Measure the values of the gray, black, and white swatches. The red, green, and blue values in the gray swatch should each measure around 128, in the black swatch around 10, and in the white swatch around 245. If your camera's white balance was set correctly for the scene, your measurements should fall into the range (and deviate by no more than 7 either way) and you can rest easy knowing your colors are true.

If your readings are more than 7 points out of range either way, use software to correct it. But now you also have black and white reference points to help. Use the levels adjustment tool to bring the known values back to where they should be measuring (gray around 128, black around 10, and white around 245).

If your camera offers any kind of custom styles, you can also use the color checker to set or adjust any of the custom styles by taking a sample photo and evaluating it using the on-screen histogram, preferably the RGB histogram if your camera offers one. You can then choose that custom style for your shoot, perhaps even adjusting that custom style to better match your expectations for color.

Glossary

AE (Autoexposure) General-purpose shooting modes where the camera automatically sets the aperture and shutter speeds using its metered reading. Along with Programmed AE, Shutter Priority and Aperture Priority modes are also considered AE exposure modes and on some cameras, the ISO settings can be automatically set as well.

AE/AF lock A camera setting that allows you to lock the current exposure and/or autofocus setting prior to taking a photo. This button lets you recompose the scene without holding the Shutter Release button halfway down.

AF-assist illuminator In low-light and low-contrast shooting situations, this feature automatically adds light to the scene to aid the camera's autofocusing system. Some cameras have a dedicated lamp that shines; others use the pop-up flash, which emits a burst of very high frequency light pulses, and some dedicated speedlights project a lighted grid onto the scene.

ambient light The light that naturally exists in the scene, which can be truly natural (sunlight) or artificial (everyday light fixtures in the room).

aperture Also referred to as the diaphragm or f-stop setting of the lens. The aperture controls the amount of light allowed to enter through the camera lens. The higher the f-stop number setting, the smaller the aperture opening on the lens. Changing the aperture in whole stops doubles or halves the light entering the camera. Larger f-stop settings are selected by lower numbers, such as f/2 or f/1.2. The wider the aperture, the less depth of field the image will possess. A smaller aperture means that the image will have more depth of field, and that more of the background will be in focus.

Aperture Priority mode A camera setting where you choose the aperture and the camera automatically adjusts the shutter speed according to the camera's metered readings. Aperture Priority mode is often used by photographers to control the amount of depth of field.

backlighting Light that is positioned behind and pointing to the back of the subject, creating a soft rim of light that visually separates the subject from the background.

bokeh The shape and illumination characteristics of the out-of-focus areas in an image, depending mainly on the focal length and aperture blade pattern of the lens.

bounce flash A technique of pointing the flash head in an upward position or toward a wall, thus softening the light falling on the subject. Bouncing the light often softens shadows and provides a much smoother light for portraits.

bracketing To make a series of exposures, some above and some below the average exposure calculated by the light meter for the scene, either by flash output or exposure settings. You would want to bracket your images when the camera's calculated exposure may not be what you had in mind, or to create a range of exposures for use in HDR image processing. Some digital cameras can also bracket white balance to produce variations from the average white balance calculated by the camera.

brightness The perception of the light reflected or emitted by a source. The lightness value of an object or image. See also *luminance*.

bulb A shutter speed setting that keeps the shutter open as long as the Shutter Release button or cable release is fully depressed.

cable release An accessory that connects to a port on the camera and allows you to click the shutter by using the cable release instead of pressing the Shutter Release button to reduce camera/shutter vibrations over slow or timed exposures.

camera shake Small movements of the camera during handheld exposure that result in blurry images. Slow shutter speeds and longer focal length lenses exacerbate this problem.

catchlight Highlights that appear in a subject's eyes from a reflection or a small amount of fill flash.

center-weighted metering A metering mode of the camera's built-in metering system. The entire scene is metered with more emphasis placed on the center area.

color balance The color reproduction fidelity of a digital camera's image sensor and of the lens. In a digital camera, color balance is achieved by setting the white balance to match the scene's primary light source. You can adjust color balance in image-editing programs using the color Temperature and Tint controls.

color/light temperature A numerical description of the color of light measured on a Kelvin scale. Warm, early and late-day light has a lower color temperature. Cool, shady light has a higher temperature. Midday light is often considered to be white light (5500K) and electronic flash units are often calibrated to 5500–6000K.

colored gel A color gel or color filter, or a lighting gel (or simply gel), is a transparent colored material that is used in theater, event production, photography, videography, and cinematography to color light and color correct. Modern gels are thin sheets of polycarbonate or polyester placed in front of a light source. Gels are often used to change the color of a black background when shooting portraits or still life photos. The name *gel* stems from the early form of filters used in theaters, which were typically made from gelatin.

contacts Electronic contacts located on the bottom of a shoe-mounted flash make contact with the camera's hot shoe, allowing the flash to communicate exposure and other settings electronically with the camera.

cool Term used to describe a photograph that has a bluish cast, often associated with higher color temperatures. See also *Kelvin.*

daylight balance General term used to describe the color of light at approximately 5500K, such as midday sunlight or an electronic flash.

dedicated flash A flash unit designed to work with one particular camera system, and which can operate in conjunction with the camera's internal metering. Dedicated flash units exchange information with the camera via a proprietary digital data line. This can be accomplished wirelessly or via the small data pins on the flash hot shoe to communicate.

depth of field The distance in front of and behind the subject that appears to be in focus.

diffusion The scattering of light rays to produce a softer, lower-contrast light quality, most readily by material that is placed in front of a direct light source to soften the light emitted. Clouds, fabrics, plastic, and tissue paper are all common forms of diffusion.

diffraction Stray light rays from a direct light source that bounce around on the various glass surfaces of the lens to produce pentagons, hexagons, and other UFOs in photos. These are often eliminated by using a lens hood, gobo, or flag.

dynamic range The difference between the lightest and darkest values in an image. A camera that can hold detail in both highlight and shadow areas over a broad range of values is said to have a high dynamic range.

exposure The amount of light reaching the light-sensitive medium — the film or an image sensor. The result of the intensity of light combined with the length of time the light strikes the medium.

exposure compensation A setting that allows you to adjust the exposure, in 1/2 or 1/3 stops from the metered reading of the camera, to achieve correct exposure under mixed or difficult lighting conditions.

exposure meter A built-in or handheld device that measures light in terms of photographic exposure, such as ISO, shutter speed, and f-stop. A reflected-light meter measures light reflected from a scene. This is the sort of light meter built into a dSLR camera. An incident-light meter measures the light falling onto a particular point. Most handheld meters are this type. Some handheld meters measure reflected light from a broad area, and others called spot meters measure light from a very narrow area. Some handheld meters measure both incident- and reflected-light metering. Most cameras have a variety of metering modes, all of which are based on reflected light.

exposure modes Camera settings that allow the photographer to take photos in a variety of modes such as Programmed Auto, Aperture Priority, Shutter Priority, or Manual for specific situations. See also *Scene mode*.

Flash Exposure (FE) lock A feature that allows you to obtain the correct flash exposure and then lock that setting in by pressing the FE lock button. You can then recompose the shot, with the subject either on the right or the left, and take the picture with the camera retaining the proper flash exposure for the subject.

f-stop A number that expresses the diameter of the entrance pupil in terms of the focal length of the lens; the f-number is also the focal length divided by the effective aperture diameter. See also *aperture*.

fill flash/fill in flash A lighting technique where the flash provides enough light to illuminate the subject in order to eliminate, reduce, or open shadowed areas. Using a flash for outdoor portraits often brightens the subject in conditions where the camera meters light from a broader scene.

flare Unwanted light reflecting and scattering inside the lens, causing a loss of contrast and sharpness and/or artifacts in the image.

flash An electronic light source that produces an instant flash of light when the shutter is opened in order to illuminate a scene. Studio pack and head systems, monolights, ringlights, and speedlights are all types of flashes.

flash exposure bracketing Taking a series of exposures while adjusting the flash exposure compensation up or down to ensure capturing the correct flash exposure.

flash exposure compensation FEC adjusts the speedlight's output to increase or decrease the amount of light output. If images are too dark (*underexposed*), use flash exposure compensation to increase the flash output. If images are too bright (*overexposed*), use flash exposure compensation to reduce the flash output.

flash head The part of the flash assembly that houses the flash tube that fires when taking a flash photo. Flash heads can be adjusted for position. See also *flash head tilting*.

flash head tilting Adjusting the flash head horizontally or vertically by pressing the tilting/rotating lock release button and repositioning the flash head. Often used to point the flash in an upward position, such as when using bounce flash.

flash mode The method the flash uses to determine flash exposure. Flash modes include, TTL, Auto Aperture, non-TTL Automatic mode, and Manual mode.

flash output level The output level of the flash as determined by the chosen flash mode. If using Manual mode, proper guide numbers would need to be calculated in order to provide the correct amount of illumination.

flash shooting distance and range The actual range in which the flash has the ability to properly illuminate a subject. The range, typically between 2 to 60 feet, is dependent on the ISO sensitivity, aperture setting, and zoom head position.

flat Describes a scene, light, or photograph that displays little difference between dark and light tones.

fluorescent lighting Common office or industrial lighting that uses fluorescent tubes. Without filtering or adjusting to the correct white-balance settings, pictures taken under fluorescent light display a greenish-yellow colorcast. In addition to primary colors, several shades of White are marketed by the fluorescent lamp manufacturers for general lighting use. These tend to fall into three shades: Warm White, Cool White, and Daylight, although some manufacturers have multiple shades or grades of each, adding the word "Deluxe," "Designer," or other designations.

front-curtain sync Default setting that causes the flash to fire at the beginning of the exposure when the shutter is completely open. See also *rear-curtain sync*.

front light Light that comes from behind or directly beside the camera to strike the very front of the subject.

grain Grain is a term used to describe the mottled texture of continuous toned areas in a print made from film. The equivalent of grain is called noise in a digital image. Grain can also be manipulated creatively to convey mood and drama. See also *noise*.

gray card A card that reflects a known percentage of the light that falls on it. Typical gray cards reflect 18 percent of the light. Gray cards are standard for taking accurate exposure-meter readings and for providing a consistent target for color balancing during the color-correction process using an image-editing program.

guide number A number that indicates the amount of light emitted from the flash. Each model speedlight has its own guide number, indicating the speedlight's flash capability at its maximum power setting. The guide number is a constant, published in the flash specifications.

hard light Undiffused light that strikes a subject directly from its source, such as sunlight, light from a light bulb, flash, or strobe.

high key Term used to describe a photograph that is predominantly light toned overall.

highlight A light or bright area in a scene, or the lightest area in a scene.

high-speed sync At very fast shutter speeds, those above the camera's rated sync speed, the shutter is never fully open at any given instant. The second shutter curtain begins to close before the first has completed its transit across the sensor plane. High-speed sync flash emits a rapid burst of flashes so that as the slit created by the first and second curtain passes over the image area, the entire sensor is exposed to flash illumination. When the High-speed Sync mode is not engaged, the camera does not allow you to set the shutter speed to faster than the camera's rated sync speed. See also *sync speed*.

histogram A simple bar graph that shows the distribution of pixels over the tonal range of an image from pure black to pure white. Most modern dSLR cameras have the ability to display the Red, Green, and Blue color channels as well as the brightness levels in the histogram.

hot shoe A camera mount that accommodates a separate external flash unit.

Inside the mount are contacts that transmit information between the camera and the flash unit and that trigger the flash when the Shutter Release button is pressed.

hot spot An overly bright spot on the subject caused by excessive or uneven lighting.

ISO sensitivity The ISO (International Organization for Standardization) setting on the camera indicates the camera's light sensitivity. In digital cameras, lower ISO settings provide better-quality images with less image noise; however, the lower the ISO setting, the more exposure is needed.

Kelvin A scale for measuring temperature based on absolute zero. The scale is used in photography to quantify the color temperature of light.

lighting ratio A ratio used to describe the difference in brightness between two light sources. A 1:1 ratio means both light sources are equal. A 1:2 ratio denotes that the second light is half as bright as the first; a 1:4 ratio describes the second light as being one-fourth as bright as the first, and so on.

low key Term used to describe a photograph that is predominantly dark toned overall.

luminance The light reflected or produced by an area of the subject in a specific direction and measurable by a reflected light meter.

manual exposure A mode in which the photographer adjusts the lens aperture and/or shutter speed to achieve the desired exposure. Many photographers need to control aperture and shutter independently because opening the aperture increases exposure but also decreases the depth of field, and a slower shutter increases exposure but also increases the opportunity for motion blur.

Manual flash mode Manually setting the flash output of the flash independently from the calculated exposure of the camera.

metering Measuring the amount of light utilizing the camera's internal light meter or by using a handheld external light meter. For most flash uses, flash units emit a preflash for the camera's light meter in order to achieve a properly exposed photo.

midtone An area of medium brightness; a medium value tone in a digital image or photographic print. Midtones are usually found halfway between the darkest shadows and the brightest highlights.

minimum recycling time The shortest amount of time a flash system needs to power back up to properly expose a shot after previously being fired. While larger flash system and monolights plug into a household outlet, smaller speedlights are powered by batteries, and the minimum recycling time is a specification used to indicate how long it takes your flash to recharge between photos.

mirror lock-up A camera function that allows the mirror, which reflects the image to the viewfinder, to flip up without the shutter being released. This is done in order to reduce vibration from the mirror moving on slow or timed exposures or to allow manual sensor cleaning.

modeling light A secondary light, usually tungsten or halogen, built into a studio strobe in order to visualize what the flash output will look like. Some speedlights have a modeling "flash" feature that fires a short burst of rapid flashes that allow you to see the effect of the flash on the subject.

noise Extraneous visible artifacts that degrade digital image quality or creatively added in post-production for effect. In digital images, noise appears as multicolored flecks, also referred to as grain. Noise is most visible in slow shutter speed digital images captured at high ISO settings. See also *grain*.

open up To switch to a lower f-stop number, which increases the size of the diaphragm opening, allowing more light to reach the sensor.

pilot/ready light Located on the power pack or rear panel of the flash, these lamps illuminate to indicate that the flash is ready to fire and when pressed, will fire a test flash from the main or remote flashes.

pixel A word derived from combining the words *picture elements*, used to describe the smallest unit that makes up a photographic image.

polarizing filter A polarizing filter removes reflected light from surfaces and thereby increases contrast and saturation. Polarizing filters screw onto the front threads of a lens and have a rotating bezel that adjusts to polarize the light. There are two types of polarizers — linear and circular — so be sure to get a circular polarizer for dSLR cameras because they help the camera meter and focus faster than linear polarizers do.

Programmed Auto (P) When using a dedicated on-camera flash with a compatible camera set to Programmed auto, the shutter speed is automatically set to the camera's sync shutter speed when using flash.

Rear-curtain sync Camera setting that allows the flash to fire at the end of the exposure, right before the second, or rear, curtain of the shutter closes. With slow shutter speeds and flash, this feature creates a blur behind a moving subject, visually implying forward movement. See also *front-curtain sync*.

Red-Eye Reduction A flash mode controlled by a camera setting that is used to prevent the subject's eyes from appearing red in color. The dedicated flash fires multiple flashes just before the shutter is opened. As a general rule, the farther the flash head is located from the axis of the camera lens, the less

chance of getting the red-eye effect. You can combine Red-Eye Reduction with slow-sync in low-light situations.

reflector Any object used to reflect light back into the photograph onto the subject, to lighten shadows or create specific highlights, shadows, modeling, or effects from a direct light source.

remote A radio or optical device that triggers cameras or off-camera flashes to fire.

ring light or ring flash A type of electronic flash that surrounds the lens and produces virtually shadowless lighting. It can also be used to describe a flash accessory that produces a similar look when using a camera-mounted speedlight.

saturation As it pertains to color, a strong pure hue undiluted by the presence of white, black, or other colors. The higher the color purity is, the more vibrant the color.

Scene shooting mode Available on some cameras, these are automatic modes in which the settings are adjusted to predetermined parameters, such as a wide aperture for the portrait scene mode and high shutter speed for Sports Scene mode. See also *exposure mode*.

Shutter Priority A camera setting where you choose the shutter speed and the camera automatically adjusts the aperture according to the camera's metered readings. Shutter Priority is often used by action photographers to control motion blur.

shutter speed The length of time the shutter is open to allow light to fall onto the imaging sensor. The shutter speed is measured in seconds, or more commonly, fractions of seconds.

side lighting Light that strikes the subject from the side, often utilized to show the texture of a subject.

silhouette A view of an object or scene consisting of the outline and a feature-less interior, with the silhouetted object usually being black. The term has been extended to describe an image of a person, object, or scene that is backlit, and appears dark against a lighter background.

slow Refers to film and digital camera settings that have low sensitivity to light, requiring relatively more light to achieve accurate exposure. Also refers to lenses that have a relatively wide aperture, such as f/3.5 or f/5.6, and to a long shutter speed.

soft light Light in the photo that strikes the subject after passing through some type of diffusion material, such as clouds, or tissue, or bounced into a card or adjacent surface.

spot metering A metering method where only a small area in the center of a scene is used to determine exposure.

stop A term of measurement in photography that refers to any adjustment in exposure by a power of 2. That means 1 stop more exposure is exactly twice the exposure, and one stop less is exactly half. Predominantly used to describe aperture/diaphragm settings, adjustments to ISO, and shutter speeds that effect exposure can also be referred to as stops.

stroboscopic flash A flash mode on the flash unit that fires multiple flashes with which to capture multiple images of a moving subject in a single photographic frame.

sync speed Most flashes are limited to only being able to be used up to a certain shutter speed. This top speed is called the sync speed. The camera and the type of shutter mechanism being used limit the sync speed. See also *high-speed sync*.

top lighting Light, such as sunlight at midday, that strikes a subject directly from above.

tungsten lighting Common household lighting that uses tungsten filaments. Without filtering or adjusting to the correct white-balance settings, pictures taken under tungsten light will display a yellow-orange colorcast.

value The relative lightness or darkness of an area. Dark areas have low values, and light areas have high values.

vignette/vignetting The darkening of edges on an image that can be caused by lens distortion, using a filter, or using the wrong lens hood. This is also used creatively in image editing to draw the viewer's eye toward the center of the image.

warm Term used to describe a photograph that has a reddish or orange cast associated with lower color temperatures. See also *Kelvin*.

white balance A setting used to compensate for the differences in color temperature common in different light sources. For example, a typical tungsten light bulb is very yellow-orange, so when adjusted properly, the camera's white balance setting adds blue to the image to ensure that the light looks like standard white light.

zoom head A small flash's mechanism that can automatically move the flash tube forward or backward during automatic flash operations to project light in a pattern that matches the angle of view seen with a particular focal length of lens.

Index